PRAISE FOR *What Rivers Know*

"Knowledge about and reverence for water has never been as important as it is today. Irland's essays beautifully weave in the critical threads of conservation and education, along with her reverence for water and its role in life and on Earth. Her work has set her apart as one of the liquid realm's most eloquent biographers."
—DAHR JAMAIL, author of *The End of Ice: Bearing Witness and Finding Meaning in the Path of Climate Disruption*

"A river is a living thing as we are: it is about time to firmly share that understanding as part of common humanity, which I believe has just been made possible thanks to Basia. *What Rivers Know*, being culturally on time, will greatly assist with the ongoing, worldwide movement to recognize the rights of rivers. The first-person narrative in each essay makes it easy for readers to feel connected at the emotional level to the river and to finally listen to what the river has to say. Please allow yourself to be intimate with each river as you go through each essay in this book. If you do, you will never see the rivers the same way you have before."
—CHANGWOO AHN, professor of Environmental Science and Policy at George Mason University and founder of The Rain Project

"In *What Rivers Know*, Basia Irland, academic, artist and advocate for water, explores twenty-five rivers around the world allowing them to speak as people sharing their stories of the changes they have been witness to. Rivers that flow through indigenous lands in North America talk of colonisation and conflict and the erosion of their riparian rights. Other rivers bemoan the impact of development, including embankments and encroachments on their once untamed waters. Basia's beautiful photographs, and the simplicity and insightfulness of her writing, are at the heart of her call for being mindful of how our lives, and that of the non-human world, have been shaped by our rivers."
—DR. SARA AHMED, Founder, The Living Waters Museum, India and Vice President, the Global Network of Water Museums

"Rivers murmur, sing, rumble. Although everyone hears them, no one listens to them, except for Basia Irland who recognizes their universality and gives them a voice. In this story, we listen as much as look at the heart of the river. To follow its course is to preserve a quest for embodied knowledge. An encounter beyond the image. Nature is always doubled, consciously or not, in the discourse of artists, with other meanings such as deep identity, the origin of things, and our common memory. This captivating book wisely blends environmental activism with poetic narrative, where the whispered voices of ancient river peoples are blended with the tumult of modern civilization. Irland leads us to wonder if this is the last chance for humans to realize that our future world and the fate of rivers are eternally linked."
—PATRIK MARTY, artist and author of *L'eau de l'art contemporain: Une dynamique d'une esthétique écosophique*

WHAT RIVERS KNOW

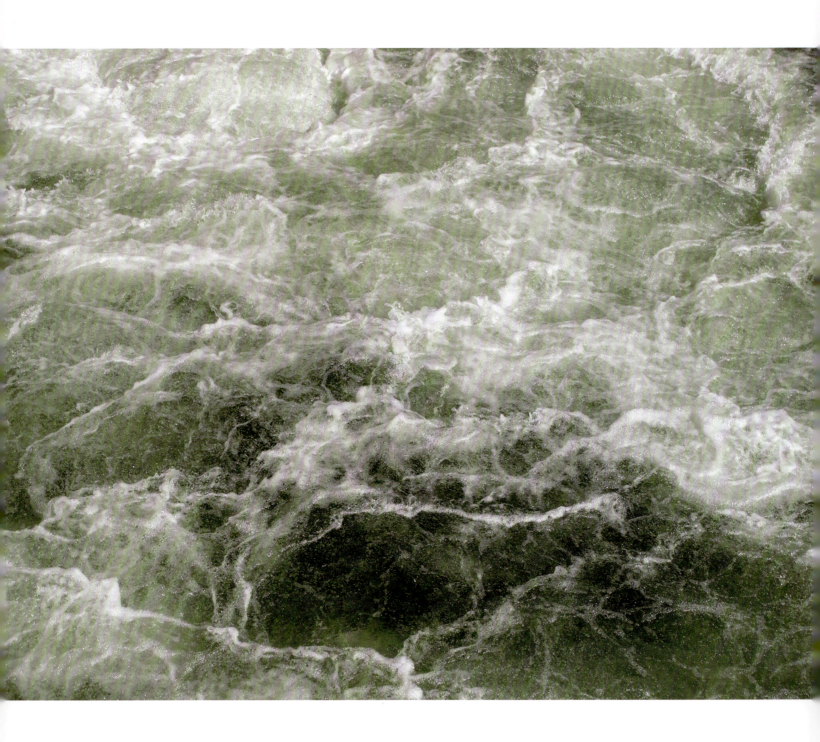

WHAT RIVERS KNOW

Listening to the Voices of Global Waterways

BASIA IRLAND

Foreword by Lucy R. Lippard
Preface by Sandra Postel

TEXAS A&M UNIVERSITY PRESS • COLLEGE STATION

Copyright ©2025 by Basia Irland
All rights reserved
First edition

(∞) This paper meets the requirements of ANSI/NISO Z39.48–1992
(Permanence of Paper).
Binding materials have been chosen for durability.
Manufactured in China through Martin Book Management

Library of Congress Cataloging-in-Publication Data

Names: Irland, Basia, 1946– author. | Lippard, Lucy R., writer of foreword.
 | Postel, Sandra, writer of preface.
Title: What rivers know: listening to the voices of global waterways /
 Basia Irland; with a foreword by Lucy R. Lippard; and a preface by
 Sandra Postel.
Description: First edition. | College Station: Texas A&M University Press,
 [2024]
Identifiers: LCCN 2024030237 (print) | LCCN 2024030238 (ebook) | ISBN
 9781648432569 | ISBN 9781648432576 (ebook)
Subjects: LCSH: Stream health. | Stream ecology. | River
 Engineering—Environmental aspects. | Water resources
 Development—Environmental aspects. | Waterways. | River life. | BISAC:
 NATURE / Ecosystems & Habitats / Rivers | PHOTOGRAPHY / Photoessays &
 Documentaries | LCGFT: Essays.
Classification: LCC QH541.5.S7 I75 2024 (print) | LCC QH541.5.S7 (ebook)
 | DDC 577.6/4—dc23/eng/20240705
LC record available at https://lccn.loc.gov/2024030237
LC ebook record available at https://lccn.loc.gov/2024030238

Unless otherwise indicated, photographs are by the author.

*For my son, Derek,
who grew up in a canoe paddling the northern Ontario lakes and
continues kayaking along the coast of Vancouver, British Columbia.
His help with this book was immeasurable.*

CONTENTS

Map	viii
Foreword by Lucy R. Lippard	xi
Preface by Sandra Postel	xv
Introduction	xix
Nisqually River, Washington	3
San Lorenzo River, Santa Cruz, California	9
Merced River, Yosemite National Park, California	15
North Fork Virgin River, Zion National Park, Utah	23
Portneuf River, Pocatello, Idaho	27
Yaqui River, Yaqui Nation, Sonora, Mexico	33
Gold King Mine spill (Animas and San Juan Rivers), Colorado, New Mexico, Utah, and the Navajo Nation	39
Eagle River, Eagle Mine Superfund site, Colorado	45
Saskatchewan River Delta, Cumberland House, Saskatchewan, Canada	47
Great Miami River, Five Rivers Fountain of Lights, Dayton, Ohio	53
French Broad River, Asheville, North Carolina	57
Deckers Creek, West Virginia	61
Gowanus Canal, Brooklyn, New York	65
Seine, Paris, France	69
Amstel River, Amsterdam, the Netherlands	75
Blue Nile, near Lake Tana and Bahir Dar, Ethiopia	79
Narmada River, India	85
Bagmati River, Kathmandu, Nepal	91
Ping River, Chiang Mai, Thailand	95
Chao Phraya River, Bangkok, Thailand	99

Siem Reap River, Cambodia	103
Singapore River, Singapore	109
Chaobai River, Beijing, China	119
Kamo River, Kyoto, Japan	125
Río Grande, USA and Mexico	129
Acknowledgments	139
About the Author	141
Select Résumé (Bibliography and Publications)	143
Index	153

1. Nisqually River, Washington
2. San Lorenzo River, Santa Cruz, California
3. Merced River, Yosemite National Park, California
4. North Fork Virgin River, Zion National Park, Utah
5. Portneuf River, Pocatello, Idaho
6. Yaqui River, Yaqui Nation, Sonora, Mexico
7. Gold King Mine spill (Animas and San Juan Rivers), Colorado, New Mexico, Utah, and the Navajo Nation
8. Eagle River, Eagle Mine Superfund site, Colorado
9. Saskatchewan River Delta, Cumberland House, Saskatchewan, Canada
10. Great Miami River, Five Rivers Fountain of Lights, Dayton, Ohio
11. French Broad River, Asheville, North Carolina
12. Deckers Creek, West Virginia
13. Gowanus Canal, Brooklyn, New York
14. Seine, Paris, France
15. Amstel River, Amsterdam, the Netherlands
16. Blue Nile, near Lake Tana and Bahir Dar, Ethiopia
17. Narmada River, India
18. Bagmati River, Kathmandu, Nepal
19. Ping River, Chiang Mai, Thailand
20. Chao Phraya River, Bangkok, Thailand
21. Siem Reap River, Cambodia
22. Singapore River, Singapore
23. Chaobai River, Beijing, China
24. Kamo River, Kyoto, Japan
25. Río Grande, USA and Mexico

FOREWORD

Basia Irland Knows What Rivers Know

Lucy R. Lippard

Basia Irland's devotion to rivers has taken many turns since her first water piece in 1973, when she photographed the word FLOW (using her young son's magnetized fridge letters) as it floated down a creek. The preoccupation comes naturally; she was raised along Boulder Creek in Colorado. *What Rivers Know*—which began as an ongoing National Geographic essay series— provides a new confluence of art and eco-activism as she moves on downstream. Having followed the entire 1,885-mile course of the (sadly misnamed) Río Grande/Río Bravo in her five-year-long piece *The Gathering of Waters*, she has now taken on shorter stretches of rivers worldwide, each one a snapshot focusing on a particular viewpoint and culture crucial to the watercourse's survival, and to those who live on and travel with it.

The genius of these essays, mentioned by many online comments, is that they are written in the first person, the persona of the river herself. This unorthodox viewpoint removes the distanced objectivity expected of journalistic criticism and delivers the writing into direct experience—not the experience of someone simply rafting and hiking and researching a river, but the experience of *being* a river. "Human" and "natural" histories are intertwined with those of vegetation, fish, and wildlife. While most of these rivers may be locally loved, what they have in common is lack of respect, given the pollution and trash they are forced to carry on their journeys. Each river "is asked to offer more than it has to give," as Irland described the Río Grande. Irland's choice of the first person makes each essay an intimate dialogue; the object becomes a subject. (And if this recalls feminist discourse, so much the better.) Yet these rivers are shapeshifters. Nothing is as constantly changing as flowing water, so assigning it a persona is to transmit not an individual voice but the multiple voices of a natural force, a braided fusion of energies and particles, controlled but ultimately uncontrollable.

Each river has a distinct voice. The essays describe their beauty and their pain. They are benign and violent, providing sustenance for daily life and

occasionally erupting in destructive floods. The saddest story (let's get it over with) is that of the Río Yaqui/Jíak Batwe in Sonora, home of the eponymous tribe that straddles the contentious Mexico-US border. The Yaqui tribe's terrible history of decimation since colonization has been shared with their river, which is often drained of life, choked with trash and pesticide runoff, and illegally appropriated by more powerful interests. But the Yaqui have resisted and been arrested, and the river survives, barely. The Eagle River in Colorado might look better, but it is a Superfund site, a victim of mining greed, with remediation under way. The North Fork of the Virgin River in Utah (named after either the Virgin Mary or a nineteenth-century colonist) joins the Colorado and is one of the nation's few remaining free-flowing rivers. (The Gila in New Mexico is another, now threatened by a huge and unjustified diversion project.) The Virgin flows through the dramatic red-rock canyon of Zion National Park, once homeland to the indigenous Paiute, another sad story mixed with a glad one, given the beauty of the preserved landscape.

Then on to Asia—to Japan, Cambodia, Thailand, and Nepal. Again, each landscape is different, although the issues are depressingly similar. The Kamo-gawa in Kyoto, Japan, is a shallow, tamed river, home to ducks, herons, and egrets, channeled into a straight line through an urban park, bridged for human convenience. The Shinto shrine at its confluence with the Takano River reflects Irland's long-standing concern with ritual. Given her artwork, it is easy to understand her attraction to the Shinto ritual of cloth-wrapped white rocks, blessed and intended for construction at the shrine. At the Maenam Ping, passing through Chiang Mai, Thailand, the focus is on a six-hundred-year-old ceremony marking the full moon at the end of the rainy season, offering homage to the water spirits and forgiveness for mistreating the river. But the abuse continues. Styrofoam flowers sometimes stand in for natural blossoms, and banana stalks and bread offerings clog the waters and kill wildlife.

"We all live downstream" has become a true truism, like "think globally, act locally." Since its naming in the late 1960s, ecological art has strived to be useful—to the Earth, to its blithely dismissive inhabitants, and to its stewarding movements. Irland joins artists who have been concerned with the environment in very different ways since the 1960s, like Mierle Laderman Ukeles (known for her work with sanitation and waste management within the municipal government of New York City), Patricia Johanson (whose large-scale reclamation projects are shaped as images from nature), or Brandon Ballengée (an artist-biologist working on species extinction from field ecology

and lab research). Most eco-art aims to make specific, local, environmental changes for the better; it tends to require massive funding and construction. But Irland steps into the current with very little baggage. Her writings are accompanied by evocative photographs depicting the scenic and the tragic. Traveling like a Mountain Woman, she is equipped only with two cameras, "a deep passion for the bloodstream rivers of the world—and my dendritic imagination."

This does not, however, limit the scale of her endeavors. Irland conceptualizes her trips and incorporates her flourishing knowledge. These essays are the result of intense research. She consults with rangers, watershed councils, scientists from various disciplines, and local people. The global reach of her original National Geographic posts permitted the artist to access the cross-cultural perspectives through which she educates herself and her audience. The essays rise into cyberspace, where they have the potential to reach thousands, maybe even millions. The *National Geographic* editors' commitment to the former *Water Currents* blog—which closed in 2020 and was edited by water guru Sandra Postel, an author and the director of the Global Water Policy Project (who invited Irland on board as the first nonscientist)—provides a welcome contribution to a down-to-earth view of the differences and the commonalities necessary to navigate these contentious and ominous times.

A naturalist in the old-fashioned sense as well as an avant-garde artist—a potent combination of two vocations that depend on looking very closely—Irland is also a poet, which enables her to encapsulate a great deal of vital information into limited words. Her writings are the new "artist's books," fresh initiatives in the long search for outlets by which eco-art can reach a broader public through innovative forms. (It's not the first time she has innovated in book form. Her Ice Books, embedded with "riparian texts" of seeds, melt and distribute botanical wisdom as they wend their way down a creek in Boulder, Colorado, and elsewhere around the world.)

Irland is an inveterate traveler, ready to continue to follow rivers around the globe, while also tracking water-harvesting projects, waterborne diseases, and watershed health. Just as rivers connect people, so does she, always working with local collaborators as she takes us below the deceptively pretty surfaces, into the darker depths. "Now there is no stopping me," she says. "I will keep writing as long as there are rivers." And she will not run out of beautiful rivers in pain.

Lucy R. Lippard is a writer, activist, curator, and author of twenty-six books on contemporary art, cultural criticism, and local history, including *From the Center: Feminist Essays on Women's Art; Eva Hesse; Mixed Blessings: New Art in a Multicultural America; The Lure of the Local: Senses of Place in a Multicentered Society; Undermining: A Wild Ride through Land Use, Politics, and Art in the Changing West; Pueblo Chico: Land and Lives in Galisteo since 1814;* and most recently *STUFF: Instead of a Memoir.* She has cofounded various artists' feminist and activist organizations and publications. She lives off the grid in rural Galisteo, New Mexico, where for twenty-six years she has edited the monthly community newsletter *El Puente de Galisteo.*

FOREWORD XIII

PREFACE

The Blue Arteries of Our Planet

Sandra Postel

Signs abound that Earth's rivers, lakes, wetlands, and watersheds are in trouble. Dams block and alter natural river flows. Big diversions siphon so much water away that major rivers no longer reach the sea. Pollutants degrade water quality and critical habitats. As a result, the rich web of life that rivers and watersheds support—and on which humanity depends—is unraveling. Better laws and policies to protect rivers are critically needed, but for these to take hold we must broaden and deepen humanity's connection to rivers and all they do to sustain not only our human economy, but life itself.

It is this existential challenge to which ecological artist Basia Irland has devoted much of her time and talent. Through her projects, Irland has helped numerous communities connect to the life force that flows through them, raised awareness of threats to river health, and bestowed honor on rivers that give so much to us, but to which humanity returns so little.

Irland's essay on the Nisqually River in Washington State, for example, helps capture the essence of this 78-mile watercourse as it flows from its glacial source on Mount Rainier to the marine waters of Puget Sound. Its watershed encompasses prairies, forests, wetlands, and streams that support a rich diversity of life, including treasured yet threatened salmon populations. The Nisqually River provides more than half of the freshwater entering the southern portion of Puget Sound and serves as the main drinking water source for the city of Olympia and other watershed communities.

Yet the story of the Nisqually, like that of most rivers, is also one of dams that block and alter its natural flow, pollution that degrades its quality, and tree harvesting that threatens the integrity of its watershed. It is this tension between preserving rivers for their gifts of beauty and life on the one hand, and exploiting rivers to meet human demands on the other that draws Irland to their banks.

A global movement is under way to extend rights to rivers and other freshwater ecosystems. It includes many different approaches and definitions, but

Sandra Postel is director of the Global Water Policy Project and the 2021 Stockholm Water Prize Laureate. For six years, she served as Freshwater Fellow of the National Geographic Society, where she spearheaded an initiative that has restored billions of gallons of water to depleted rivers and wetlands across North America. Postel is the author most recently of *Replenish: The Virtuous Cycle of Water and Prosperity.*

a core idea is to view rivers not as property over which humans have dominion, but rather as living entities with rights to exist and thrive. Indigenous communities for whom this way of thinking is ingrained in their culture have led the way, and the idea is spreading. For these rights to have more than symbolic value, however, this evolution in law must be matched by a deeper and broader evolution in human awareness and consciousness.

In literally assuming the voice of rivers in these essays, Irland helps us see and experience the world as a river might, building empathy and care for these blue arteries of the planet. She listens, and then speaks for the rivers, in hopes that more of us will care and act to protect them.

Seventeen of the twenty-five essays in this book originated from Irland's unique contributions to National Geographic's *Water Currents*, an online platform for the expression of water findings and ideas, which I cocreated and hosted when serving as Nat Geo's Freshwater Fellow. I am thrilled to see these essays refreshed and given new life in this book.

So let us listen, and then act to protect the rivers that flow through our landscapes and communities. They are among planet Earth's most precious and vital gifts.

INTRODUCTION

Can We Imagine for a Moment *Being* the River?

Let's begin with the clouds gathering and releasing moisture. In cold, high elevations, the water freezes and comes down as snow, piling up in winter and beginning to melt in the warmer spring weather. It trickles downhill, joins other brooks and streams, forms cascades, and as the grade grows steeper, plunges over cliffs as waterfalls. So begins one river's descent to the sea.

Above rivers, lakes, and oceans, evaporating water rises again to form new clouds—and the hydrologic cycle continues its ancient dance as it has for millions of years.

<div align="right">

Basia Irland, quote from her video documentary
A Gathering of Waters: The Río Grande, Source to Sea

</div>

Rivers are just as alive as you and me! They have a body called a catchment with a mouth at the delta; cells of water molecules; organs of wetlands and riparian zones; and, like us, a circulatory system. We are inseparable from the waters of the world. Our bodies are circulating streams of tears, sweat, blood, urine. Liquid enters and circulates within us, and when waste leaves our bodies, it is flushed down the toilet and flows though pipes into a sewage facility, where the effluent is treated before it empties into rivers,

Hydrologic cycle.

often becoming our drinking water. Everything is interconnected through a cycle. Each of us is a walking river, sloshing along with damp insides held together by our paper-thin epidermis. Clogged arteries in the human body are analogous to the structures of dams, where entire ecosystems are changed when streams cannot flow naturally. If all of us could deeply understand that rivers are living beings, would we treat them with respect and cause them no harm?

I grew up in Boulder, Colorado, with a small stream running through the pasture in our backyard. The banks of Boulder Creek became my playground, my hiding place, my sanctuary. I have been fascinated with rivers since those early years of childhood spent cavorting with cold winter waters. My family went ice-skating on frozen lakes. We built snow figures topped with one of Dad's hats, had sword fights with icicles, skied the Colorado Rockies, trudged through deep forest snow in December to find the perfect Christmas tree. In spring, we would head up into the mountains to camp beside snowmelt creeks.

When my son, Derek, and I were hiking along the Virgin River in Zion National Park, Utah, in 2013, we were experimenting with a new underwater camera. As I took photographs through that cold water looking up at the cliffs above, I began to wonder how this ancient river, millions of years old, might view such an incredible landscape as it flowed downstream. Could we imagine even for a moment being that river? Waterways are alive and have memory, yet most humans simply take them for granted and don't treat rivers with respect. What if we paid deep attention to these resonant, liquid voices? What would they say?

What Rivers Know is a collection of twenty-five essays written in the first person from the perspective of the water. It focuses our attention on the numerous challenges confronting living bodies of water and the necessity of caring for rivers everywhere. We cannot survive without clean water, much of which is supplied from rivers that are diminishing because of climate disruption and human misuse. Each chapter offers important insights into the problems faced by watersheds around the world and how numerous advocacy community groups are formulating solutions, conservation ideas, and inspirational methods to come to the aid of their streams.

Among these ways of caring is the growing movement recognizing the rights of rivers. The Whanganui River (Te Awa Tupua) in New Zealand, home to Māori tribes for centuries, was the first to be legally recognized as a living whole in the Te Awa Tupua Act of 2017. Most Western legal systems place

XX INTRODUCTION

humans above all other life-forms, but giving rivers legal status as living entities is catching on around the world and having important impacts that can be enforced in a court of law.

I was invited to write a chapter for the 900-page UNESCO publication *River Culture: Life as a Dance to the Rhythm of the Waters* (2023, edited by Karl M. Wantzen), where I was one of two artists among 120 scientists from twenty-four countries. In this UNESCO book, I describe a primary reason for founding the Art and Ecology Program at the University of New Mexico: to get diverse students away from campus and out into wild, high-desert regions. Students can intellectually research wilderness sites while sitting within the confines of a classroom, but it is quite another thing to camp beside a designated Wild and Scenic River and the next day raft for hours, experiencing riparian ecosystems and the force of the current pulling our boat toward the sea.

I've dedicated my life and art to water issues and have taken an interdisciplinary approach to the creative process by collaborating with a variety of colleagues, including biologists, stream ecologists, botanists, hydrologists, environmental groups, engineers, poets, musicians, and other artists. The focus on the importance of respecting and preserving water is fundamental to all my documentary films, performances, community actions, waterborne-disease scrolls, archival objects, installations, sculptures, and publications. Books about my projects include *Water Library* (University of New Mexico Press, 2007) and *Reading the River: The Ecological Activist Art of Basia Irland* (Museum De Domijnen, the Netherlands, 2017). A monograph authored by Patricia Watts, *Basia Irland, Repositories: Portable Sculptures for Waterway Journeys*, was published in 2023. My work has been included in over seventy international publications, some of which are listed in the bibliography at the end of this book.

All the rivers I write about are ones I have visited in person and had the pleasure and honor to spend time with. Most of these riparian visits have come as an invitation from groups, institutions, and universities. Wherever I am invited, I meet with community members, activists, tribal elders, park rangers, and scientists who have accumulated deep knowledge of their local streams and who have graciously shared understanding and experience of these places. For many of the chapters in this book, specialists, who are thanked in the acknowledgments, have kindly reviewed and checked the text for accuracy. In-depth research into each body of water is paramount, but more so is the personal, firsthand experiential connection to every creek, stream, or river that I have met. Seventeen of the essays were originally

posted to National Geographic's online blog *Water Currents*, between February 16, 2016, and November 13, 2017, at the invitation of Sandra Postel, a National Geographic Fellow. (These writings have been revised and updated since their initial postings.) Even after the posts stopped, my dedication and enthusiasm for writing these essays continued while I visited and described another eight river systems. It is a privilege and a weight to transcribe these stories of our waterways.

Many of the rivers in these chapters are perhaps not the most "impressive" waterways, and yet each one is important to the communities through which it flows. Although there is broad international coverage and an expansive spread of river locations, there are also numerous places that are not included, such as South America. The Amazon is one of the most powerful rivers in the world, and yet it is omitted since I have not yet had the opportunity to visit this mighty being—and as already explained, I will write only about places where I have been in person, and not simply as a research assignment. There are innumerable fascinating flowing examples that I hope someday to get to know, such as the 45-mile Elwha River in Washington State, where dam removal has helped restore the entire ecosystem in the sediment-deprived delta region.

Perhaps there could eventually be a second volume (this would be a joy) that would include new discoveries plus many other rivers I have already visited and have begun writing about, which are not in this publication, including the Thames, London; the Oconee, Georgia; Boulder Creek, Colorado; Ottawa River, Canada; River Irwell, Manchester, plus others. The chapters in this book are a selection of rivers with which I am intimate that are diverse and yet share so many commonalities.

One of my pet peeves is when a river is referred to as a "resource." We hear this all the time. At the University of New Mexico there is even a program of Water Resource Management. A resource is something to be utilized and often refers to capital and property, which negates the idea of a living being. It is like referring to a forest as timber and implies something to be taken. What can we give back to waterways, instead of expecting them to provide us with something? We could reword President Kennedy's famous phrase: "Ask not what this river can do for you, but what you can do for this river." I suggest that we could replace the word "resource" with the term "source."

Indigenous cultural heritage and language in relation to rivers, which are considered sacred, is imperative and is often overlooked or not

even mentioned in writings about waterways, even though there are about 574 federally recognized tribal nations in the United States, more than 630 First Nations, Inuit, and Métis communities in Canada, and thousands of global tribes, most of whom live in proximity to rivers, creeks, and streams and practice ceremonies that celebrate a time-honored deep relationship to a water source. Their history is complex, with broken treaties, trails of tears, brutal treatment by colonizers, and significant fights over water rights. Indigenous peoples around the world have moved into the forefront of decision-making power in every discipline, especially in relation to land and water issues at the local, state, provincial, and national levels, helping all of us to better care for this planet. In the United States, for example, Debra Haaland, an enrolled citizen of the Pueblo of Laguna, was sworn in as the fifty-fourth secretary of the interior in 2021. Her department has committed billions of dollars to help fulfill Indian water rights settlements.

Studying the meandering dendritic blue lines on printed maps that depict rivers and their tributaries is totally different from physically being with the flowing current. Nothing compares to being present with a river, incorporating all the senses; watching a stick caught in swirls and eddies; touching cold glacier melt or floating naked, face up in a quiet, warm expanse of water; listening to melodic, rhythmic sounds of a brook; smelling ionically charged air near a waterfall; and tasting fresh spring water.

I am incredibly impassioned by how important it is to understand and appreciate each waterway since we rely on these living bodies for our very survival, and yet they have been mindlessly channelized, dammed, and polluted. In response, what are communities doing to begin the healing process, develop restoration projects, and involve others in the necessity of caring deeply for their local rivers? My life's work has been to educate people about this question and bring awareness to its urgency.

By the end of this book, I hope you, too, will feel called to action on behalf of your local brook, creek, stream, or river.

Basia walks in a cold mountain stream.

INTRODUCTION XXIII

WHAT RIVERS KNOW

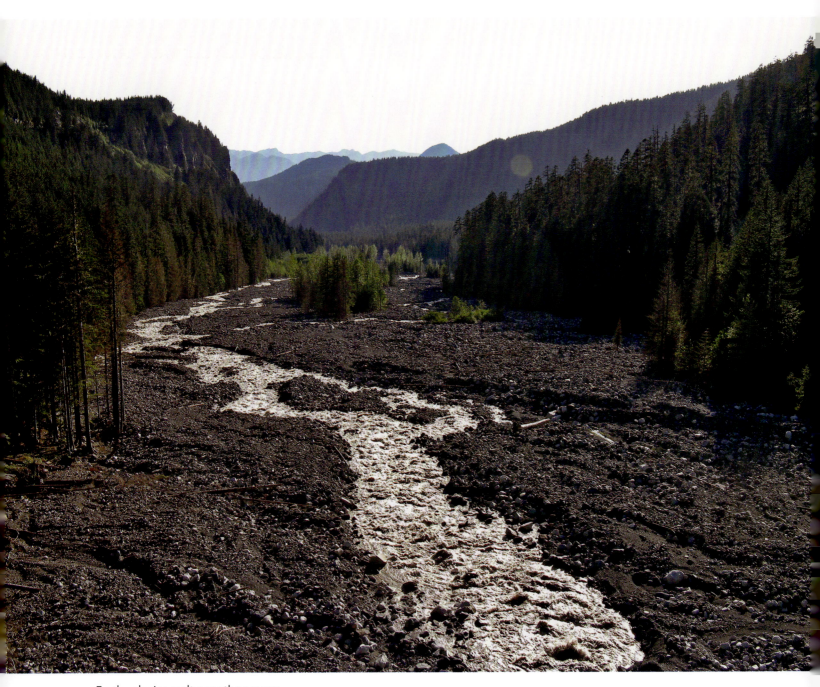

Frothy glacier melt near the source

Nisqually River, WASHINGTON

Birthed in Mount Rainier National Park, Washington, from glacier melt on the southern slope of Mount Rainier, I flow seventy-eight miles into the Billy Frank Jr. Nisqually National Wildlife Refuge and on into the Salish Sea, a fast and galloping ride from fourteen thousand feet down to sea level. I leave the glacier as meltwater, with a milky cloudiness made from small particles of rock, minerals, and organic matter picked up and carried in my swift current.

These days, I get to flow free for only twenty-eight miles before being stopped by the first of two dams. I'm dancing along quite contently, when—bam—dam! I come to an abrupt stop behind a huge curved structure called

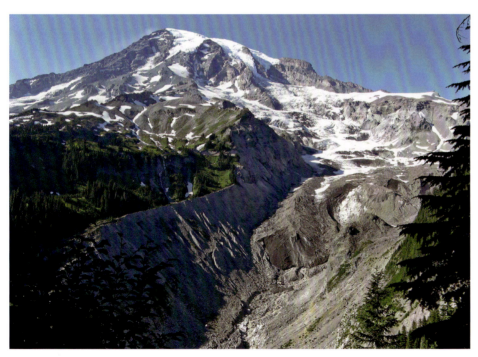

Mount Rainier (Tacobet in the Nisqually language) with tongue of Nisqually Glacier.

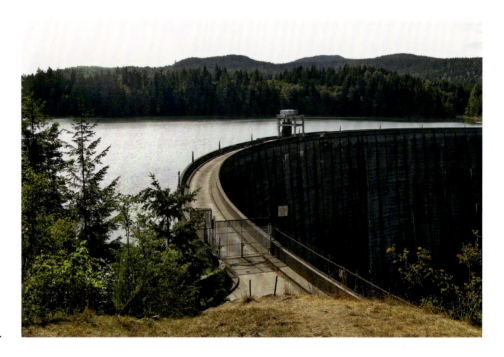

Alder Dam.

Alder Dam, with a height of 285 feet, and walls 15 feet thick at the top and 120 feet thick at the base. Since 1945 I have been obliged to plunge down huge pipes, called penstocks, and turn two turbines inside a powerhouse to generate electricity. I am impounded (descriptive word for how I feel) for Tacoma Power hydroelectricity. My backed-up water forms a reservoir. I wish the people swimming and boating on my surface every summer would recognize how stagnant it feels to be a "popular recreational area."

A few more miles downstream, I am plugged up again by Tacoma Power for additional electricity generation at La Grande Dam, completed in 1912 and rebuilt in 1945. This dam, like most dams, causes a large backup of sediment that is no longer available to accumulate at the delta. So often, my needs and the needs of the people who use me as a "resource" are diametrically opposed. My natural functions are changed, permanently altering and sometimes killing the ecosystems through which I flow. I wish the word "resource" would be obliterated as a descriptive term, and instead people would think of me as a living being. The question needs to be not what a waterway can provide for people, but what humans can do to help a liquid entity survive and thrive.

I, naturally, would prefer to run free from mountain to sea. I hope that soon there will be alternative energy sources, but until then, these two dams

provide power to thousands of homes. To its credit, Tacoma Power does look after my water quality, fish, and some endangered species. It funds the Nisqually Tribe's Clear Creek Hatchery, where millions of Chinook and coho smolts are raised every year. However, nobody asks me what I want, which is to regain my rhythm and my range, and to bring back balance along my entire length.

Many groups are working on my behalf. The Nisqually River Council, founded in 1987, is a watershed protection framework for communities along my shore. The Nisqually Indian Tribe, for whom I am named, has been my close friend through many trials and tribulations. The Nisqually call themselves the Susqually'absh, which means "people of the grass" in Twulshootseed. One of my favorite places, located among old maple, fir, cedar, and dogwood trees, is called Frank's Landing, named after Tribal Elder Willy Frank Sr. (born Qu-lash-qud). He and his son, Billy Frank Jr., and their families have lived on these six acres since it was purchased in 1919.

All through the 1960s and 1970s, the tribe endured repeated harassment because the state of Washington began filing injunctions to curtail Indian fishing rights. As the Nisqually continued to practice their culture and feed their families, state law enforcement officials continually arrested them. The tribe would stage "fish-ins," followed by arrests, convictions, and jail time. Eventually, Billy Frank Jr. and others went to federal court.

Frank Jr. (whose tribal name is Kluck-et-sah) was arrested more than fifty times in the struggle, but he kept his eye on the long run, often bringing together former adversaries to preserve me and the fish. For a quarter century, he headed the Northwest Indian Fisheries Commission, which brought a cooperative and consensus style of decision-making to watersheds in the Northwest. Its work often centered around the problems with dams, erosion caused by logging, and increased fecal coliform levels from agricultural runoff.

The Nisqually Tribe's decades of legal battles led to one of the most important Indian laws ever passed. The Boldt Decision, known as the 1974 case *United States v. Washington*, affirms Nisqually off-reservation fishing rights. Overnight, Native Americans, who were 1 percent of the state population and had been limited to 5 percent of the fish harvest, now had the right to catch half of the state's harvestable steelhead and salmon. The tribe works alongside Washington State as comanagers of fisheries, and tribal members harvest in accordance with treaties the US government signed with the tribes. This case was among the first to help decide an underlying question:

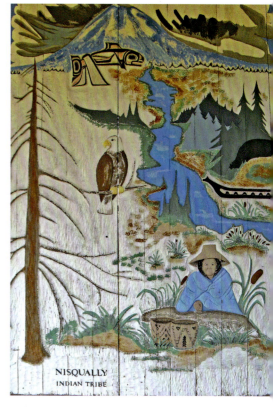

Tribal sign depicting Mount Rainier and the river.

WASHINGTON 5

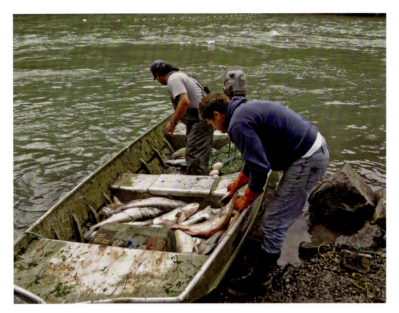 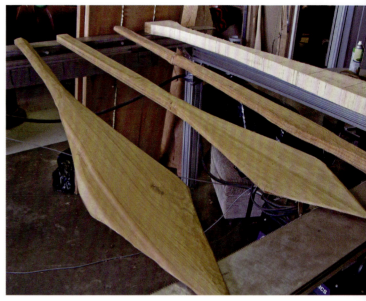

(top left) Unloading salmon.

(top right) Paddles being carved by Nisqually tribal members.

To what extent do the tribes, as separate nations within a nation, control their own destinies? State officials and nontribal fishers were outraged at this decision, and some even burned Judge Boldt's image in effigy, but in 1979 the Supreme Court affirmed the ruling.

Eight years later, at the ripe age of 103, Willy Frank Sr. provided testimony about my historical importance to his tribe, a major factor in determining that I qualify as a "navigable river." Salmon and steelhead were dying in the turbines of the two dams, and the Nisqually Tribe had sued the cities of Tacoma and Centralia, seeking damages and changes to federal licensing requirements. The tribe won both lawsuits, and Frank Sr.'s testimony helped convince the judge that I am still vital to the Nisqually people. "Me and the river are the oldest things around here," he said. "The river was here a long time before I came, and it'll be here a long time after I'm gone."

Today you can see evidence of two nations along my shore. On one side the US Army has occupied parts of the Nisqually Reservation since 1917, when Fort Lewis, a US Army base, was built nine miles from Tacoma, Washington. Fort Lewis merged with McChord Air Force Base on February 1, 2010, to form Joint Base Lewis–McChord. Directly across on my other shore you may see a native fishing boat pull onto land, laden with freshly caught salmon, the ancestral lifeblood of the Nisqually Tribe.

Elementary students from Wa He Lut Indian School gather small aquatic bugs and take them back to their classroom, which is nearby on my bank,

where they look at the critters through microscopes. Faculty and students from The Evergreen State College come to my shore to study the riparian ecosystem. More than forty classes of teachers and students throughout the watershed monitor my water quality twice a year, sharing their results with our community and making recommendations to keep the water healthy. Stream ecologists look for logjams to see what life is hidden in the debris. Art students draw the grasses, banana slugs, herons, and wildlife.

As I stretch out into the Billy Frank Jr. Nisqually National Wildlife Refuge and enter the Salish Sea (Puget Sound) about fifteen miles east of Olympia, Washington, my freshwater mixes with saltwater, forming a nutrient- and wildlife-rich estuary. In 2009, British Columbia and Washington State, which share this cross-border ecosystem of Puget Sound, the Strait of Georgia, and the Strait of Juan de Fuca, voted to overlay (but not replace) a name on the entire waterway—"Salish Sea"—to honor the original inhabitants of this region, the Coast Salish people. Also in 2009, the Nisqually Tribe worked closely with numerous groups, including Ducks Unlimited, the National Wildlife Refuge System, US Fish and Wildlife Service, and US Geological Survey, on a large estuary restoration project here, which removed dikes, reconnected hundreds of tidal acres, and increased my estuary delta habitat by more than 50 percent. It is a step toward recovery and is greatly appreciated by the threatened Chinook and steelhead, and everyone else who calls me home.

The Nisqually Tribe has lived beside me for at least six hundred generations, or twelve thousand years. I am honored to witness their ceremonies and their commitment to me, the salmon, and the natural world. When the first salmon return to spawn, I hear drumbeats across my water. Children coated in red ocher and bird down gather with the elders at my edge to praise the fish spirits. The meat of the first salmon is cooked on skewers above open fire pits and shared with the whole community. Ceremonially, the fish skeleton is saved intact and given back to my body, with its head pointing upstream to ensure the return of salmon year after year.

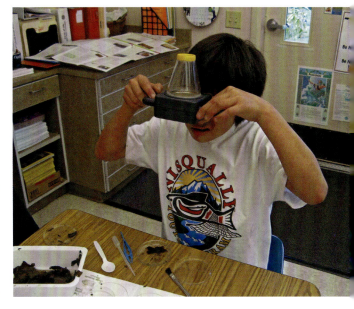

Wa He Lut student looking at river bugs.

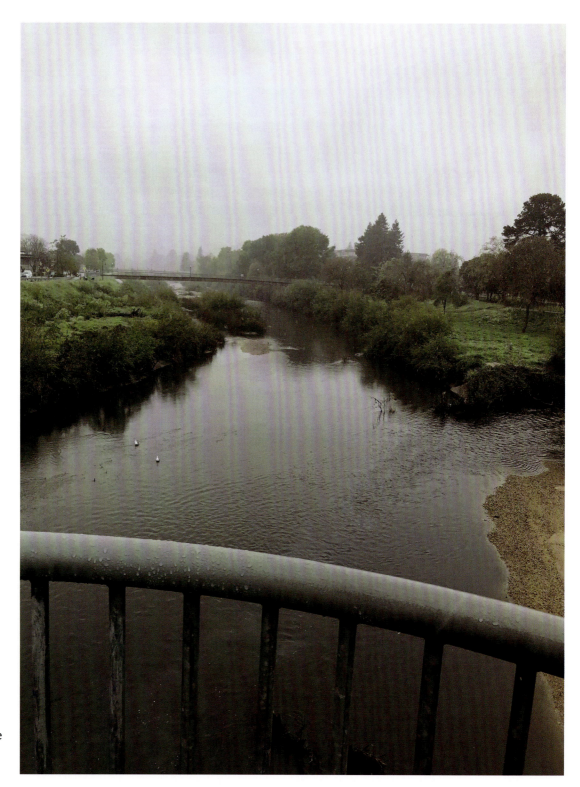

View of the San Lorenzo River from Soquel Avenue Bridge on a rainy, overcast day.

San Lorenzo River, SANTA CRUZ, CALIFORNIA

Enjoying a glass of water here in Santa Cruz, California? You are drinking *me*. After being processed at a treatment facility, about 54 percent of the drinking water here comes directly from my body. The resident population, lots of visitors, and numerous species rely on my fluid to sustain them each day, which is naturally why it is so important in every watershed around the world to defend and support beings like me, whether great waterways or small streams. I am called the San Lorenzo River and begin my 29.3-mile ride from my headwaters in Castle Rock State Park in the Santa Cruz Mountains before flowing down to Monterey Bay and out into the chilly waves of the Pacific Ocean. As with many towns and villages around the globe, Santa Cruz exists on its current site today because of water.

Subgroups of the Ohlone Native American tribes were the first residents along my shores, but unfortunately and drastically, their numbers and the numbers of so many other indigenous Californians dropped enormously between 1769 and 1834, when colonizers attempted to wipe out the native population. Leaders in this movement were even rewarded with positions in the state and federal government! Invasions by Europeans brought smallpox and other lethal epidemics that further decimated the tribes. Today the remaining members of the Ohlone peoples are trying to promote tribal and historical recognition and carry on with some of their ancient traditions.

The original indigenous villagers, who understood well my rhythms and how they were sustained by my waters, were perplexed at the hubris of the newcomers who decided to build in my floodplain. Consequently, when I do as all rivers do and occasionally overflow my banks, I flood the downtown area. Large amounts of sediment choke my channel and cause higher water levels. Plans were made to periodically dredge my stomach, but that turned out to be too expensive and detrimental to aquatic life and riparian habitat, so sediment buildup is a continuous problem.

In 1955, as with so many rivers across the United States, the Army Corps of Engineers painfully straightened my spine, bracing me with stone riprap levees. All streams delight in meandering sensuously from side to side, but

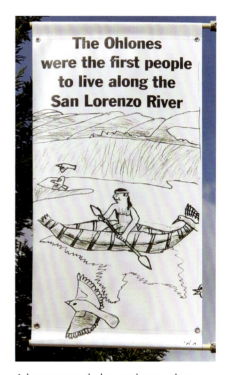

A banner made by students adorns the riverbank and informs the public about the first inhabitants of this region.

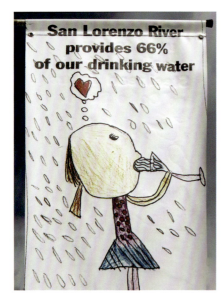

Another banner educates about drinking water.

After a rain, stormwater runoff empties directly into the river.

here I am imprisoned in concrete embankments, compromising my tidal waters, fish, riparian plants, and animals. Several local groups, including the Coastal Watershed Council (CWC), are working diligently to protect me and improve my water quality. There is a history of pollution, and despite regulations and improvements, bacteria levels in my water are sometimes so high I do not even meet the requirements for safe swimming. The Water Quality Working Group, including the CWC, the city and county of Santa Cruz, the Surfrider Foundation, and the Regional Water Quality Control Board, focuses on reducing bacteria within my system. Colorful sidewalk banners with drawings by schoolchildren illustrate important aspects of my life. The CWC and other groups host numerous events near me each year, and there is even a celebratory community festival in my name in June. Also, there is a campaign to increase favorable mention of me in the local press.

These organizations have vastly improved my environs by establishing the Santa Cruz Riverwalk, with pedestrian and bike paths on both sides of my course. Signage has been placed along the greenbelt with information about bird, aquatic, and plant life. Over one hundred species of birds regularly rely on me, including buffleheads, common goldeneyes, and common mergansers. At my mouth, shorebirds such as semipalmated plover, yellowlegs, dowitchers, peeps, and the ever-present gulls wade, play, and dive-bomb into me in search of food. I am home to fish species including the endangered coho salmon and the threatened steelhead trout. The most common native plant species are the California blackberry, coffeeberry, and arroyo willow.

I was in major flood mode on New Year's Eve, December 31, 2022. And then in January and March 2023, a series of atmospheric river storms totally drenched parts of California, washing out roads, downing trees, closing schools and businesses, cutting electricity, and causing mudslides. My body swelled to overflowing and I wreaked havoc, submerging everything in my path and causing evacuations. Like all my cousins around the world, I flood. That is what I do. It is a natural part of being a river, and yet people get upset with us because we destroy their property. If humans would not build in floodplains, we could expand naturally, inundate nearby land, and then recede. If communities would plan for flooding and build away from my shores, there would be little damage to infrastructure. I could breathe out widely during heavy flow, exhale once the storm had passed, and continue to flow on downstream.

Depending on how much moisture has fallen upstream, the structure of my course at the mouth changes. If there is enough runoff, I can cut a wide

SANTA CRUZ, CALIFORNIA 11

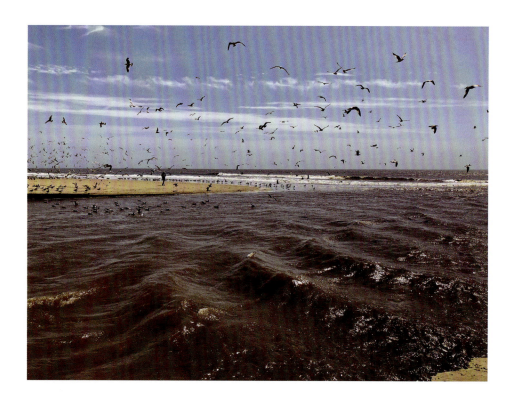

The San Lorenzo River fully flowing into Monterey Bay.

path and flow vigorously out into Monterey Bay. At other times, in variable conditions, I am disconnected from the ocean altogether, because sand deposited by ocean currents blocks my way, and a small lagoon is formed. If the lagoon is a mixture of saltwater and freshwater, it is called "brackish." My lagoon provides critical habitat and a welcoming nursery for numerous fish species, including the small, endangered tidewater goby, which can breed year-round but relies on the calm conditions in the lagoon for increasing its population. Also, ocean species such as the starry flounder and the top smelt propagate here. My water in the lagoon seeps underground through the sand until my freshwater mingles with the saltwater of the bay.

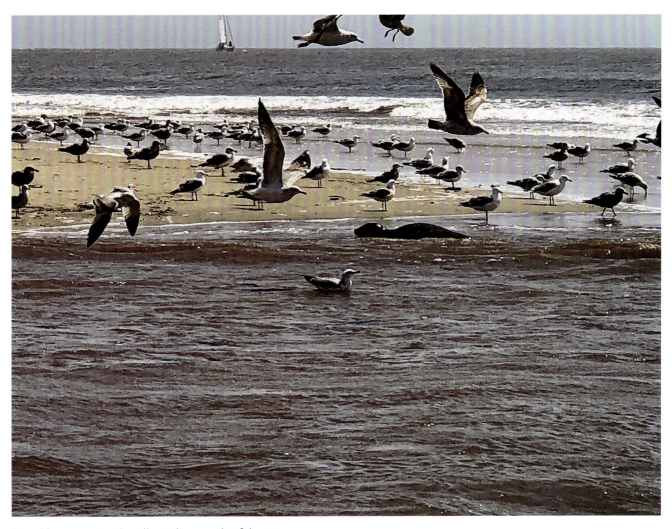
A seal hangs out with gulls at the mouth of the river.

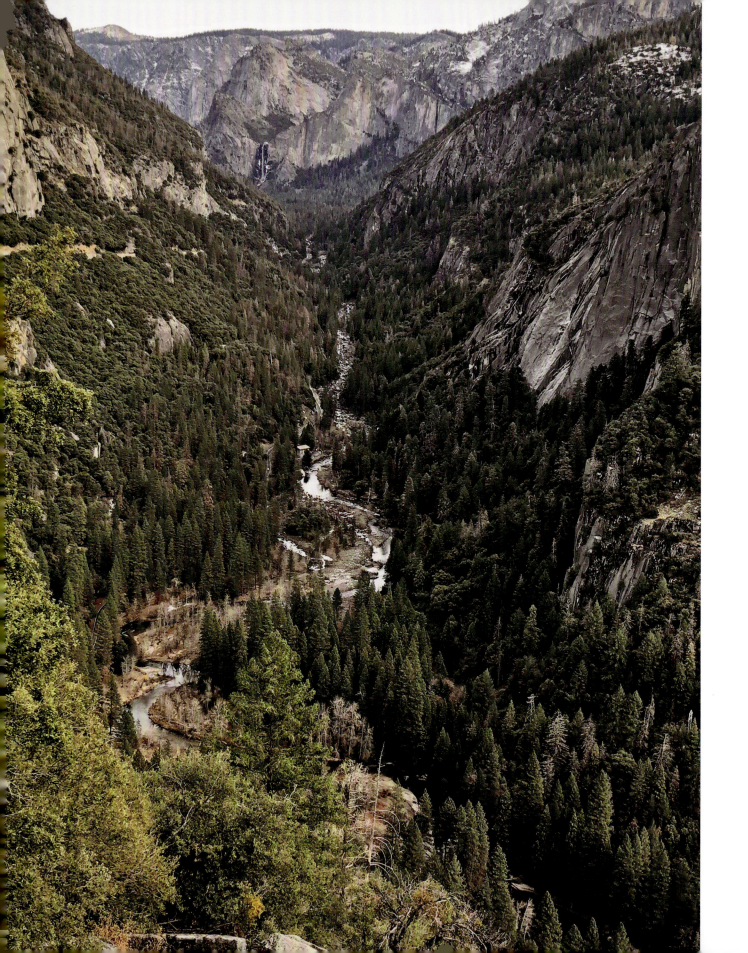

Merced River (Ahwahneechee: Wa-kal-la; Spanish: El Río de Nuestra Señora de la Merced), YOSEMITE NATIONAL PARK, CALIFORNIA

Currently (one of my favorite words!), my headwaters lie above eight thousand feet and I run wild through canyons and gorges at the beginning of a 145-mile course that has helped carve this spectacular landscape. I was an infant ten million years ago when the Sierra Nevada range began to rise. Glaciers contributed to sculpting the high elevations of my watershed, and one million years ago, the advancing ice scooped out this U-shaped valley. When the glacier melted, a lake formed behind the terminal moraine, and as it eventually filled with sediment, it created the present valley floor.

During my lifetime, I've witnessed successive human cultures that stretch back thousands of years. Generation after generation of indigenous peoples have relied on me for water and food. The Ahwahneechee (including the Southern Sierra Miwok and the Paiute tribes) lived in villages along my shores, constructing their conical homes, or *umachas*, of pine poles, with incense cedar bark insulation and a hole in the top for smoke ventilation. They slept on bear and deerskin bedding, with blankets woven from the fur of smaller animals. These people respected and cultivated groves of black oak for the acorns, which they pounded into flour for mush or acorn biscuits. They were skilled hunter-gatherers, relying on a variety of game as well as the greens, seeds, nuts, roots, and berries of all seasons.

For so long I was Wa-kal-la, a musical word that simply means "the river." All the famous places within this national park still have Ahwahneechee names, but unfortunately these have mostly been replaced by settler names. This entire valley, which I carved with the force of my water, is Ah-wah-nee ("place of the gaping mouth"); consequently, the Ahwahneechee are the "people of the place of the gaping mouth." Bridalveil Fall is named Po-hó-no ("a puffing wind"); Half Dome is Tis-sé-yak ("woman stained with tears") for its dark vertical stripes of lichens; and El Capitan is Tu-tok-a-nú-la ("inchworm"

The valley that the Merced River helped carve, with Bridalveil Fall in the distance.

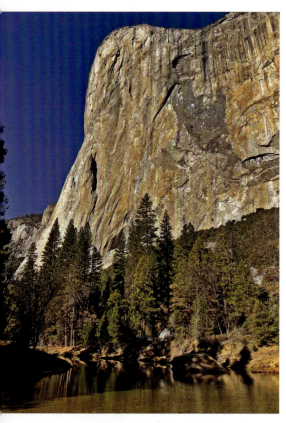
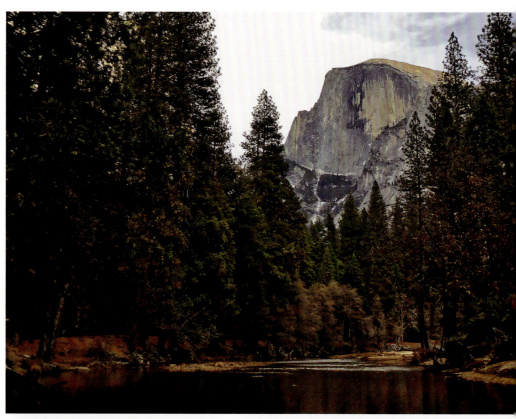

(top left) Merced River (Wa-kal-la) at a site called Devil's Elbow, with El Capitan (Tu-tok-a-nú-la) looming overhead.

(top right) Merced River and Half Dome (Tis-sé-yak). Photo by Derek Irland.

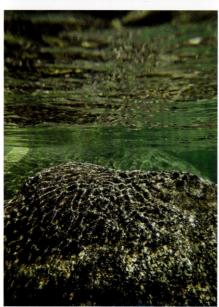

Underwater view of a granite boulder, similar to the granite cliffs above. Photo by Derek Irland.

Ice patterns on a frozen segment of the Merced River.

or "measuring worm"), for it is said that two bear cubs were sleeping on an enormous flat rock near my shores when the rock began to grow up toward the moon. The mother bear asked other animals to rescue her cubs, but none succeeded until a small inchworm crawled to the top and led the two babies down to their mother.

Among the new colonizers, I am referred to as "the Merced," and the region around me became "California." Then, in 1849, greed for small gold nuggets brought miners and treasure hunters by the thousands to the stream banks of the Sierra Nevada, and here, as in most other places, the indigenous population was threatened, destroyed, or pushed out. By 1851, troops of the Mariposa Battalion, a California State Militia, began burning tribal villages and destroying Ahwahneechee food supplies. The soldiers called their "newly discovered" valley "Yosemite," believing that to be the name of the local inhabitants. The Ahwahneechee word *yohhe'meti* actually means "some among them are killers." In less than a decade, tourists were arriving by stagecoach, and land in the valley belonged mostly to nonnatives.

Human thinking ebbs and flows, just as water does, and there came a man who spent a lot of time in my company. John Muir was an American author, naturalist, and environmental philosopher who said of Yosemite that it was a special nature temple. His writing about wilderness began to enlarge people's idea of what is valuable, and he helped found an environmental organization, the Sierra Club. Muir argued for the preservation of the Yosemite Valley, lobbying Congress until its lawmakers created a national park here in 1890, following Yellowstone in 1872, and Sequoia, also in 1890 but a week before Yosemite.

The park now brings ever greater numbers of people to this valley. They come with their cameras to watch me plummet over the cliffs at Nevada and Vernal and Yosemite Falls. Whew, that is quite the exhilarating ride, free-falling such distances! Yosemite Falls, which is three separate falls, drops 2,425 feet and is the fifth highest waterfall in the world.

Today, I and the several creeks that join me inside the park's boundaries—Tenaya, Yosemite, Bridalveil, and Cascade—are prized for our beauty and our natural ways. My human neighbors accept that the alpine climate produces heavy snow in the High Sierra, and that flooding is a possibility when all that snow melts. In January 1997, I raged far beyond my banks, setting a record of 23.43 feet total depth at the Pohono Bridge gauging station. Many facilities in the valley were inundated. After portions of El Portal Road were damaged, the National Park Service began rebuilding by upgrading and

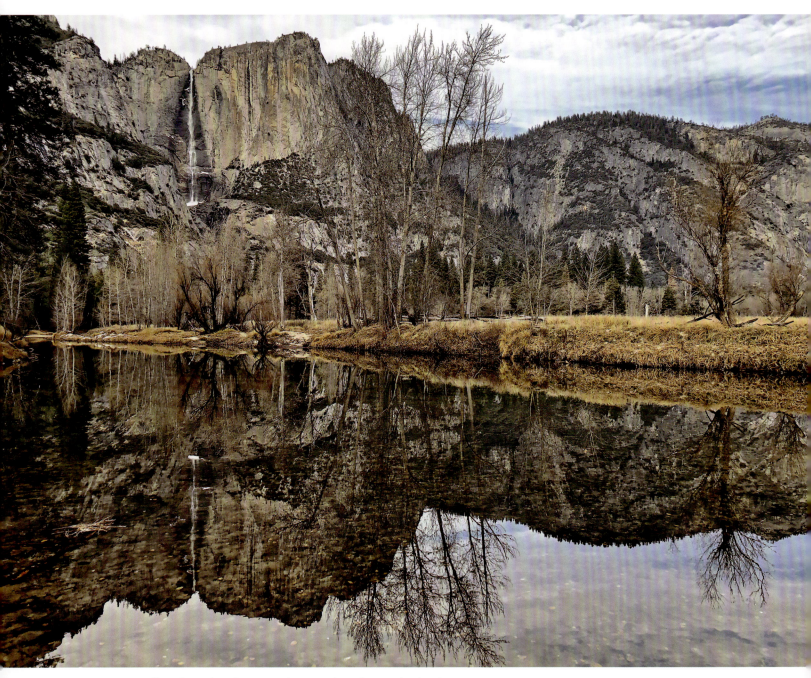
Yosemite Falls reflected in the Merced River. Photo by Derek Irland.

widening the road, which had historically been unsafe. Even after the flood, there was no talk of dams or levees to confine me, because in 1987 Congress designated seventy-one miles of my body as a Wild and Scenic River, and under federal law, I am free to swell or diminish, and to sweep from side to side across my natural drainage, as every stream desires. April 2018 brought another flood to the valley when I rose as high as 13.73 feet. The deluge, caused by warm tropical moisture from a strong Pacific storm called a "Pineapple Express," closed the park for two days when roads were under two to four feet of water. My waterfalls exploded into full glory. But my waters receded quickly, Yosemite was soon reopened, and staff began the cleanup.

This process of flooding continues through the years. Because of unusually high snowpack and unseasonably warm temperatures in 2023, once the accelerated snowmelt began, I reached flood levels again during the late spring and early summer months, submerging boardwalks and meadows in the Yosemite Valley. Campgrounds were closed, most services were canceled, and disappointed visitors had to postpone their stays.

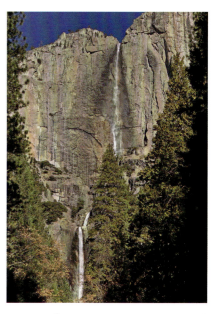

At 2,425 feet, Yosemite Falls is one of the tallest waterfalls in the world.

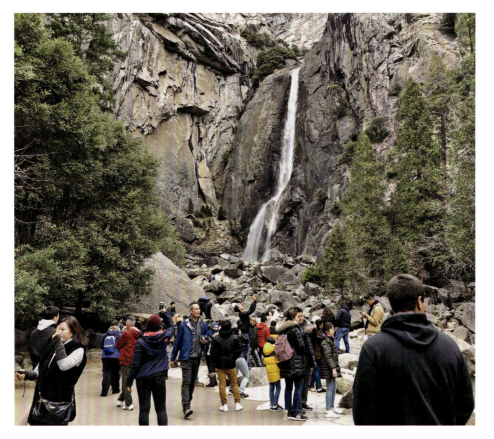

Tourists from around the world photographing Yosemite Falls.

YOSEMITE NATIONAL PARK, CALIFORNIA

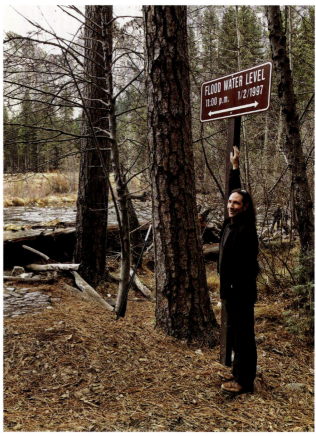

(top left) Bridalveil Creek, one of the numerous small tributaries flowing into the Merced River within Yosemite National Park.

(top right) A park visitor reaching toward a sign showing the high-water mark of the flood on January 2, 1997. In the background, the Merced flows at its normal level.

I am blessed to have abundant fauna who visit my shores often. Numerous birds thrive here including mourning doves, Cassin's finches, dippers, woodpeckers, great blue herons, Steller's jays, red-winged blackbirds, red-tailed hawks, cliff swallows, canyon wrens, mergansers, bald eagles, and the ever-present scavenger ravens who are always looking for leftovers from the tourists. Mammal species who come for a drink include Sierra hares, raccoons, bats, skunks, beavers, coyotes, bobcats, black bears, and Sierra bighorn sheep. Tiny pikas chatter and gather twigs for their nests to help them get through the cold winter months. Mule deer wander the grounds of the park and have become almost oblivious to human encounters.
The trees that live within my watershed include the California black oak, incense cedar, white and red fir, western juniper, and several groves of giant sequoia. Some say that the majestic ponderosa pines have a warm smell similar to vanilla, while the bark of the Jeffrey pine might have the aroma

of butterscotch. I also sustain many small meadow ecosystems with vibrant wildflowers.

I have become a popular recreational destination, with the prevalent activities of camping, hiking, and fishing occurring along my shores. I hear the screams of passengers in boats as they shoot downstream while white-water rafting upon my spine. Millions of tourists visit Yosemite each year, which can be a tad overwhelming, so I am always glad when the sun goes down and I can glide under the night sky with the stars watching overhead.

It is gratifying to know that there are groups working on my behalf. The National Park Service and the University of California, Santa Barbara, have cooperated on a project, the Merced Wild and Scenic River Final Comprehensive Management Plan and Environmental Impact Statement, to preserve and restore my system as I flow through Yosemite. The project hopes to provide engineering and scientific information to assist in both long- and short-term efforts to protect me and enhance my value as a Wild and Scenic River. One of the primary criteria for eligibility to be designated Wild and Scenic is "outstandingly remarkable values" that make a river worthy of special protection. These values can include "scenery, recreation, fish and wildlife, geology, history, and culture." Luckily for me, I possess all these values, which is cause to celebrate each day! The collaborative team assesses the human impacts of heavily visited areas. Data are collected along my riparian zone to address the geomorphic, hydrologic, and vegetative conditions. Also, Yosemite Valley American Indian ethnographic resources have created a map of traditional-use plants and information about today's cultural principles. Members of the Ahwahneechee tribe now work in the park and help illuminate their current indigenous practices and the history of their ancestors for visitors to the Indian Cultural Exhibit at the Yosemite Museum.

For I am still Wa-kal-la, the river, flowing like time through this wondrous valley.

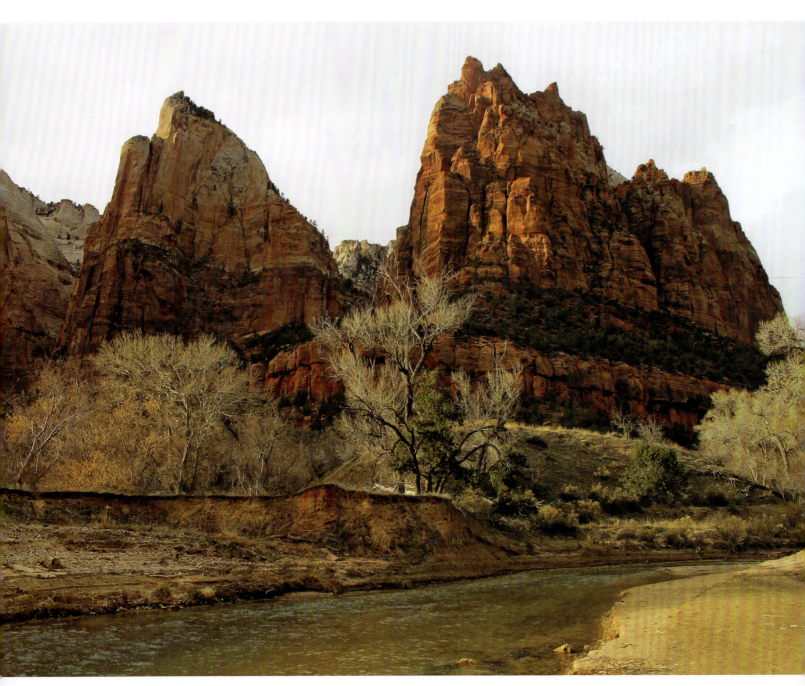
Red cliffs above river.

North Fork Virgin River, ZION NATIONAL PARK, UTAH

I flow out of a cave at nine thousand feet elevation near Navajo Lake at Cascade Falls, Utah, descend toward Lake Mead at one thousand feet, and empty into the Colorado River. The length of the Virgin River is 180 miles; however, I am only the 33-mile stretch of the North Fork.

I could tell you tales of other parts of my course, but the favorite section of my journey is the eight and a half miles through the steep Navajo Sandstone canyon walls in the Colorado Plateau Mojave Desert ecosystem of southern Utah at what is now called Zion Canyon but is also known by its Paiute name, Mukuntuweap or Mu-Koon'-Tu-Weap.

What I experience as I travel from where the Zion Canyon Scenic Drive ends, at the Temple of Sinawava (a Paiute word for the Coyote God), to the south entrance at Springdale is an amazing adventure! I can look up and view 3,000-foot-high red-rock walls, many of them with vertical charcoal- and beige-colored streaks created by moisture leaching out of the rock. I carved and sculpted and moved all this rock, with the assistance of my other shape-shifting forms—rain, snow, sleet, and ice. My stream gradient, fifty to eighty feet per mile, is one of the steepest in North America. I am one of the few remaining free-flowing rivers in the United States and was designated Utah's first Wild and Scenic River in 2009, during the centennial celebration of Zion National Park.

Zion Canyon walls seen through river ice. Photo by Derek Irland.

In English I am called a river, but since thousands of international visitors come here every year, I hear many languages daily: *río*, *irmak*, *flume*, *река*, *fleuve*, *flod*, נהר, *rivière*, *fluß*, *folyóba*, *sungai*, *song*, *up ė*, *jõgi*, *lumi*, and hundreds of other designations. We all are given specific names by the people who inhabit our shores, and over the years the designations change, depending on who has settled beside us or whoever wields the most influence at any given time.

I provide sustenance for flora and fauna here in the park and even harbor endangered minnows, the Virgin River spinedace (*Lepidomeda mollispinis*), which are found nowhere else except the Virgin River basin. Some of the trees that rely on my water for nourishment include single-leaf ash, bigtooth

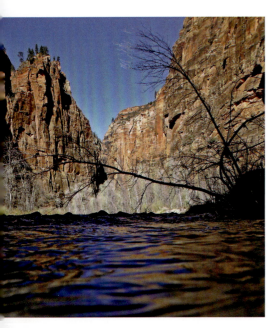

Toward evening. Shadow view from the river.

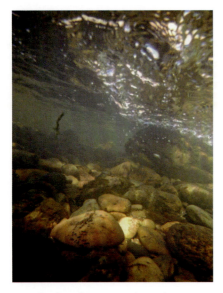

Riverbed underwater. Photo by Derek Irland.

maple, Fremont cottonwood, and box elder. The cottonwoods are especially prevalent and in springtime their fluffy seeds snow down to be transported on my current and planted along the riparian corridor for future generations of *Populus fremontii*.

You can see the tracks of creatures who come down to my sandy banks to get a drink: mallard ducks, wild turkeys, mule deer, great blue herons, ringtail cats, beavers, and canyon wrens. However, these days the most numerous prints left along my shores are of hiking boots and flip-flops. Some of the human footprints are created by visitors, but others are those of my park ranger friends who help look after me year after year.

Most of the time my flow is fairly low, but sometimes after a heavy rain I can turn into a raging flash flood, destroying roads and knocking out anything in my way. On December 21, 2010, I crested at 9.8 feet and went rip-roaring through the park. My cubic feet per second (cfs) vary throughout the seasons. Without rain during the summer months, I average about 20–30 cfs. During the late summer monsoon season, heavy rains can raise my flow up to 200–1,000 cfs. One cubic foot is 7.4805 gallons of water and is about the size of a basketball. Zion Outfitter describes this by stating that on a "40 CFS day you could imagine 40 basketballs moving past you in 1 second."

Because of the depth of the canyon, groundwater feeds numerous springs, providing flow throughout the year. However, my waters are not always clean, and sometimes I have overexuberant levels of *Escherichia coli* (or *E. coli*) within my system, most often caused by both human and animal feces. At the visitor center near my shore there are two signs with important information. The first one reads: "Every time you fill your reusable bottle you keep a disposable bottle out of the landfill. Americans discard an average of 167 bottles each year. If you put all of them end to end, they would circle the Earth 217 times." And the second sign, with a large photograph of a columbine flower, says: "Zion's water is naturally filtered through 2,000 feet of Navajo Sandstone. Drink the same water as the golden columbines in the park's famous hanging gardens. But never drink untreated water directly from a spring."

When my flow is high, I leave behind debris clumps of small leaves, twigs, and interwoven grasses that get caught on low-lying limbs. As more detritus is added, these litter hovels have the appearance of bird's nests found in bushes along my banks, which are good architectural shelters for riparian spiders. So, I provide sustenance for an enormous variety of flora and fauna

who rely on me for their very survival. The Virgin River has been moving along downhill for so long, and I have every intention to keep flowing for future generations.

And yet, I would like to flow clean. The year 2023 brought sad news. A dog who swam in my waters died an hour later from harmful cyanobacteria toxins produced by algal blooms that unfortunately have been grossly proliferating within my body. Cyanobacteria are natural growths within an aquatic environment, but in abundance the elevated toxin concentrations can be very unhealthy. The kind of cyanobacteria at the bottom of my stream that grow on rocks and plants are known as benthic cyanobacteria and look like slime. Signs are posted warning visitors not to swim in or ingest my waters and to keep animals away. People often complain when I flood, but rapid cfs helps wash away the toxic "blue-green algae." With warm waters and no flooding for extended periods within Zion National Park, the algal bloom spreads. I hope that this unsavory muck will clear up so that visitors to this glorious park can enjoy a clean and healthy stream flowing through majestic canyons.

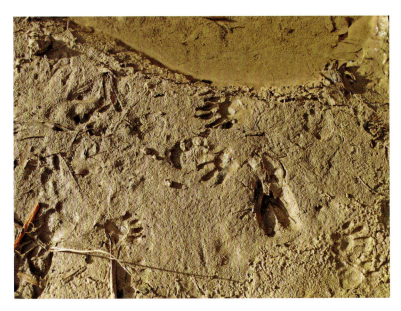

Who comes to this river to drink? Tracks of mule deer (*Odocoileus hemionus*) and a ringtail cat (*Bassariscus astutus*).

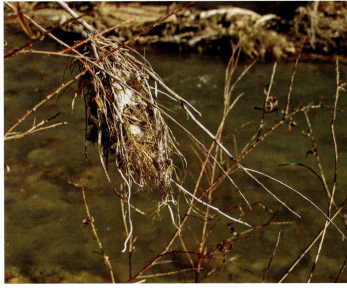

Litter hovels. River debris provides shelter for riparian spiders.

ZION NATIONAL PARK, UTAH 25

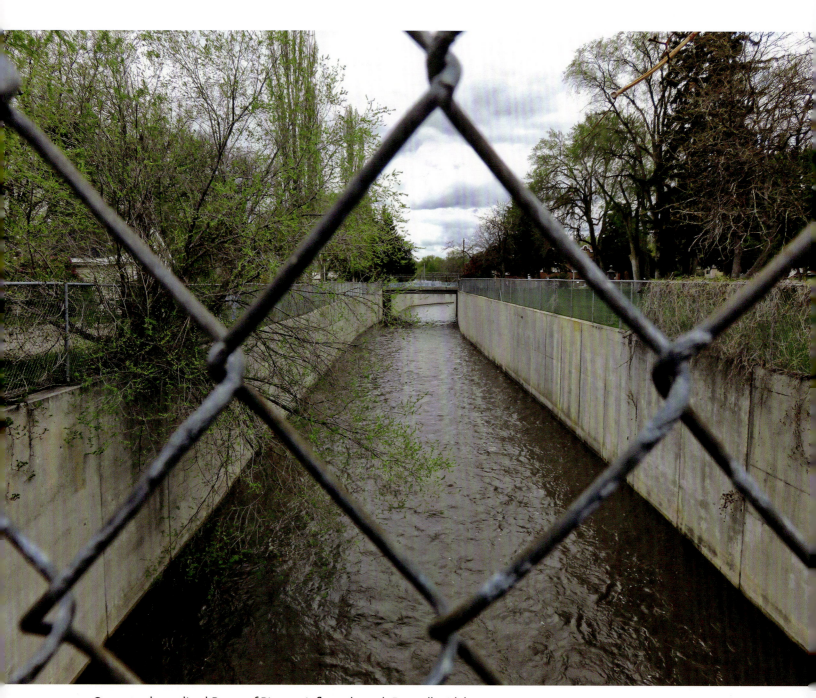
Concrete-channelized Portneuf River as it flows through Pocatello, Idaho.

Portneuf River, POCATELLO, IDAHO

I flood. That is what I—and all my cousins—do from time to time. It is part of our rhythm. In their hubris, humans build cities and towns right on our banks, then get upset with us when our waters rise and destroy some of their property. They try to control us by building dams and straightening our courses, so we no longer flow naturally and cannot aid the hydrologic cycle, create meanders, spread silt, or sustain entire ecosystems of aquatic life.

I am the 124-mile long Portneuf River, a tributary of the Snake River, in southeastern Idaho in the United States. I begin and end on the ancestral lands of the Shoshone-Bannock Tribes, and I will tell you a story of just one reach of my body as it flows through Pocatello, Idaho, a town founded in 1889 and named for a Shoshone chief. It is a sad tale of how people think of me not as a living being, but rather as a nuisance. They have encased my body in 1.6 miles of concrete, putting me in a straitjacket so that there is nothing natural about me anymore. I am not even called a river, but rather a "channel." Locals sometimes refer to me as "the moat" or "the bunker." One longtime resident who grew up along my banks remembers that when she was young, her siblings would flush the toilet and then run outside to watch the waste dump directly into my bloodstream.

Historical photographs depict me meandering through broad meadows in the semiarid lands upstream of Pocatello. But a series of events would change my fate. In 1877, the Portneuf Valley became the site of the first railroad in Idaho. The straight line of the raised track bed cut off segments of my flow, and the town was built around the railroad, not around me.

Throughout Pocatello's history, I have periodically flooded. As early as 1938 the Works Progress Administration (WPA) put in riprap—piles of rocks on my shore—to lessen the damage I might do to agricultural fields when I overflow. In 1962 and 1963, I unwittingly created havoc in the valley again, so in 1967 the Army Corps of Engineers built a concrete channel to "keep me in my place." Upstream and downstream of the channel, my body is confined by a series of levees. I miss the trees that were removed.

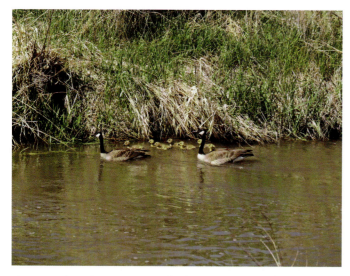
Geese and goslings swim in the levee segment of the river.

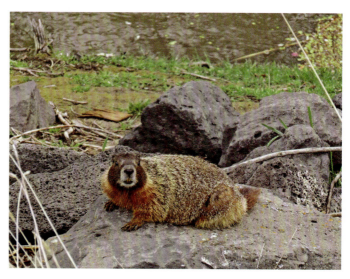
Marmot sunning on rock riprap in the levee.

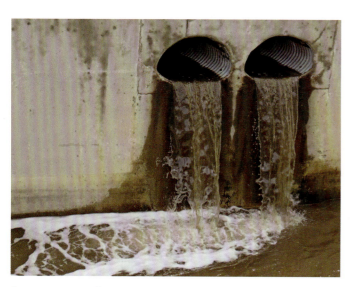
Stormwater outflow.

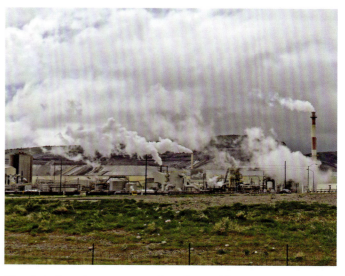
Simplot phosphorus-processing plant with mountainous slag heap.

 As a result of many factors, they say I have a "complex biogeochemistry." Stormwater runoff dumps directly into me through a series of large pipes, and droppings from resident pigeons living under bridges, dog waste, and livestock manure upstream add to the buildup of *E. coli* bacteria in my guts. Additionally, discharge from the municipal wastewater treatment facility, fertilizers from agricultural fields, and runoff from the nearby Simplot

phosphorus-processing plant create increased phosphorus loads, leading to low dissolved oxygen levels. Unfortunately, this toxic mixture can cause higher temperatures and algal growth, which reduces insect and fish populations within my body.

As with most of my relatives around the world, people think they can dump unwanted trash directly into our bodies, with no thought of the consequences. They think our flow will simply take it away, out of sight and out of mind, but there is no "away" anymore. All this trash ends up someplace. Certain people cause the mess and then others must come along and help with cleanup. The effort expended on these cleanups would not be necessary if all people took it upon themselves to be responsible and careful about how they dispose of trash. There is no reason at all for shopping carts, plastic water bottles, food wrappers, and mattresses to be dumped into us, anywhere

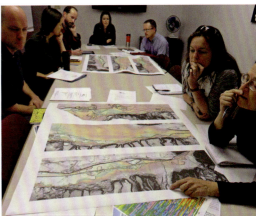

Watershed meeting.

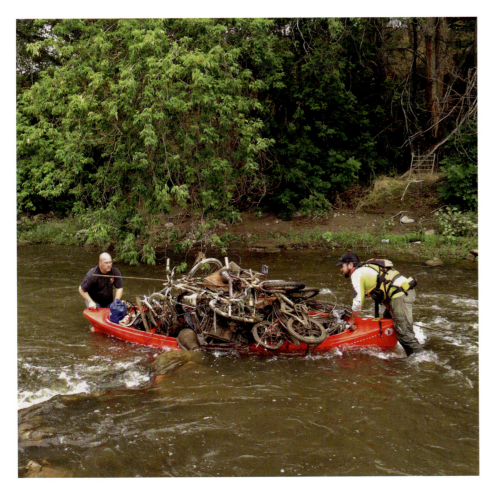

River trash being hauled out of the Portneuf by canoe. Photo by Hannah Sanger, Science and Environment Division manager, city of Pocatello.

POCATELLO, IDAHO 29

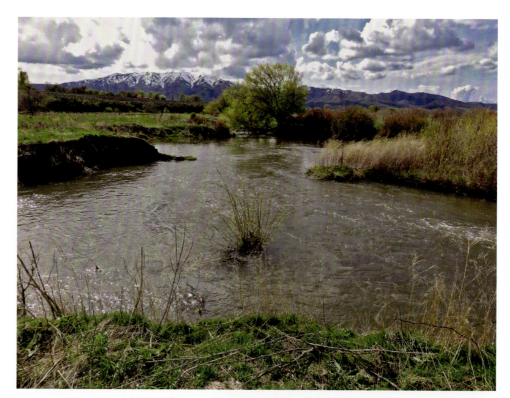

Portneuf River upstream of the concrete channel.

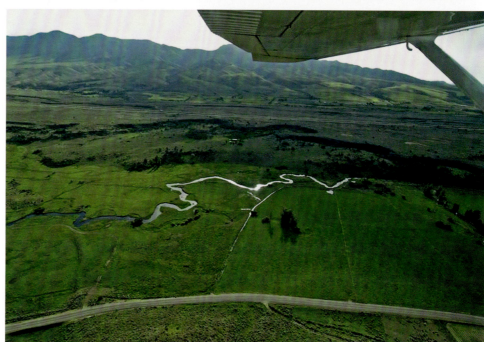

Natural meanders in Portneuf River upstream of Pocatello. Aerial photo by John Sigler.

in the world! A little good housekeeping goes a long way toward creating a better environment.

I am thankful, however, that plenty of thoughtful humans along my banks work tirelessly to envision a better future for me. Numerous restoration projects are happening in the Pocatello reach, thanks to local governmental, environmental, housing, health, economic development, and transportation organizations, residents and businesses, nearby schools, and Idaho State University.

Community members are asking questions about what is possible for my disfiguring concrete channel: Can it be removed? Could some sections be replaced by gently sloping grassy areas? If some of the channel must remain, what measures would aid in restoring the aesthetic pleasure of visiting me? How can my pollution be reduced? Are there ways to restore me to even a semblance of how I appear upstream, where I meander freely through meadows? I hope the answers to these questions will soon turn into action on my behalf.

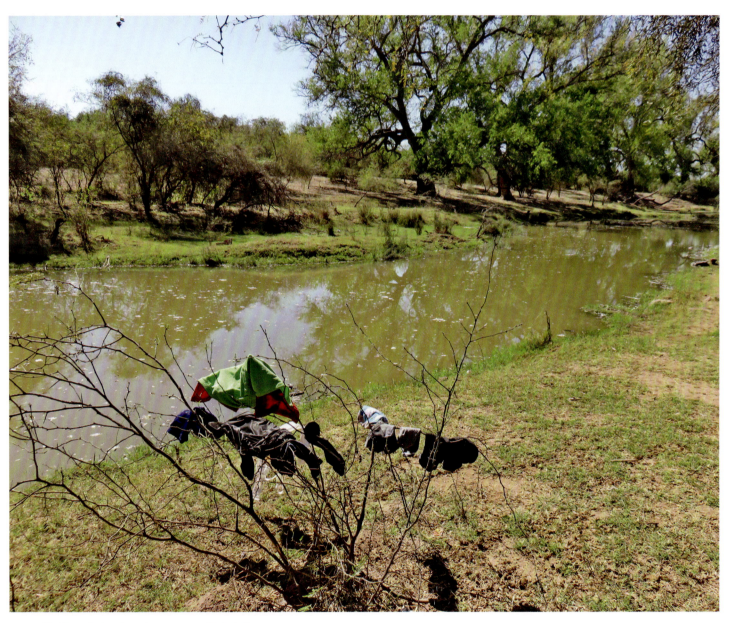
Clothes drying in a tree near polluted river.

Yaqui River (Spanish: Río Yaqui; Yaqui or Yoeme: Jíak Batwe)
YAQUI NATION, SONORA, MEXICO

My struggle as a river is interconnected with the struggle of my people, the Yaqui indigenous community of Mexico in the Sonoran Desert, as I try to provide the ancestral source of water for drinking, everyday use, irrigation, and ceremonial purposes. Together we have had a long and complex history. Manuel Esquer Nieblas, a member of the Yaqui Defense Brigade, grew up playing in my waters during a time when I still had some clean flow. His relatives live in several of the eight remaining Yaqui villages along my northern banks as I move south and empty into the Gulf of California, twenty-eight miles southeast of Guaymas.

My water that is destined for Yaqui land is diverted for the cultivation of hybrid wheat, corn, and rice impregnated with synthetic fertilizers. With high-tech farming methods, the crop yields have been impressive, but little if

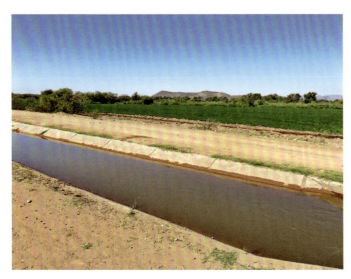 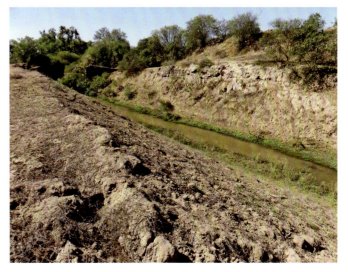

Compare and contrast: (top left) Irrigation ditch with corporate water coming from the Álvaro Obregón Dam to grow wheat for export. (top right) Toxic pesticide runoff from large agribusiness fields nearby slugs along in a ditch that flows into the stagnant *río* in the Yaqui village of Tórim.

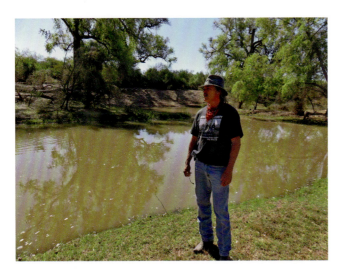

Manuel Esquer Nieblas standing next to the *río*, now stagnant and polluted, where he used to play as a child.

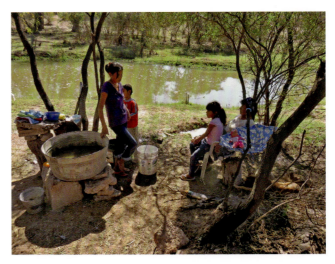

A Yaqui family washes clothes in the pesticide-clogged *río* since there is no running water in their village of Tórim

any of the money made from these fields goes to the tribes, and most of the noxious pesticide runoff is funneled into channels that dump directly into my body. Ugh. It is difficult to tell you this, and for you to hear about what shape I am in these days.

In 2015, Manuel stood beside me and chatted with a family who had to wash their clothes in this putrid mess because they had no running water in the village of Tórim. And when I slog on to the village of Bakum, I must witness poor families forced to purchase drinking water since none is available within their homes. Four gallons of bottled water costs around one dollar in US currency. Four gallons is not much water, and with so few pesos coming into the household, this is an extravagant amount for a necessity that should be free, and a given right for all people.

There are regularly scheduled tribal council meetings about what to do concerning my situation. Since May 2013, one form of protest has been to maintain a resistance camp and roadblock at Vícam (the tribe's main headquarters) to stop large transport trucks along Federal Highway 15 from Mexico City to Nogales. As a result of this action, in 2021, the governor of Sonora and other agencies issued criminal charges and arrest warrants against some of the Yaqui leaders. Amnesty International denounced this action in an open letter.

A brief history of me and my people is important to put what is happening

today into perspective. As early as 500 CE native inhabitants known as the Yoem Vatwe or Yaqui were living along my shores in small family units. The Yaqui used irrigation techniques to grow squash, corn, and beans. In 1533 a Spanish military expedition searching for slaves began a war. They were defeated but killed thousands of Yaqui people. In the early 1600s, the Spanish repeatedly attacked Yaqui settlements. Then again around 1684, when silver was found near my banks, the Spanish attempted to move into the region. But throughout this turbulence, the tribes continued to defend me, the land, and their culture.

The villages were fairly independent until the late 1800s, when a different enemy appeared. The Mexican Army forced families to flee to other areas, with some groups relocating to Yaqui communities in Arizona. Mexican troops occupied pueblos to keep watch over them and deported many to work as slaves in distant areas in Mexico and abroad. In 1939, Mexican president Cardenas tried to change the attitude toward the Yaquis by granting the tribe official recognition and title to its land. But the struggle is not over, because land and water rights issues remain contentious to this day. The most recent obstacle has been the Independencia Aqueduct, which was built to transport water from my body to Sonora's capital, Hermosillo, a manufacturing hub

Here in Bakum, drinking water must be bought since there is no potable water within any of the eight Yaqui villages. A necessity that should be free is expensive, sometimes prohibitively so. A water purification plant was promised by the Mexican government to aid all the villages but was never built.

YAQUI NATION, SONORA, MEXICO

Dry Yaqui riverbed outside Cócorit, Mexico.

with high-water-use plants such as Heineken, Ford, and Big Cola. Yaqui leaders have stated that about 40 percent of the municipal water supply in the capital city is being lost to faulty infrastructure. The diversion began operating in April 2013 despite protests, injunctions, and court orders from the tribe, which has first rights to my water.

On July 9, 2013, the Zapatista General Command, together with the Mexican National Indigenous Congress, issued a statement of solidarity and support for the Yaqui, condemning the theft of water. In December 2014, a conference titled "Pillage of the Water of the Pueblos: New Challenges" took place in Mexico City. Many speakers described how even with all the legal injunctions against the building of the aqueduct, the project proceeded, and still nothing has been done to provide clean water to the Yaqui people.

Tribal members sat on my banks to tell me tales of Yaqui activist Mario Luna Romero, who in March 2023 was at Harvard University talking about the struggle of his community to protect the rights of my water and how his people emerged from the sacred depths of my body. He stressed that his tribe is still besieged by forces that want to remove the people from their ancestral

lands, as has happened around the world so often. Large companies, industries, and agribusinesses are constantly trying to move onto indigenous lands because they do not understand the concept of protecting water rights for future generations. Lithium deposits have been discovered on tribal lands, and there is strong pressure from mining companies. The huge economic interests in this region have led to several Yaqui water protectors being harassed and even murdered, including Tomás Rojo Valencia, an agricultural engineer who was assassinated in June 2021.

So, the fierce struggle for my survival and that of my people continues!

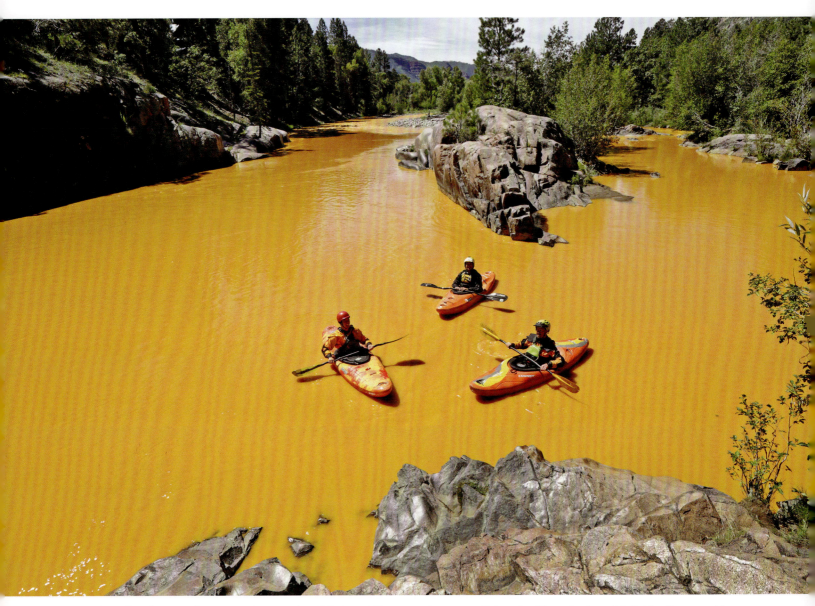

Three kayakers on the orange juice–colored Animas River near Durango, Colorado. Photo by Jerry McBride, *Durango Herald*, 2015; used with permission of Polaris Images Corp.

Gold King Mine Spill (Animas and San Juan Rivers)
COLORADO, NEW MEXICO, UTAH, AND THE NAVAJO NATION

Have you ever seen a river flow bright orange? Instead of a shade of blue or muddy brown, there was a time when my body turned the sickening color of orange juice, or Tang, or mustard—not a healthy hue for any river. My dramatic color caught people's attention around the world. This is the consequence of an extractive industry and shows what an environmental disaster looks like.

On August 5, 2015, this Gatorade-colored plume was caused by millions of gallons of wastewater and sludge spewing from the dormant Gold King Mine into Cement Creek, one of my tributaries, ten miles north of Silverton, Colorado. The water had backed up in the mine behind a plug formed when part of the mine's ceiling had collapsed sometime earlier. Environmental Protection Agency (EPA) workers had planned to install a pipe to drain the water so that they could eventually plug the mine permanently, keeping the contaminated water inside it—and out of my body. Instead, they ended up accidentally breaching the dam, releasing a concoction of major contaminants including mercury, silver, lead, cobalt, nickel, iron, magnesium, copper, zinc, aluminum, arsenic, chromium, vanadium, and beryllium. In the first hours after the spill, EPA officials downplayed the impacts and failed to notify those downstream. Unfortunately, without my consent, I was the one to deliver all this poisonous mess to the communities along my shore, even though I had no say in what was dumped directly into my current, the consequences of which were disastrous.

When the plume of toxins reached Durango, Colorado, sixty miles downstream, a somber group of people stood on the bridge to view the encroaching brightly colored contamination, exclaiming how sad and angry they were that this tragic event was happening to their river. I could hear them talking, but I wonder whether they had any idea how I felt having this happen to *me*! The pollution flowing into my water was not new, although the huge quantity was. Miners began digging for minerals in the 1870s, and I have been

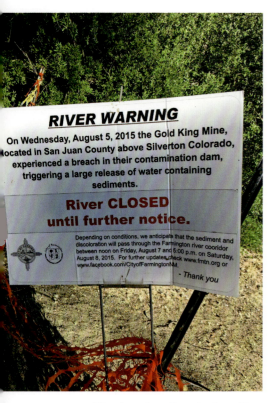

Warning sign, Farmington, New Mexico.

the victim of their pollution ever since. Mines simply poured their tailings directly into me until, in the 1930s, downstream farmers forced mining companies to stop. The mine is at 11,480 feet elevation, and because of the steep gradient, gravity pulls me quickly at the beginning of my journey, but I slow down upon reaching flatter stretches, so that I move an average of about two miles per hour. A healthy pH level for drinking water is around 7.7, but during the toxic flow, my pH dropped all the way down to 2.9. In chemistry, pH is a measure of the acidity of a solution: the lower the number, the more acidic the liquid.

This kind of event is not new. In June 1975, a huge tailings pile on my banks northeast of Silverton was breached, dumping thousands of tons of tailings loaded with heavy metals into my body. Whew! Sometimes I wish I could just pack up and move to a new location away from all these mines, and away from people who are so careless with what gets dumped into my gut. I am a perfectly wonderful river with a lot to give to everyone, yet I am often mistreated. It seems that it is not until something tragic like this happens that citizens suddenly wish to assist me. It is as if they become doctors and want to help me get well, but what about the ancient Chinese way of practicing medicine, where it is the doctor's responsibility to be sure that patients stay healthy all the time, instead of waiting until they are sick and need to be treated?

The problems are complex and massive. Many agencies became involved, including universities and federal, state, municipal, and tribal organizations. At a public meeting in Durango held just hours after the plume reached town, David Ostrander, the EPA's emergency response director, declared, "I'm very sorry for what happened. This is a huge tragedy. We typically respond to emergencies, not cause them."

The impacts of the spill on the Navajo Nation were substantial and included damage to crops, home gardens, and cattle herds. Concerns included the river's cultural and spiritual significance to the Diné way of life. Direct contact of river sediment pigments on the body is important for ceremonial purposes. Cake used in ceremonies is baked underground. Lead, arsenic, and manganese at low exposure over a long period can be harmful, and the impact on future generations is unknown. "Tó'titso" (The water is yellow) was heard among native Diné speakers.

Dr. Karletta Chief, a Diné hydrologist and professor at the University of Arizona, specializes in how the Gold King Mine spill impacted her tribe. An

important challenge in trying to inform communities about the scientific data related to the toxic mine spill was how to translate these data into the Diné language. Karletta and her assistants worked with the people in each section of the reservation near my shores, collecting samples of water, soil, blood, and urine to determine the effects of the toxins transported in my water. When it came time to communicate these data back to the community at meetings, a new way to envision all this important scientific information was needed. A traditional graph would not work. So, Perry Charlie, a senior scientist at Diné College, helped devise a new vocabulary that could be more easily comprehended by nonscientists.

The Navajo Nation ceased irrigating its crops with my waters on August 7, 2015. While San Juan County in New Mexico lifted the ban on August 15, 2015, the president of the Navajo Nation, Russell Begaye, who had ongoing concerns about my water's safety, did not lift the Navajo Nation's ban until August 21, 2015. During this time, the US EPA had water delivered to tribal households. Thousands of Navajo farmers and ranchers were directly affected by the closing of the irrigation canals after the spill. While water was trucked into the area for the fields, many home gardens and some remote farms did not receive any assistance and suffered widespread crop damage.

Unfortunately, by 2021, there was still little effort to address this mining site, as well as many others that continue to leach toxins into rivers, creeks, and streams. Thousands of abandoned mines remain in Colorado that still need to be cleaned up. When we, the Animas and San Juan Rivers, returned to our normal color, the urgency began to wear off. The enormous volume of waste typical in mining disasters means that there are usually no quick solutions. Where is the mess stored, and how safe will it be? What community wants thousands of truckloads of toxic waste to be driven through its neighborhoods during the disposal? There are limited resources, especially from the EPA's Superfund program. The town of Silverton, Colorado, was ground zero for the mine disaster, and since the EPA contractors were responsible for the spill, there has been uncertainty about what the agency might accomplish.

Dr. Clifford Villa, a professor in the School of Law at the University of New Mexico and a 2023 senior adviser to the EPA Office of Land and Emergency Management, has written lengthy articles about my plight and knows that the cleanup will take a long time. He writes, "From the perspective of a river or other geologic features, maybe thirty years or more for cleanup is

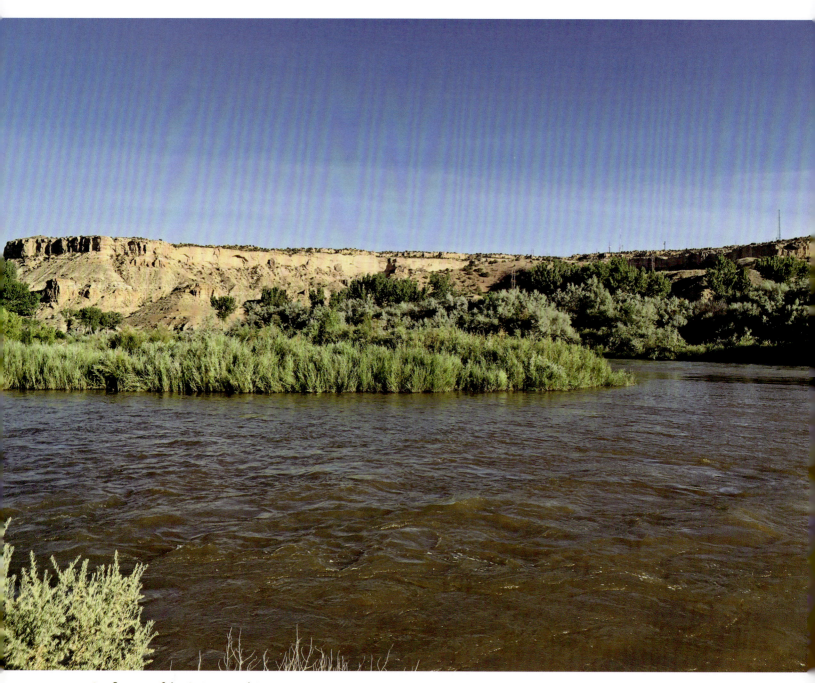
Confluence of the Animas and San Juan Rivers, Farmington, New Mexico.

indeed 'fast.' If there is one thing we might learn from a river, perhaps it is patience." However, I do not always want a patient approach, but rather a speedy determination to clean up the mess, and more importantly, to find practical ways to prevent such disasters in the first place.

The Navajo Nation continues to suffer the consequences of the toxins that flowed downstream. Its communities are culturally attached to the land and water. Even though research has shown that not too much of the contamination got into irrigation systems and onto farms, there is still mistrust of outside institutions and a hesitation to plant corn and other crops. The Shiprock Farmers' Market stopped for three years because of this disaster. When it reopened, the farmers posted flyers with EPA and local data stating that their produce was safe. I am still sometimes called the "Contanimas River." There is a continuing issue of lead being high when my current swells. A computer system has been installed that monitors water quality and can shut off flow when heavy metal levels rise.

In May 2016 the New Mexico Environment Department and the attorney general filed a lawsuit against the EPA, its contractors, and mine owners seeking damage costs. For years New Mexico fought to hold those responsible accountable, and thanks to this persistence, litigation settlements were eventually reached in 2021 and 2022. In June 2023 the New Mexico Office of Natural Resources Trustee and San Juan County celebrated the first project completed using funding from the Gold King Mine settlements, which resulted in a boat ramp being constructed that provides new access to a section of my body.

I am hoping that this kind of toxic mine spill will not occur again and that I can continue to flow clean, although I am wary and weary from this experience.

Eagle River in winter.

Eagle River, EAGLE MINE SUPERFUND SITE, COLORADO

I am doing better now, but for decades I was very sick. Here is my story. In the 1870s a mine was built right on my bank south of Minturn, Colorado, near a small mining town, Gilman, now abandoned. Originally, miners were searching for gold and silver, but after 1917 they were in pursuit of zinc. When the mine closed and the pumps were turned off in 1984, the interior shafts began to fill with water, leaching metals out of the rock and spilling directly into my body. This toxic mixture of heavy metals immediately killed the fish and other beings living within me for miles downstream.

But the strange phenomenon was that these metals turned my flow a bright orange, so the problem became visible to all. In winter some of my water was used to make snow for the nearby ski resorts of Beaver Creek and Vail, so when the snowmaking machines began to line the steep slopes with fresh powder, the ski runs turned an alarming orange: a warning orange. As a result, the Eagle Mine was designated a Superfund site by the Environmental Protection Agency.

Even after all these years, my water in this region is still somewhat contaminated with copper, zinc, and cadmium, although the amounts have been greatly reduced since the 1980s. These metals negatively affect aquatic life trying to survive. Although the mine will always remain an ongoing issue, much has been done to improve the situation. As part of the cleanup process, the myriad tailings piles that dotted the landscape have been consolidated into one pile that now lies beneath an impervious cap so that, I hope, metals cannot leach out of it. A water treatment plant treats all the water coming from the mine before it is put back into my body. There has also been significant revegetation throughout the site, and ongoing monitoring helps various organizations stay up to date with the status of my water quality.

Just to show you how complex these collaborative remediation efforts can be, here is a partial list of some of the entities that have worked to address the problems at the Superfund site: NewFields, Environ International Corporation, Eagle County, town of Minturn, Eagle River Watershed Council, Eagle River Water and Sanitation District, CBS Operations, Inc. (yes, the TV giant owned the mine at the time it was designated a Superfund site), Upper Eagle Regional Water Authority, Environmental Protection Agency, and Colorado Department of Public Health and Environment, including the Hazardous Materials and Waste Management Division.

The rest of my reach beyond this contaminated stretch is doing better each year, thanks to support from so many groups.

Traveling through a marsh on the Saskatchewan River.

Saskatchewan River Delta

CUMBERLAND HOUSE, SASKATCHEWAN, CANADA

I am the Saskatchewan River (Kisiskâciwani-sîpiy in the Swampy Cree dialect, traditionally an oral language), and I have created the largest inland freshwater alluvial delta in North America. I cover approximately 3,860 square miles, an area larger than Everglades National Park in Florida, yet I receive little recognition for this treasure, and almost no protection from the human forces that negatively affect me. My delta is formed from the sediment dropped as I slow down to enter Cumberland Lake. There, my main waterway splits into numerous smaller channels forming dendritic patterns similar to tree branches, roots, or arteries. As I've matured over thousands of years, my principal channel has changed course many times. This natural process, known as avulsion, is a characteristic of all my cousins and occurs when one channel is abandoned in favor of a new course, as fluctuations in discharge lead to erosion.

Over 80 percent of my delta consists of vegetated wetlands, and millions

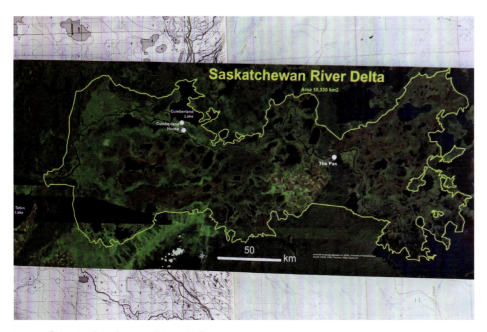

Map of the Saskatchewan River Delta.

Rivière Saskatchewan illustration depicting interweaving channels.

Inhabiting a small island and vying for space are cormorants, pelicans, and seagulls.

E. B. Campbell Dam.

of birds visit me annually. I am both feeding and nesting grounds for hundreds of thousands of waterfowl that migrate to and from the United States, including mallard ducks. Dr. Tim Jardine of the University of Saskatchewan has analyzed chemical ratios in duck feathers and has found that my enormous wetland provides a critical stopover for this massive number of ducks, most of which hatch outside the delta, not within it.

My entire ecosystem is threatened and has been drastically disrupted by several dams, including the E. B. Campbell Dam, built in 1962. As with most of my river cousins around the world, dams have altered my natural flow regime. The transport of sediment has all but stopped, and my wetlands are being starved of nutrients. Human-made hydroelectric structures also prevent seasonal floods. Cumberland Lake used to be twenty-two feet deep. Now, it is only about three feet deep, and my wonderful delta is shrinking along with habitat for countless species. At the same time, human demand for my water is increasing—for household purposes, agricultural irrigation, and industrial needs—further reducing flow to the marsh. My entire system is out of balance.

Water quality is an issue for me, too. In the past, mercury was one of the most significant risks, especially to the fish who call me home. Inputs of

mercury from a bleach factory, and the filling of reservoirs over what was previously pasture and agricultural land, introduced mercury into my system. Fortunately, scientists who monitor my delta today find that this problem has subsided, but many of the upland agricultural areas are still draining pesticides and other toxins into my already stressed body.

Yet another threat to my wetlands is a prolific invasive perennial grass, *Phragmites australis*, which lowers biodiversity and secretes gallic acid, a toxin to native plants. Because monocultures of *Phragmites* reed beds spread across vast distances, their physical size above and below ground chokes out healthy plants. Animals don't like to eat it, and so it has mostly negative effects on a marsh ecosystem. One way to control it is through burning, something that was regularly done by local trappers on my banks for generations. Currently, this practice is discouraged by provincial government agencies that see any fire as a threat to nearby forests.

Even though I am the third largest river in Canada and pass through many populated areas, there is one small village that I'm especially fond of near the end of my journey. Cumberland House is home to both the Swampy Cree and the Métis (who trace their ancestry to First Nations peoples and European settlers, particularly early fur traders who intermarried with the

Collecting water samples to test for mercury.

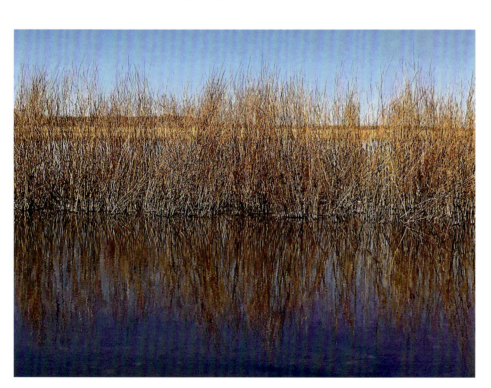

Phragmites reed beds.

CUMBERLAND HOUSE, SASKATCHEWAN, CANADA 49

Karen and Gary Carriere at breakfast in their hand-built Mistik Lodge.

aboriginal inhabitants of the region). Together these indigenous people and their ancestors have looked after me for as long as I can remember.

The original Cumberland House dates to 1774 and is the oldest permanent settlement in Western Canada. In the Swampy Cree dialect, its name is Waskahikanihk, which means "at the house," for it was an important fur-trading post and a depot for pemmican, a staple food of the voyageurs who paddled my waters in canoes laden with furs and trade goods. Pemmican (pimîhkân in Cree) is a nutritious mixture of protein and fat made from whatever ingredients are available, including bison, deer, moose, or elk mixed with fruits such as saskatoon berries and cranberries. A nonperishable and portable food supply was a necessity, for it took about forty days of paddling to get to the Hudson's Bay Company base at York Factory, and almost five months to reach Montreal.

As the productivity of my great marsh declines, many of the indigenous cultural ways of surviving also decline. Fortunately, there *are* people fighting for my existence. Among them are the Swampy Cree voices of two strong advocates, Gary and Karen Carriere, who run a hand-built wooden lodge on my banks to host hunters in the fall months and provide shelter, meals, and a living laboratory for artists and scientists from around the world throughout

50 SASKATCHEWAN RIVER DELTA

the year. One of these scientists, Dr. Graham Strickert of the University of Saskatchewan, has worked here many times with interdisciplinary colleagues, most recently a university class of artists. As he sat on a dock at Cumberland House, I heard him say, "Science can move the mind, but art can move the heart."

They say that Karen Carriere cooks a yummy, tender walleye, caught fresh from deep in my interior and breaded with crushed cornflakes, lemon, pepper, and eggs. But another mainstay of the Cree culture here, sturgeon, are far fewer in number than they were historically. Passionately, Gary Carriere explains to anyone who will listen how the entire food chain is affected by the changes in my marsh. He bemoans the fact that since the delta habitat is shrinking, so is the number of mammals. Gary used to make a steady income by trapping muskrat, but now they have all but disappeared from my shores. He takes his motorboat out along my spine and acknowledges that he owes his life to this delta, where he was raised. Gary is always trying to figure out ways to give back, and he asks poignant questions: While the government will protect an endangered species, what about the endangered indigenous cultures who rely on this wetland for their survival? He says he would like to see traditional indigenous knowledge added to school curricula, because passing along native wisdom about me and the animals who rely on my water is one way to preserve this irreplaceable region.

Yes, I *am* fortunate to have the remaining beaver who live here building lodges on my shores, slapping their tails as a warning to kinfolk. Otters bob in and out of my current, and almost daily I see moose, woodland caribou, elk, deer, bear, badger, skunk, fox, marten, squirrel, weasel, wolverine, and coyote, although at greatly reduced populations from a few decades ago. Oh, what a delight to be able to cohabit with such a rich variety of creatures! There are light-hearted curiosities, such as the satellite dish sitting atop one beaver lodge, ready to help receive far-away messages. And there are festivals, dances, and canoe races upon my skin. Another advantage of being a river this far north is that I get to witness the aurora borealis dancing across the night sky, a ribbon of lights arcing from horizon to horizon mimicking my own shape—an undulating, luminescent river in the sky.

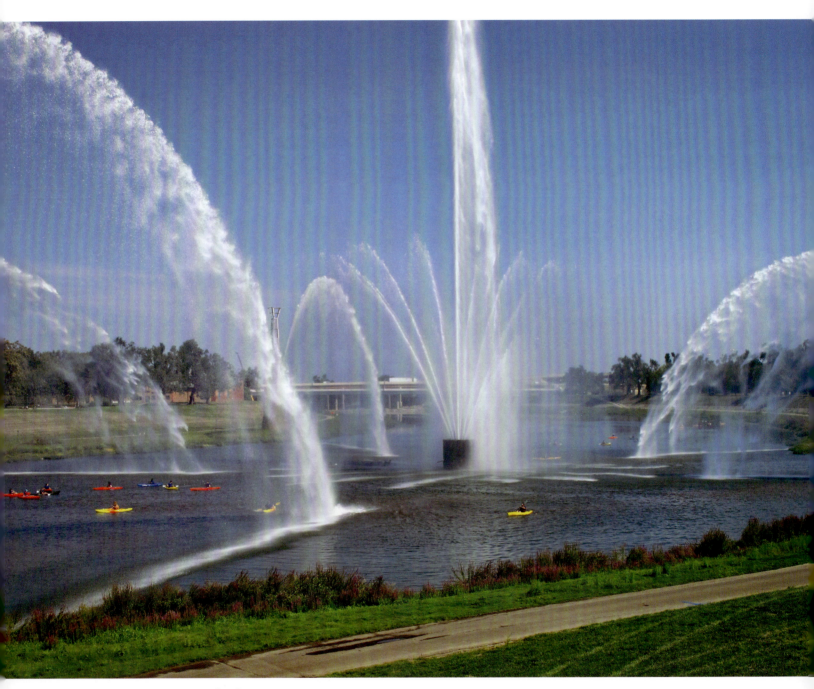
Five Rivers Fountain of Lights.

Great Miami River, Five Rivers Fountain of Lights, DAYTON, OHIO

I am the Great Miami River, a tributary of the Ohio River, flowing 160 miles through southwestern Ohio and Indiana. My Shawnee name is Msimi-yamithiipi. In English I am named for the Miami, an Algonquian-speaking tribe. I flow along quite contentedly until I reach the confluence with the Mad River in Dayton, Ohio, where suddenly I am drenched from above—moisture on moisture—not by rain, but by water falling from an enormous fountain! Pumped from the local aquifer, my water is harnessed into five jets housed in concrete towers surrounding a central geyser.

About 2,500 gallons per minute shoot toward the center of my churning body. The central geyser rises in strong jets up to two hundred feet in the air, covering a diameter of eight hundred feet, making this one of the largest fountains in the world. Equipped with directional wind sensors, this fountain will cease operating if the direction and velocity of the prevailing winds interfere with traffic on nearby roadways. Also, the fountain is shut off during the winter months. In some parts of the world, and in the arid southwestern United States, any fountain is subject to being "unplugged" most of the year because of drought conditions. It is quite amazing that there is enough water in Ohio to be able to propel this amount of aquifer surplus into the air for the sheer delight and spectacle of it.

The city of Dayton, the Miami Conservancy District, and the Ohio EPA researched the effects of the fountain and agreed that it would not harm the aquifer because the groundwater in this region is so plentiful that many buildings must continuously operate sump pumps to prevent moisture from getting into the basement structures. The amount of recycled aquifer discharge dumped into my body each day from this pumping is more than is used by the fountain. Continuous groundwater monitoring is conducted by the Miami Conservancy District's Groundwater Preservation Program to ensure that the fountain does not negatively affect the aquifer or local water systems.

This decorative fountain was built in 2001 to honor the abundance of water within the Great Miami Buried Valley Aquifer, one of the most plentiful aquifers in the United States. At night the fountain is lit with a multitude of colors and can be seen from afar, five jets of water paying tribute to me

River Stewards paddling toward the fountain.

Kayakers being drenched in the fountain spray.

River Stewards kayak.

and four of my river cousins. It is fun to see exuberant kayakers paddling under the strong jets, trying not to get too much water in the boat to keep from capsizing. Most of the fifty kayakers paddling across my body today are members of the River Stewards, a program of the Rivers Institute administered by the Fitz Center for Leadership in Community at the University of Dayton, Ohio, whose mission is to inspire and educate leaders who empower communities to be stewards of rivers. During the three-year interdisciplinary program, the River Stewards, who come from over twenty-five different majors at the university, participate in experiential learning, civic engagement, and sustainable community development around rivers. They have designed the RiverMobile, a 53-foot tractor-trailer learning studio that travels to schools and communities in the Great Miami watershed to teach students about their global responsibility for me and all my relatives across the globe.

I am privileged to see children running back and forth on my banks getting drenched under the spray. And in the evening, people sit quietly and watch the colored lights from the fountains reflect on my body while my current flows downstream. With so many horrendous problems facing my compatriots around the world, it is nice to tell you this lighthearted, joyous story.

Children running through the fountain spray. Photo by Leslie King, River Stewards director.

French Broad River, ASHEVILLE, NORTH CAROLINA

According to geologists, I am one of the oldest rivers in the world, having flowed for millions of years. As an old-timer, I have a low gradient with slow erosion, whereas younger cousins flow more quickly, tumbling down to the sea carrying lots of sediment. My waters flow south to north for 218 miles and helped shape the Appalachian Mountains. I am the French Broad River, named by French settlers in the region centuries ago at a time when I was one of the two broad rivers in western North Carolina.

The Cherokee have a variety of names for me: Agiqua in the mountains, Zillicoah above Asheville, and Tahkeeosteh after Asheville. As with most indigenous groups around the world, the Cherokee go to the river to pray and perform submergence ceremonies. The phrase "going to water" in the Cherokee language is synonymous with the words for bathing and submerging. Historically, the tribe recognized my floods as a natural part of any river's cycle and did not attempt to dam or divert my waters. They knew, too, that I brought rich soil for agriculture when I flooded, and fresh sand for floors of their dwellings.

The second and third largest craft breweries in the United States, New Belgium and Sierra Nevada, are located on my shores. New Belgium and a local brewpub, Wedge Brewing Company, invite people to their facilities to enjoy craft beer, and the two companies also collaborate on events to benefit greenways, which are undeveloped land set aside for recreational use or environmental protection. Since I flow right by the New Belgium facility, I witnessed the construction of its plant on a brownfield property that revitalized a former landfill and auto parts salvage yard.

I slowly glide by the River Arts District in Asheville, where more than 150 artists have studios. In many cities, artists often move into run-down industrial and factory spaces, creating a vibrant new area of town. Then a small café will move in, followed by fancier shops. Incrementally rents go up and the artists will be forced again to find new spaces. This cycle occurs often in urban areas, but for now, this site, which artists have designated as their own, is thriving and lively.

There is easy access to the water, and all kinds of people like to float on my body in kayaks or canoes. A friend of mine, Matt West, a young "extreme

Canoeing the French Broad River.

Old cars buried along the riverbank.

kayaker," is devoted to being on the water as often as possible. Matt likes to describe his dawn patrol routine: he wakes up before the sun, gets all his gear ready, and is prepared to put his kayak into the water at first light to enjoy several hours of paddling when no one else is around. He's off the river early and heading to work just as most people are having their first cup of coffee.

Floating along my ancient spine, a canoeist today notices some unnatural objects within and alongside my body. Here is a coat covered with a gray-green slime of algae wrapped around a rock. And there is a serpentine piece of vinyl that sways in the current like a long-dead aquatic creature. As happens to so many of my cousins elsewhere, people think that they can dump debris into my body and it will disappear. It isn't their problem anymore. However, these discards reemerge so that future generations must deal with the pollution and try to clean up the messes left behind by others. A section of my banks is even embedded with old cars dumped here decades ago in a streamside junkyard. As I flow north toward Tennessee, it sure looks strange to see headlights from a 1940s Oldsmobile peering out from the roots of a tree buried in the mud onshore. Even though it is safe to boat, it is usually not safe to swim. A 2023 report analyzed over a thousand samples from ninety locations and found high levels of *Escherichia coli* (*E. coli*) bacteria, which come from cattle and human waste that gets into my water from sewage overflow during storms.

In more and more communities, concerned citizens are forming organizations to help my compatriots with revitalization efforts. This is true here in Asheville, where the nonprofit organization RiverLink works tirelessly on my behalf to promote conservation, recreational easements, and greenway development. RiverLink members and volunteers reclaim contaminated land, educate thousands of students each year, and ensure permanent public access to me throughout the seasons.

Students and faculty at the French Broad River Academy (located on two middle school campuses, one for boys and one for girls, grades 6–8) have centered their curriculum around me! Whether the subject is social studies, humanities, or geography, the focus is on me and my watershed. What a great concept. My water provides inspiration for art and writing classes, and a living laboratory for scientific and mathematical explorations. There are also lessons to be learned paddling tandem in a canoe, which requires teamwork and the ability to make quick decisions based on my surface conditions at any given moment. I wish other schools would follow their lead, so future generations would understand the relevance of us rivers in their lives!

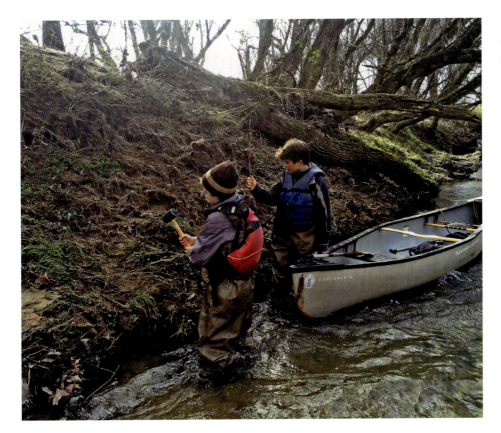

French Broad River Academy students help prevent erosion by pounding cuttings of native alder or willow into the riverbank. Photo by Andrew Holcombe.

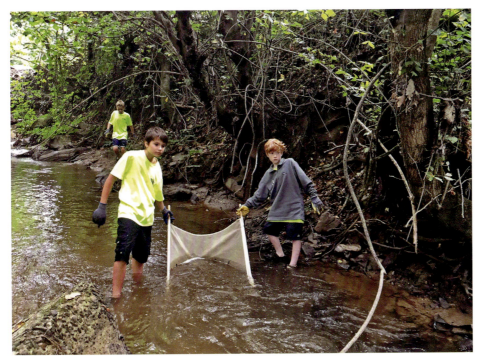

Students seine for macroinvertebrates, looking for indicator species of healthy stream ecology. Photo by Elizabeth Douglas.

Adding water to a canteen at the source.

Deckers Creek, WEST VIRGINIA

As a tributary of the Monongahela River, which runs through north-central West Virginia, I am only 24.6 miles long, with a watershed of 64 square miles. In my upper reaches I flow through beautiful stretches of land, including a rocky gorge that is particularly stunning in autumn. My beginnings are quite humble. I trickle out from a small spring on private land where my pH is a strong 7.7. This is a good number and indicates drinking water quality. In chemistry, pH is a measure of the acidity of a solution: the lower the number, the more acidic the liquid. About six miles from my mouth, at the lower reach of the watershed, my waters turn a deep terra-cotta red orange, and the pH drops all the way down to 4.2 because of acidic mine drainage leaking into my system. When rocks that contain sulfur and iron dissolve, a chemical reaction causes the color of the water to change. It looks like I am bleeding from an ugly open wound. For many years this highly toxic concoction has been gurgling out of the old Richard Mine, along with discharges of aluminum, iron, and manganese.

Source pond at spring.

Beginnings of the creek.

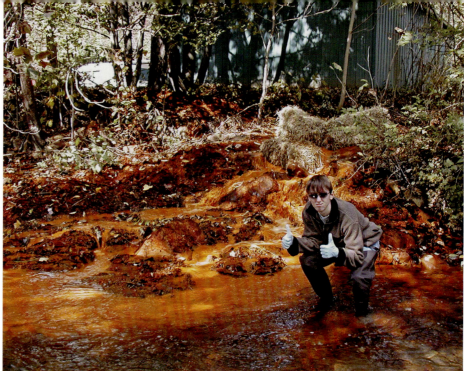
Derek Springston, an optimistic volunteer for Friends of Deckers Creek (FODC), at the Richard Mine discharge site. Photographer unknown.

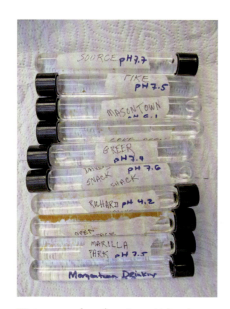
Water samples showing pH levels.

The Richard Mine was opened in 1903 by the West Virginia Coal Company. By 1942, the mine employed over five hundred people and produced thousands of tons of coal. Because the Upper Freeport coal seam is still found today throughout the region, this abandoned mine unfortunately continues to produce acidic drainage. Moisture seeps into the mine shaft, and when the pool rises above the level of my surface flow, it spills out. Today the hillsides still bleed blood orange in some areas from acidic mine drainage. This by-product is the long-term cost of coal production in the region. Because coal was not sustainably mined, communities will be paying for it with high-cost remediation for years to come, as well as with negative impacts to property values and ecological health. Another problem is that even today, there are still houses within my West Virginia watershed that have straight pipes leading directly to the creek where raw sewage is dumped. As a result, fecal coliform bacteria and toxic soaps disturb my microbial balance. Straight piping is illegal, and yet older houses remain that have not complied.

But it's not all bad news. As with so many of my other relatives around the world, caring people are stepping up to take care of us. Here in West Virginia, Friends of Deckers Creek (FODC) is a community-based group

composed of hydrologists, water remediation specialists, local citizens, kayakers, and bikers working together on my behalf to improve water quality and end decades of environmental abuse inflicted on this watershed. They have begun to find ways to reduce the toxic flow coming into my body and have crews working to clean up the trash that is so carelessly dumped into me.

Through remediation projects, education, and community outreach, it is the FODC's goal to make me a fishable and swimmable creek again, envisioning my waters as an asset instead of a liability. In my upper watershed, eight drainage treatment sites operated by the FODC have been constructed to greatly reduce the toxins emptying into my system. Installation of a treatment facility at the Richard Mine has been delayed because of high costs and a lack of funding from West Virginia and the federal government. I hope these obstacles can be overcome.

Also, the FODC has partnered with the West Virginia Division of Natural Resources as well as Trout Unlimited to stock young brown trout fingerlings in my waters. People have caught fourteen-inch brown trout while fly-fishing, but usually the fish are around eight to ten inches long. It is possible to follow my entire course by bicycle along a trail converted from old railroad tracks. Bikers, hikers, joggers, and parents pushing baby strollers all enjoy this path. Upstream of the outflow is a scenic section where I cascade over waterfalls, boulders, and rockslides to create world-class kayaking.

Tiny friends who live under rocks close to shore in my healthy reaches are caddis fly larvae, of the order Trichoptera. They do well in the waters upstream of the mine drainage and are amazing underwater architects. They build dwellings from whatever minute substrate material is nearby as a protective coat for their fragile bodies while they are in the larval stage, before they grow into flies. The cases, constructed from small pieces of sand, twigs, or aquatic plants, are held together with silk excreted from salivary glands near their mouths. Caddis fly cases are open at both ends, with the soft bodies protruding from the larger end, allowing them to move while dragging their cases with them. As an indicator species, "canaries in the coal mine," so to speak, these larvae experience my health daily.

Drainage treatment pond. Photo by Holly Purpura, FODC director.

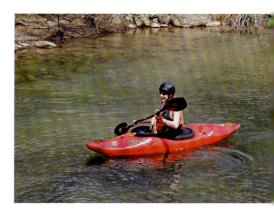

Enjoying the upper reaches in a kayak.

Caddis fly larvae cases.

Gowanus Canal, BROOKLYN, NEW YORK

My name is the Gowanus Canal, and I am so putrid that people plug their noses anywhere near me. I am furious that my condition has deteriorated to this extent, and I am also tired and sluggish along my short 1.8-mile length. I've been terribly sick for a long, long time. A foul-smelling oily slick constantly coats my wretched body, unwittingly forming quite beautiful blue patterns that float on my surface. This slick is caused by off-gassing from the coal tar in my sediment at the bottom of the canal. I'm surrounded by industrial decay, abandoned old school buses, rusty pylons, and junkyards. For most of my length I don't even have the respite of anything green to view, although emergent vegetation now grows on my banks in some places, including *Paulownia tomentosa* (princess tree), an invasive plant whose seeds were brought to the United States as packing material. Even with all the deterioration, an assortment of native and invasive plants has found a way to survive in the "soil" concocted from industrial debris. *Solidago sempervirens* (seaside goldenrod), *Robinia pseudoacacia* (black locust), and *Ailanthus altissima* (tree of heaven) secure their roots into asphalt and brick and somehow find a way to grow in this run-down urban environment.

It was not always this way. In my younger days I was called Gowanes Creek, after Gouwane, a chief of the Lenape Indian tribe who lived on my shores, and I was a picturesque waterway with a tidal inlet and wildlife that made the surrounding meadows home. Then, in 1636 the Dutch government bought the land around me to build a tidewater gristmill for the town of Breukelen (today's Brooklyn). By the mid-nineteenth century, Brooklyn was the third largest city in the United States. A canal was dredged to supply water for operating the mill, and my transformation began. My body was widened by the government of New York in 1774, and locals who used the land nearby were charged taxes. As has happened to so many of my global cousins, I began to be used not only as a transportation hub, but also as a convenient sewage disposal system. By 1867, people straightened my backbone and dredged me deeper to provide a commercial waterway. There were some enlightened designs to install a lock system that would have flushed toxins from my water, but it was considered too expensive, so you could say it was greed that brought about the mess I'm in today.

More than twenty coal plants dotted my shores in the late 1800s, along

Oily slick floating on the Gowanus Canal.

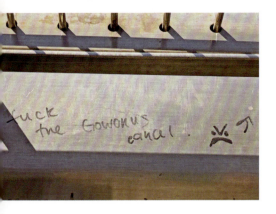

with flour mills, tanneries, chemical plants, and various factories. Slaughterhouses poured waste products and blood into my stream. The engineers who had straightened my body had hoped the tides would flush my system, but my waterway was open at only one end, and wooden and concrete embankments did not allow for a thorough cleaning. It was difficult to breathe because my oxygen levels were so depleted. I became a breeding ground for noxious pathogens, adding to the bad odors from my bowels. Raw sewage from newly constructed buildings drained into me, as did storm runoff and pollutants. By 1910 you could almost *walk* across my body thanks to the accumulated solid waste! A commission appointed in 1889 had decided I was such a disgrace that I should be closed to commercial boating and covered over completely.

Decades passed, but nothing was done to remediate my dire situation. When microbiologists tested my water in 1974, the results were positive for cholera, dysentery, tuberculosis, and typhoid—a stunningly virulent soup mix, indeed! And in 2007, scientific tests even showed I was infected with gonorrhea, of all things! I was supposedly a dumping place for the Mafia, with bodies of gangsters floating in my muck in the 1930s and 1940s, and in a 1998 documentary film about my plight called *Lavender Lake*, the local police recall a suitcase bobbing on my surface that frighteningly turned out to contain human body parts.

Again and again, commissions were formed, studies were done, plans were made for ecosystem restoration, but nothing was accomplished. The Environmental Protection Agency proposed in 2009 that I should be designated a Superfund site. Conservancy groups, the Riverkeepers, and Cornell and Rutgers Universities formed partnerships on my behalf. In 2013 a

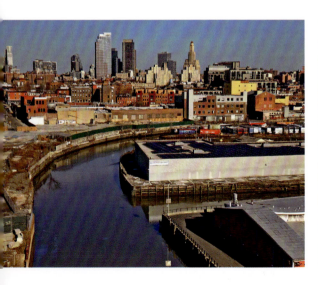
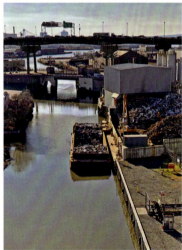
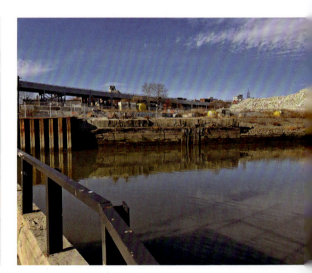

cleanup plan was approved that included dredging my ten to twenty feet of contaminated sediment, which would be hauled away and treated off-site. When the dredging is done, the bottom of the canal will be capped with a layered seal and topped with aggregate to support the reestablishment of aquatic habitat. Bulkheads will be rebuilt and fortified to stabilize the edge and stop the seeping of upland contaminants.

Finally (finally!) in 2017, some cleanup efforts began. So far, so good: new stormwater systems *are* being installed, but a clean me, the Gowanus Canal, is still a long way off. Each day I continue struggling to breathe through this sludge, wondering how in the world humans have allowed this travesty to occur. Sometimes I simply laugh at the mistakes that continue to plague my waters. In January 2021, a barge sank near me that was loaded with eight hundred tons of toxic sludge dredged from my body, dumping the muck back again. This was another attempt by the EPA to clean the filth. In 2020 a $506 million cleanup began, a decade after the EPA declared me a Superfund site. In March 2022, a small boat sank into my waters. Newspaper reports wondered whether the boat was removed the next day or whether it simply dissolved in my chemical-laced bowels, but naturally I know what happened.

In 2023 New York City mayor Eric Adams and Andrea Parker, executive director of the Gowanus Canal Conservancy, symbolically broke ground in an urban infrastructure ceremony to mark the beginning of construction on two sewage storage tanks. The plan also includes three acres of recreational green space and a kayak launch site. The city will pay $1.6 billion for this project, which is projected to be finished by 2030. I hope that at long last I will be able to breathe easier and present myself in a better, cleaner light.

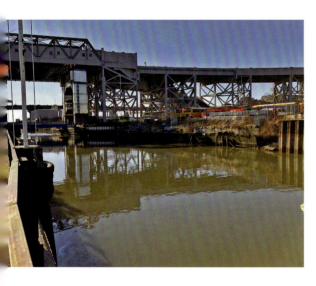

(from left to right)
The canal with downtown Brooklyn in the distance.
Trash dumps.
The canal lined with wood, metal, and concrete siding.
Vertical-lift Ninth Street Bridge, which opened in 1999.

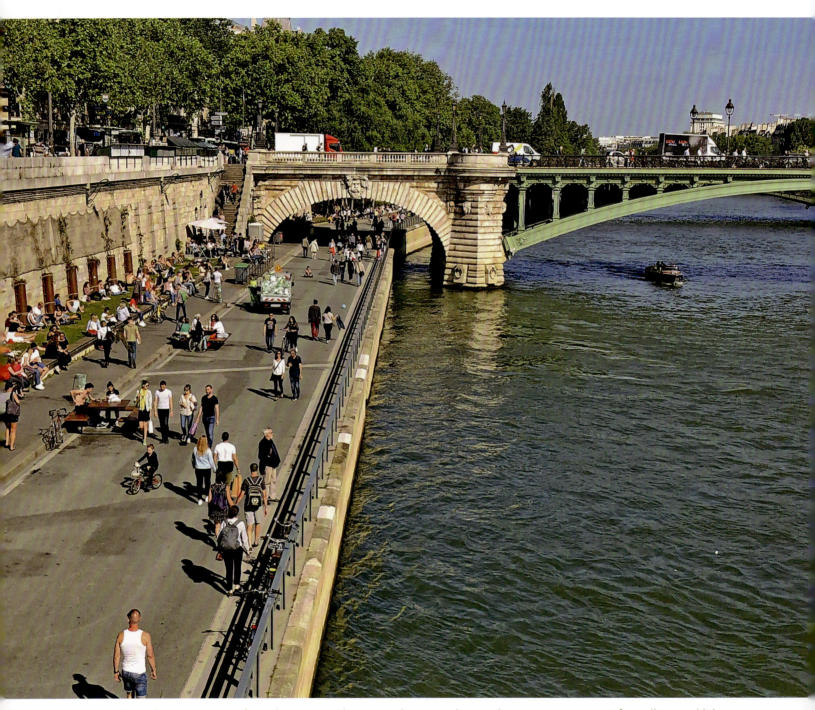
Parc Rives de Seine as seen from the Pont au Change (Exchange Bridge), with a concrete segment for walking and biking and a grassy area to sit.

Seine (la Seine), PARIS, FRANCE

In the third century BCE, a tribe of Celtic fishermen known as the Parisii settled on a tiny island, the *Île de la* Cité, amid my current. This is how Paris got its name. My steadfast body defines the city of Paris and provides an essential point of reference because I divide the capital into the Right Bank (Rive Droite) on my north side and the Left Bank (Rive Gauche) on the south. When you face downstream, the Left Bank is on your left and the Right Bank is on your right. This simple system was devised because my curvy nature often makes orientation difficult. Once noisy, congested expressways for cars, both of my shores have been transformed into the Parc Rives de Seine (Park Banks of the Seine), a nature-focused pedestrian promenade with play areas for children, open-air food vendors, bicycle paths, and comfortable green spaces that swap tarmac for trees and grass. Both banks are listed by UNESCO as World Heritage Sites.

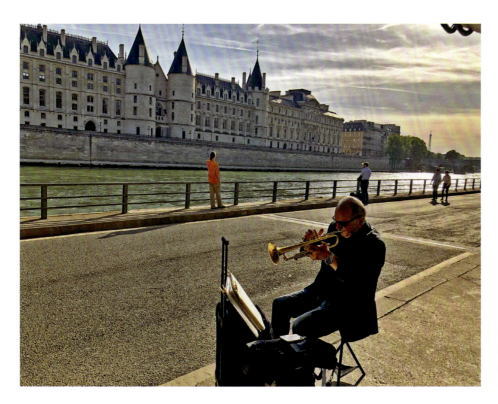

A street musician with the Conciergerie, a medieval royal palace, across the river, and the Eiffel Tower in the far background.

Notre-Dame at night, with people mingling on the Left and Right Banks.

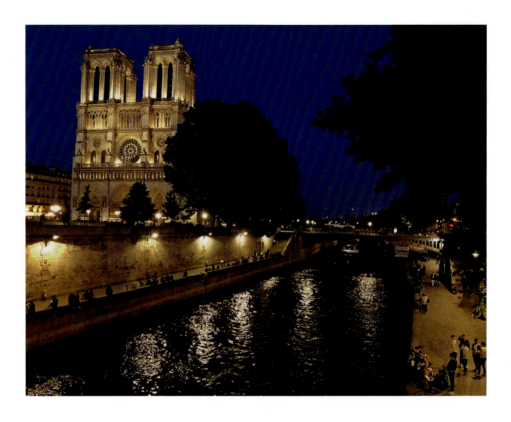

Artist's sketch of water from the Seine being diverted.

Distances are measured from my banks and determine street numbers. One might even say that I am the very heart of Paris, with ten of the twenty arrondissements (administrative subdivisions) bordering my shores. Many grand monuments are found near me, including the iconic iron architecture of la Tour Eiffel; the Grand Palais; the enormous Louvre, with its I. M. Pei–designed glass pyramid; the Musée d'Orsay; the Musée de l'Orangerie, which houses Monet's room-sized paintings of water lilies; and the grand Notre-Dame Cathedral, especially beautiful when lit at night. I am 483 miles long and a famous waterway. My backbone within Paris is busy each day with traffic from commercial barges and the enormous Bateaux Mouches (pleasure boats) carrying tourists to view the city sites.

An artist once diverted my flow away from the main stem to create a living work of art. Between March 30 and August 31, 2018, French artist Stéphane Thidet gave me the opportunity to leave my prescribed riverbed and view the inside of the Gothic architecture of the Conciergerie by pumping my water up into pipes that cross the road and go into the ancient building, thereby transforming the interior space into a living water installation. The work was entitled *Détournement*, which means "diversion." It honored the flood of 1910,

caused by impermeable frozen ground and torrential rains that inundated most of Paris, resulting in extensive damage. Within the Conciergerie a high-water mark delineates the level of the flood inside the building. This national historical monument was used during the French Revolution as a detention center, with its most famous prisoner being Queen Marie Antoinette. The art installation allowed my water to enter the Conciergerie, drop over a waterfall, flow through a series of wooden troughs that meandered among the columns, and eventually exit the building in another waterfall, which returned me to my natural channel.

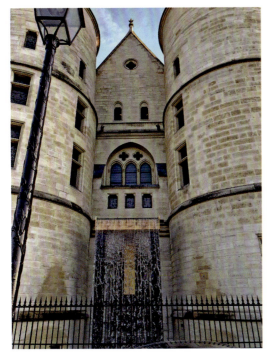
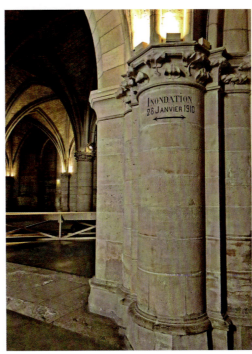

(clockwise from top left)

Extracting water from the river and piping it into the Conciergerie.

Indoor waterfall.

High-water mark denoting the 1910 flood level inside the Conciergerie.

Outdoor waterfall, where water is returned to the Seine.

PARIS, FRANCE 71

(left) Stuffed rats on display at the Paris Sewers Museum.

(right) Untreated sewage flowing through the museum.

From the sublime to the profane, we move from art to shit, literally. I help transport sewage in a vast city-below-the-city. Visitors can even visit Le Musée des *Égouts* de Paris, or the Paris Sewers Museum, to learn how the underground tunnels function, while at the same moment, people are sitting at street level at an outdoor bistro with no thought of where their waste will go after they have sipped their cappuccinos and eaten their croissants. The museum opened in 1867 as a way for the public to observe the expensive work that was being done to solve the capital's wastewater treatment problems. On view are large conduits, cleaning equipment, an automatic flush tank, a storm overflow, and grit chambers. It's a good idea to bring nose plugs to help block the intense odors, since raw, untreated sewage flows right through the museum.

For centuries, wastewater was dumped directly into the streets, which unfortunately ended up in *my* bowels. As Paris grew in population, the situation became intolerable. Rats spread horrible epidemic plagues. In fact, rats are still a common problem today, as they are in many large urban centers. In January 2018, as my banks began to swell and overflow yet again, the proliferating vermin could be seen in all the arrondissements along my shores. Rife with parasites, these rodents are often immune to poison and seem to outsmart the city government's million-euro attempts at control measures.

Extensive flooding in Paris has occurred over many decades, and in August 2022 streets and metro stations were flooded by sudden torrential rainfall. Hundreds of thousands of works of art from such museums as the

Louvre have had to be moved out of the city at various times, since much of the art is kept in underground storage units that would have been inundated. I suffer too during these times when my waters rise, because untreated sewage is discharged into me, resulting in an oxygen deficit caused by bacteria. The 2018 flood was caused by heavy rainfall, which the deputy mayor of Paris, Colombe Brossel, blamed on climate disruption. He said, "We have to understand that climatic change is not a word, it's a reality."

Another horrific aspect of being flowing water is that human remains are sometimes dumped right smack into my guts. In 1431, after Joan of Arc was burned at the stake, her ashes were thrown into my current, washed away but hardly forgotten. Following the French Revolution, the bodies of hundreds of victims were dredged from my depths. Mortuary clerks kept records of 306 bodies pulled from me between 1795 and 1801. And even in 2019, four bodies were found within three weeks, floating in my waters. Unfortunately, I also provide a popular place for the disposal of murder victims and suicides.

Before pumps were installed, water carriers were paid to haul water from me to private homes. In 1600 there were five thousand carriers, and by 1789, over twenty thousand haulers were lugging buckets back and forth to houses. Henry IV of France had the first hydraulic pump installed in the early 1600s. It was driven by my current.

In 1832, a cholera epidemic decimated the population of Paris, killing thousands of residents. At that time, no one understood what caused cholera. Some thought it was the result of impure air, known as "miasma." It was not until 1854 that an Englishman, John Snow, discovered that the source of an outbreak in London was fecal-contaminated water. This waterborne disease became an important factor in urban planning when it became necessary to institute a series of major sewer works to help eradicate the repeated epidemics, and to solve the twin problems of providing drinking water and disposing of waste. Broader streets were designed that included sidewalks. Gutters that once ran down the middle of the road were placed at the side of the street. Both Paris and London owe their wide boulevards and wastewater treatment plants to an epidemic of a dreaded and deadly disease that I unknowingly helped facilitate, since people would dump raw sewage directly into me without understanding the devastating consequences.

Fortunately, as humans have devised smarter ways to purify drinking water, treat effluent, and facilitate its transportation, I have benefited too. Today, my parklike banks offer refuge in the heart of a bustling city, and my water is acknowledged as an asset.

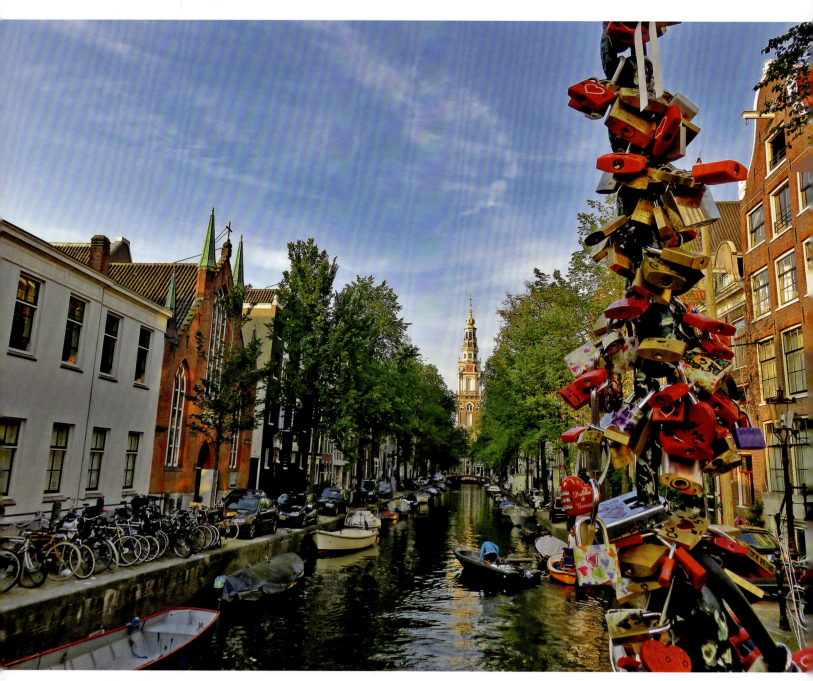
Looking along a canal toward the Zuiderkerk, a church built in 1611 (and once the subject of a painting by Monet).

Amstel River, AMSTERDAM, THE NETHERLANDS

My name, Amstel, is derived from the Old Dutch Aeme-stelle, which means "water area." In the thirteenth century, a small fishing village, Amstelredam, was constructed near my mouth beside a dam. Today we know this town as Amsterdam. As early as the eleventh century, farmers began building dikes to try to keep me from flooding these lowlands. In 1936 my mouth was filled in and sealed shut, so that today I end at Muntplein Square, although I remain connected to a body of water called the IJ by flowing underground through pipes. The IJ (an ancient Dutch word for water) used to be a bay but is currently considered more of a lake. During the Dutch Golden Age in the 1600s, Amsterdam was among the wealthiest cities in the world and one of the most important ports. My extensive system of canals, built during this time, is now on the UNESCO World Heritage List.

A boy dives into the Amstel River.

I flow south to north through this flat and low-lying city, the capital of the Netherlands. Parts of me are below sea level, and some of the land around me was reclaimed from the nearby sea or marshes. Dutch children must learn to swim at an early age and receive diplomas for that effort. Some dive from houseboats and swim in my water, careful to dodge the variety of boats that move day and night upon my body. I have a beer named after me! The Amstel Brewery is located along my shore, as are other breweries, and my water is sometimes used in the production of these beers.

Renowned artists have painted my portrait, including Rembrandt van Rijn (1606–1669), Willem Witsen (1860–1923), and Piet Mondrian (1872–1944). It was such an honor to have them sketching beside me with their wooden easels and portable paint sets. One of my favorite times was when Rembrandt drew with pen and brown ink on oatmeal paper a work entitled *A Bend in the River Amstel near Kostverloren House*. It depicts boats floating on my surface and two riders on horseback beside my bank. In 1611, Adam van Breen painted *Skating on the Frozen Amstel River*, which shows people ice-skating up and down my smooth, hard surface. Dozens of contemporary painters, printmakers, and photographers have used my waters as subject matter in their artwork.

All kinds of boats ply the river and canals.

With the flat terrain, the inconvenience of driving a car, and over 249 miles of bike paths in Amsterdam, humans prefer to get around by bicycle. Since there are over a million bikes, it is no wonder that theft

Magere Brug with the full moon.

and vandalism lead to approximately fifteen thousand two-wheelers being dredged out of my stomach each year. A barge with a claw attached to a crane fishes bikes from my depths that are either repaired or sold for scrap. The Amsterdam Central Station has 7,800 parking spots for bikes.

Amsterdam is located on approximately ninety islands and is linked by over 1,400 bridges that cross back and forth. Some of these bridges are especially wonderful at night, when their lights reflect on my dark water. One in particular, the Magere Brug, uses an old Dutch design that in earlier times was opened by hand, but now an electronic mechanism raises its two sections so boats can pass underneath to enter one of the many canals that traverse Amsterdam.

Any visitor to this city will notice a lot of plastic trash floating on my surface, and there are currently attempts to clean up my sixty miles of canals. One such venture, Plastic Whale, is a company that removes plastic bottles and other debris from my water and transforms the trash into material to make boats that will be used to fish for more plastic. *Boat Number Seven* is constructed from over seven thousand plastic bottles that might otherwise have found their way out to sea. The company also organizes cleanup festivals to get a lot of community members involved.

Someone else who recycles trash from the canals is my dear friend the *meerkoet*. These waterfowl use floating debris to create their unkempt nests, which are seen everywhere wedged among the houseboats. The meerkoets live on my surface and tickle my ribs when they dive down to feed on plants. The monogamous pairs also eat aquatic insects, seeds, grasses, and small animals, and they are one of my favorite playmates as I flow through Amsterdam.

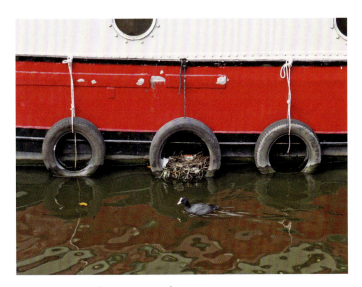

A meerkoet and its nest in a boat tire.

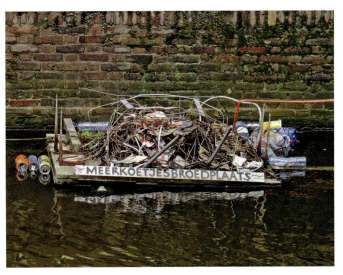

A meerkoet nest built from river debris.

AMSTERDAM, THE NETHERLANDS 77

Lake Tana with storm clouds.

Blue Nile (Amharic: ጥቁር አባይ, *T'ik'uri Ābayi*; Arabic: النيل الأزرق, Al-Nīl Al-Azraq), NEAR LAKE TANA AND BAHIR DAR, ETHIOPIA

Most people are familiar with the White Nile (often just referred to as the Nile), whose drainage basin includes parts of Tanzania, Burundi, Rwanda, the Democratic Republic of the Congo, Kenya, South Sudan, the Republic of the Sudan, Uganda, Eritrea, Egypt, and yes, me in Ethiopia. My flow in the Blue Nile is lesser known and shorter, but equally as important because I supply about 59 percent of the water that reaches the main stem, and in the rainy season that amount jumps to 70–80 percent, contributing to the fertility of the Nile Valley thanks to the silt my body carries. The disputed length of the White Nile as the longest river in the world, compared to the Amazon, is about 4,132 miles or 4,258 miles, depending on the reference. My length within Ethiopia is 500 miles, while my total length as I flow through Sudan and join the White Nile at Khartoum is 907 miles.

My source is a spring near Lake Tana (Amharic: ጣና ሀይቅ), located in the northwestern Ethiopian Highlands on the shores of Bahir Dar. Lake Tana is the largest lake in Ethiopia, approximately fifty-two miles long and forty-one miles wide, at an elevation of 5,866 feet. This region was nominated in 2015 as a UNESCO Biosphere Reserve, which recognizes its international natural and cultural importance.

The surroundings here are picturesque, although lurking beneath my water in the lake and river is a deadly microscopic waterborne disease known as intestinal *Schistosoma mansoni*, which the World Health Organization estimates infects hundreds of millions of people globally and kills several hundreds of thousands annually. A waterborne disease is an infection transmitted primarily though contact with or drinking infected water. It saddens me to know that some communities around Lake Tana's edge have a schistosomiasis (also known as bilharzia) infection rate of up to 80 percent in children. Research results vary widely depending on the type of tests performed. This parasitic disease is spread through my water by a small snail, *Biomphalaria pfeifferi*. The density of the infected snail population depends on the amount of rain, water levels, and type of vegetation lining the lake and my riparian corridor. The drug praziquantel is often used to treat this disease.

Nonchemical molluscicides can help control snails, and an environmentally friendly plant named endod (*Phytolacca dodecandra*) or African soapberry has also been used to kill snails.

People become infected with direct exposure to my lake and river water that contains the infective stage of the parasite, which is known as a cercaria and is spread by the snail. This exposure can happen through swimming, washing clothes and utensils, fishing, planting agricultural crops while barefoot, or using the water for household purposes, including drinking. A national deworming program continues throughout Ethiopia, focusing on school-age students, in addition to health educational initiatives and direct community involvement.

I worry about a mother carrying a baby on her back as she dips a large plastic jug into my water so she can take it home for drinking and cooking. I worry because my own body is infected with schistosomiasis, and I feel bad that it is through exposure to me that others become ill with this serious waterborne disease. Also, men are exposed to the infected water each day as they ferry produce across the lake in low-riding reed boats known as *tankwas*.

A woman with a baby on her back fetching polluted lake water.

Paddling a papyrus boat across Lake Tana.

Papyrus boats, *tankwas*.

The materials for the construction of these boats are papyrus and eucalyptus growing naturally around my shores.

In the skies above my lake waters, numerous bird species provide a serene counterbalance to the parasitic troubles within my gut. Flocks of great white pelicans glide quietly across my surface. Both the endangered black-crowned crane and the wattled crane stand tall as they perform their intricate courtship dances. The half-collared kingfisher reflects vivid colors in my liquid mirror, and the African fish eagle perches in trees nearby observing all that goes on and awaiting its next meal. This sharp-eyed eagle can also watch the villagers nearby as they shop at the local market in Bahir Dar, perhaps one of the best in Ethiopia. One large section of the market is devoted to recycled tires, where one can obtain custom-made sandals. I often see the containers for carrying water constructed from these old tires, when people come to my shore to fetch their fill. Local crafts can be found here, including handwoven fabrics, clay coffeepots, and large metal plates for serving injera—the spongy flatbread used to scoop up stews and meats that I watch the fishermen eat. It is made from teff, a tiny grain that grows in the highlands of Ethiopia. Large local baskets overflow with brightly colored spices used in many Ethiopian

NEAR LAKE TANA AND BAHIR DAR, ETHIOPIA 81

(clockwise from top left) Great white pelicans skimming the surface of Lake Tana.

Sandals made from tires for sale at the Bahir Dar market.

Spices.

dishes, such as fragrant berbere made from red chili, fenugreek, black pepper, ginger, cinnamon, coriander, cardamom, ajwain (also known as "bishop's weed"), allspice, and cloves.

Eighteen miles downstream from Lake Tana I plummet 121–147 feet over a steep cliff forming the Blue Nile Falls, also known as Tis Abāy in Amharic, meaning "great smoke." The surrounding mists and water droplets often create colorful rainbows arching over my body. The spray from my abrupt fall helps form a lush rain forest that I have helped nurture for thousands of years. In the humid forest dwell yellow-fronted parrots sporting green

82 BLUE NILE

plumage and yellow faces; black-winged lovebirds, green parrots with bright red heads and beaks; white-cheeked turacos with green feathers and orange beaks; and vervet monkeys, who provide plenty of lively company. A hydroelectric station built in 2003 reduces the flow over the falls except during the rainy season, when my width can reach 1,300 feet. In addition to the sounds of the birds, including the loud, shrill call of the parrots, and the communication and alarm calls of the monkeys, a young boy playing a handmade flute often accompanies the orchestra of this waterfall.

Vervet monkey.

Flute player at Blue Nile Falls.

NEAR LAKE TANA AND BAHIR DAR, ETHIOPIA 83

Fetching water from the river at dawn.

Narmada River, INDIA

I was born from the sweat of the Hindu Lord Shiva while he was dancing. Or perhaps he was meditating so hard that sweat flowed down *his* body to become *my* body. Another legend says that I was formed from the tears of Lord Brahma. From whomever I was birthed, I am sacred, second in sanctity only to the River Ganges. I am like a mother for many worshippers and am called Narmada Mai. The name Narmada literally means "the giver of joy." Festivals such as Narmada Jayanti honor me with thousands of oil lamps floated at night on my surface. I am also called Rewa, "the leaping one," because I move quickly to escape the advances of heavenly princes. The mere sight of my water is said to absolve people from all their sins, whereas to gain the same grace, one must physically bathe in the Ganges.

Lingam stones.

Flowing east to west through a rift valley formed four hundred million years ago, I am 815 miles long. Beginning at Amarkantak in the Maikala Range of east-central India, my route carries me across the three Indian states of Madhya Pradesh, Maharashtra, and Gujarat. At my humble source, waters from numerous springs collect to form rivulets that flow into a pond surrounded by white temples. My current produces polished, lingam-shaped stones of cryptocrystalline quartz, called Banashivalingas, that are considered sacred and are sought after for daily worship. The unique markings on them are thought to be auspicious by those who worship Lord Shiva.

Every year hundreds of sadhus (holy people or religious ascetics) and pilgrims begin the arduous Narmada Parikrama, a circumambulation of my entire body. Dressed in white and carrying their earthly possessions, devotees perform the meritorious act of walking along one side of me from the Arabian Sea at Bharuch, all the way to my source at Amarkantak in Madhya Pradesh, and then returning to the sea along the opposite bank, keeping my waters to their right. It is a two-to-three-year journey of over 1,600 miles! At each small creek or tributary, the pilgrims scoop water into their cups, take a drink, and call out, "Bless Mother Narmada." Every day prayers are offered to my flow, and small oil lamps are floated upon my spine. Along the route, pilgrims are given water, food, and places to rest.

Both shores are lined with holy cities, temples, and bathing ghats (steps leading down to the water for easy access). Sugarcane, cotton, maize, lentils, millet, vegetables, and bananas grow beside me. In the few remaining forests of teak, mahua, and other trees along my shores, there are still tigers,

leopards, bears, wolves, flying squirrels, hyenas, deer, monitor lizards, eagles, and hornbills.

Bathers must be careful of what is lurking in my water, because crocodiles have attacked and killed people. "Muggers" (*Crocodylus palustris*) have survived in my body for over two million years, and saltwater crocodiles (*Crocodylus porosus*) live in my estuary near Bharuch. They feed on animal and fish carcasses, thereby helping to keep me clean. The crocodiles' future is threatened by pollution, poachers, and the construction of dams, which hamper their movement and flood the shallow pools where they nest. I am sometimes portrayed as a lady dressed in a red sari, riding the back of a crocodile through turbulent waters. In these images, which are often carried by the pilgrims, I spread my arms wide to deliver blessings.

The age-old pilgrimage along my banks has been threatened since the 1980s by construction of a series of dams, both small and enormous. Extensive stretches of the path are currently submerged in the reservoirs of the Narmada Valley Development Project. The most colossal of these structures, the Sardar Sarovar Dam, is one of the largest in the world. Its reservoir has displaced over a million *adivasi*, or original inhabitants of the region, mostly village tribal people whose entire culture and livelihood are

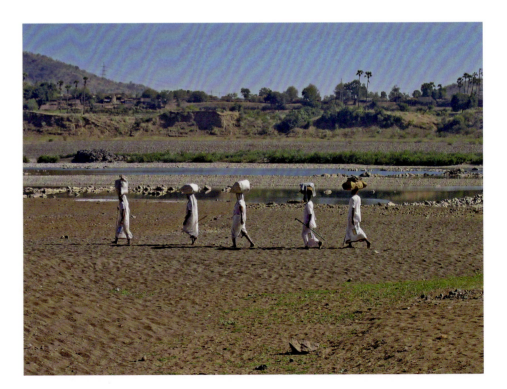

Barefoot Narmada pilgrims carrying all their possessions.

86 NARMADA RIVER

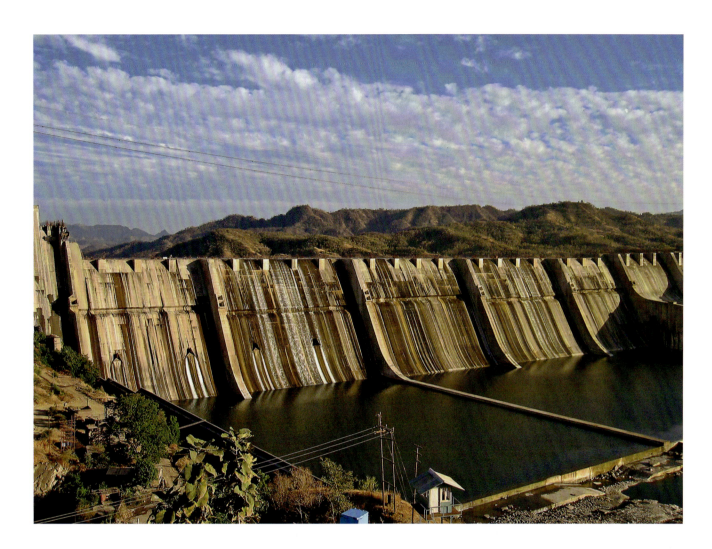

Sardar Sarovar Dam.

at stake. Conflict continues between the Indian government and the courts as to whether these people affected by this dam are being adequately resettled. Many villagers who have been displaced to resettlement sites have not received new land, water, or other entitlements.

As early as 1946, there were plans to dam my body (or should I say damn my body?), and in 1961, Prime Minister Jawaharlal Nehru laid the first foundation stone. But the construction did not begin in earnest until 1988, the same year that the Narmada Bachao Andolan, or Save the Narmada Movement, unsuccessfully called for all work to be stopped. In September 1989, thousands of people gathered in my valley to protest the destructive development, yet the building continued against their will. Now, my sacred waters are forced through pipes and turbines, my natural flow halted

View of Narmada River from the dorm room of a dam worker.

behind megatons of concrete that plug my bowels and block my flow. This means I can no longer perform one of my primary jobs of transporting sediments and nutrients, to the long-term detriment of farmlands and fisheries downstream.

The government of India supports the building of an expanding system of dams along the entire length of my anatomy. With a multibillion-dollar budget, the 2023 infrastructure projects include building several new canals and many more dams. There are also plans for dikes, irrigation projects, and related water infrastructure to harness me and my tributaries. This enterprise is referred to as "National Development." The government continually argues that the benefits of hydroelectric power, flood control, and irrigation substantially outweigh the costs in human and environmental disruption. As the height of the Sardar Sarovar Dam is raised, the backwater of the reservoir increases, inundating yet more biodiversity-rich forests, and rendering homeless more and more families whose lands are submerged.

Alternatives to big dams have been developed across India. Water conservationist Dr. Rajendra Singh has pioneered work for decades to transform arid land with community, watershed-based irrigation systems and revegetation

projects. The "Waterman of India," as he is known, and his movement are responsible for constructing thousands of rainwater storage structures, called a *johad*, or percolation pond, in Rajasthan villages. His traditional water conservation techniques have spread throughout the world. Though residents have actively participated in such efforts, they are relatively small in scale, and it has been suggested that a more extensive shift in thinking needs to occur in a countrywide approach to water use. Urban communities expect tap water to be there for easy consumption, and commercial-scale agribusinesses also expect to have enough water to meet the needs of their business model. A transformation is needed to bring demand for water into line with my natural availability. How is it that I am worshipped, and simultaneously desecrated and degraded? How is it that I am sacred and profane at the same time?

A visitor from New Mexico, a desert place far away in the United States, sits on a river rock near me and reads aloud from the book *A River Sutra*, by Gita Mehta. The novel is about me and the people who live along my shores. In the story, a river minstrel, with cymbals on every finger, sings songs of praise for my sacredness and explains how people can take refuge in Holy Narmada. Wouldn't it be wonderful if every river—all my relatives around the world—had a minstrel to offer songs of praise?

Hindi words for "water" written in henna and photographed in a room at the dam site. Translation starting at top of image: little finger, "Sagar" or sea; ring finger, "Nadhiya" or river; middle finger, "Dhara" or flow; index finger, "Jal," pure or holy water.

INDIA 89

Funeral pyre.

Bagmati River, KATHMANDU, NEPAL

I am clogged with human ash and bits of bone. Garlands of marigolds float on my body as an old monkey watches nearby. I have always borne the remains of the dead, who are taken to the Pashupatinath Temple on my banks near Kathmandu, Nepal, placed on pyres, ignited, and blessed in Hindu ceremonies. The cremated are swept into my murky waters to plod along toward the confluence with the great Mother Ganga as I, the Bagmati River, join other tributaries downstream.

One of my primary roles is as a source of spiritual salvation for millions of Hindus. And yet at this site, the Pashupatinath Temple, my plight has been the same for decades—I am an open sewer, full of garbage from an ever-increasing population. I try to flow, but really I just slog along. Local valley dwellers have made gallant efforts in recent years to clean my body and rid my ribs of slush and guck, but it is an overwhelming task.

Most days my banks here at the temple are ablaze with half a dozen wooden funeral pyres built on the concrete ghats of my shore. Bent men and boys wade knee-deep as they search for small remnants that might have value, such as gold from teeth. Nearby, sitting on the steps of the temple, sadhus wearing orange robes chant prayers. Holy men perform complex Hindu rituals for families. Since infrastructure in most of Nepal, and certainly in Kathmandu, is sorely lacking, residents living in nearby caves still come to my waters to wash their clothes and submerge their dishes into my putrid bowels in a sad attempt at cleanliness.

My daily life is hard, but in the days after a 7.8 magnitude earthquake devastated Nepal on April 28, 2015, killing at least eight thousand people, my role as a holy river and sacred site became overwhelmingly difficult. Thousands of bodies were brought to the ghats here to be cremated day and night. It was unrelenting. The fires burned around the clock, and all the remains of the loved ones were shoveled into my body. With so much devastation from the earthquake, diseases such as cholera were easily spread, making an already difficult situation even worse. Nepal is among the world's most unsanitary nations, with numerous government surveys finding that a huge percentage of Nepalis do not have access to toilets, which is one reason that so much of the drinking water is contaminated with fecal bacteria. Please keep me and my people who live in this beautiful mountainous region in your thoughts whenever you flush toilets, wash clothes, brush your teeth,

Old monkey.

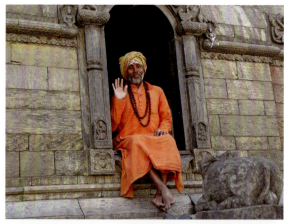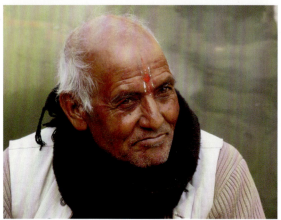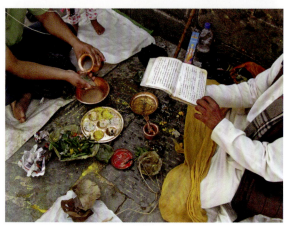

(clockwise from top left)
Searching for gold teeth.
Sadhu.
Spiritual ceremony.
Holy man.

and turn on a tap to drink clean water, and never take these actions for granted. A 2023 *National Geographic* report stated that 75 percent of drinking water samples in Nepali schools were contaminated with fecal bacteria, primarily because of open defecation, suggesting a need for education and action to teach about the dangers of this practice.

 What can be done to help alleviate the problems I face each day? I am grateful that major strides have recently been made toward producing a cleaner riverine environment. I have told you primarily about my stretch at the Pashupatinath Temple in Kathmandu, but I am birthed nine miles upstream at the confluence of three rivers and am fed by spring water. My upper reaches have remained relatively clean, but by the time I arrive at Kathmandu my body is pure filth and turns into a black sludge of waste, raw sewage, and industrial overflow. Unfortunately, some of my natural springs dried up because of expanding urbanization and the paving of roads. Because of this concrete overlay, rainfall is unable to soak into the soil to recharge

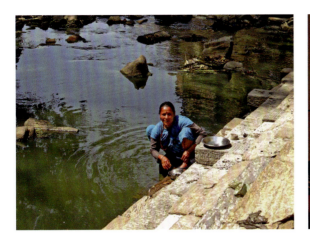

(top left) Washing dishes.
(top right) Musicians.

the aquifers. It is beyond sad to say that during the eight months of the year when there is no rain, most of my water near the temple comes from pure untreated sewage! Can you imagine if this happened to your body? There are plans for a new sewage treatment plant, so let's hope that will help produce better-quality water.

The government of Nepal's Ministry of Urban Development, under the direction of the "High Powered Committee for Integrated Development of the Bagmati Civilization," came up with a plan to build a dam. A dam? Really? We have heard nothing positive about these structures. But here is the reasoning behind the Dhap Dam project: since I am not fed by glacial or snow melt, I am dependent on rainfall, which means that during the dry season I have very little flow; therefore, the purpose of this concrete-faced rock-filled dam is to try to improve water quality in the Kathmandu Valley by allowing continuous (although minimal) flow from the newly created artificial lake to help flush toxins out of my system farther downstream. Skeptics doubt that this dam, which was completed at the end of 2022, will be effective because of the relatively small amount of my water that can be released. There are additional plans to build a larger Nagmati Dam to supply yet more flow, which will be sited where my waters meet those of the Nagmati.

Education is necessary to begin an attitudinal change in how the population views me. I am considered the most holy river in Nepal, and yet people continue to dump solid waste and raw sewage into my waters. How can this change come about, and who will step up to the task of making it happen? Future generations might better understand. At the Kathmandu School of Music, young musicians play traditional instruments and write songs about me. Hear them sing and raise your own voice on my behalf.

KATHMANDU, NEPAL

Several krathongs floating in the river.

Ping River (Thai: แม่น้ำปิง, Maenam Ping), CHIANG MAI, THAILAND

On the night of the twelfth lunar month during the full moon at the end of the rainy season, communities gather along my banks to pay homage to the Buddha and my water spirits. They thank the Goddess of Water, Phra Mae Khongkha (พระแม่คงคา).

This festival of lights is called Loy Krathong (ลอยกระทง). The name is translated "to float a boat or a basket" and refers to the tradition of making krathong, or buoyant, banana-stem sculptures that are decorated with folded banana leaves and contain flowers, incense, candles, and coins (an offering to the river spirits). Sometimes hair and nail clippings are added in the hopes of increased blessings from the water spirits. These sculptural offerings are floated on my moist skin in the evening, forming a candlelit parade dancing downstream. Lights hanging from trees and buildings reflect on my surface, creating myriad new constellations.

In addition to the Loy Krathong celebrations, another awesome sight is

(left) Krathong with incense and flag floating in the Maenam Ping. Photo by Derek Irland.

(right) Banana-leaf krathong.

Full moon with ascending lanterns. Photo by Derek Irland.

called Yi Peng, an ancient tradition in which hundreds of hot-air lanterns rise into the night sky. Known as Khom Loi, these fragile paper and bamboo structures fill the sky with flickering lights to honor Buddhist and Hindu traditions. For some participants, the release of the lanterns symbolizes good luck for the coming year. In 2022, sky lanterns were banned in certain locations because of interference with air traffic and the increasing threat of fires when the flimsy, combustible structures containing candles would land in nearby trees. There are still several places where this spectacle can be witnessed along my shores.

During these celebrations all my senses are heightened. I am enthralled by the abundant splashing sounds of children diving into my water to find coins within the elaborately decorated banana boat sculptures, and in the sky there is the loud cracking of fireworks exploding. The sight of thousands of flickering lights in the air and on my liquid surface is amazing, while the rich aromas of spicy Thai food from many food vendors fill the air. The experience of thousands of the colorful ephemeral offerings being released onto my current brings joy to the myriad participants, many of whom have come from around the world for this beautiful event. Banana stalks and bread krathongs are biodegradable or eaten by fish, but modern ones are sometimes made of Styrofoam, which pollute my body and take up to hundreds of years to decompose! There is already enough trash clogging my waterway, so the

(left) Boy looking for coins in a krathong.

(above) Riverside trash.

96 PING RIVER

Styrofoam sculptures are now banned, for which I am grateful, because my riparian ecology needs all the protection it can receive.

The 6,000-year history behind the festival is complex, and Thais celebrate for many reasons. The main rice harvest season has ended and it's time to thank me for a year's worth of abundance, as well as apologize for not taking care of me and other waterways during the past year. It is a time of celebration, fun, reflection, and great spirituality. Loy Krathong incorporates beliefs from different religions, including elements from ancient Brahman doctrines and more modern Buddhist ideas. Numerous temples along my shores fill with monks in bright orange robes who chant as I flow by. The krathong offerings meandering downstream symbolize letting go of negativity and a time of optimism for the year to come. Participants ask water spirits to sail away their troubles in their krathongs. Other traditions set eels, snails, frogs, and turtles free to live within my body.

Having been born at Doi Thuai in Chiang Dao district, I travel 409 miles on this ancient trade route. After passing through Chiang Mai, I am stopped suddenly behind the Bhumibol Dam. I, along with the Nan, Yum, and Wang, are the main tributaries of the Chao Phraya River, whom we will meet in Bangkok. I am grateful for this brief time of ceremonies, which happen for only a few days once a year, because after I leave the rural area outside Chiang Mai, I am on my way to busy, bustling, metropolitan Bangkok.

Eels offered to the river.

Frog "reintroduced" back into the river by celebrants. Photo by Derek Irland.

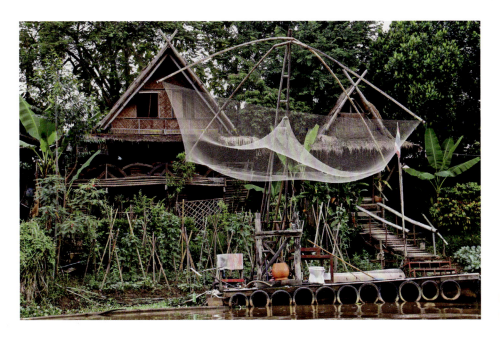

Fishing net downstream from Chiang Mai. Photo by Derek Irland.

CHIANG MAI, THAILAND

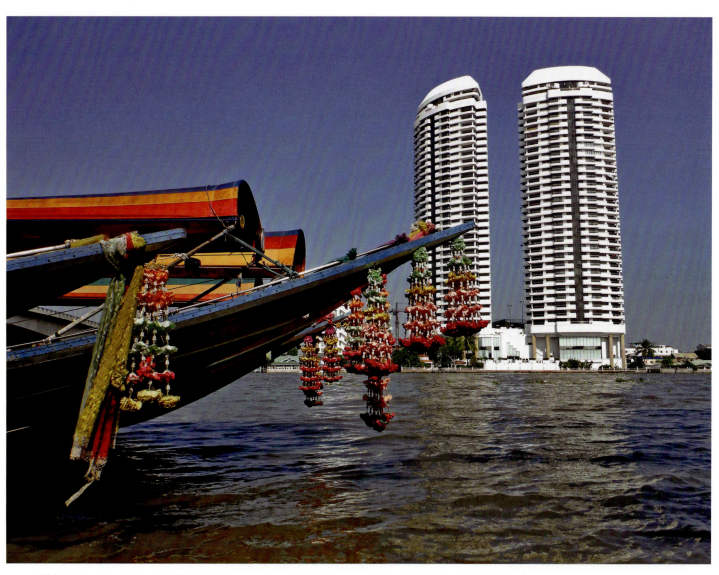
Old and new contrast on the river.

Chao Phraya River (Thai: แม่น้ำเจ้าพระยา, Maenam Chao Phraya)

BANGKOK, THAILAND

Here in the heart of hurrying, busy Bangkok, I am an urban working river with constant traffic of long, heavily laden cargo barges pulled by tugboats chugging upriver. Speedy water taxis (known as longtails) zip across my spine from dock to dock. Wooden sampans speak of days gone by. Every day jam-packed ferries transport thousands of passengers including schoolchildren, commuters, monks, visitors, and families.

The site of the city of Bangkok was chosen for its fertile soil and was especially verdant because it had once been a swamp. It was also a strategic location since the city is located at my mouth, which aided the transport of goods. My name, Chao Phraya, is often translated as "River of Kings." I flow south for more than 225 miles before reaching the Gulf of Thailand, providing a valuable way to transport exports. On paper maps, rivers are often depicted in blue, but in person, my course usually appears drab brown because of heavy rainfall resulting in sediment-filled water.

I am a river of contrasts, sandwiched between the contemporary and the historical. Along my banks I witness ritzy hotels with tourists getting foot massages beside the swimming pool. New high-rise buildings stand next to rickety

Backhoe on a barge being pulled upstream. Photo by Derek Irland.

The tile-covered spire of Wat Arun.

(below left) Produce sold from floating market. Photo by Derek Irland.

(below right) Catfish up close and personal. Photo by Derek Irland.

old wooden warehouses. Saffron-robed monks sit in prayer at enormous temples glittering with gold leaf. I have a close-up view of the multicolored tile-covered spire (*prang*) of Ratchawararam Ratchawaramahawihan, better known as Wat Arun or the Temple of Dawn, a Buddhist temple on my west bank. The central prang is covered with seashells and colorful broken pieces of porcelain, some of which were used as ballast on boats arriving from China.

I feed a system of canals (*khlongs*), which reflect a more traditional Siam, a less-hurried way of life. Laundry drying in the sun hangs from wooden shacks over the water, with children bathing below. Men and women haul in their next meal of catfish. My canals fan out to irrigate numerous rice paddies. Coconuts, rice, noodles, and bananas are sold from the numerous floating kitchens located on this extensive system of canals. The Khlong Lat Mayom Floating Market is one of my favorites, with dozens of small watercraft full of produce floating on my surface as the vendors yell out prices for their food, which is often cooked directly onboard. Hundreds of fish swim through me to get at the scraps of food thrown into the water from the boats.

My tidal flow is evident by the islands of hyacinth floating either upstream or down depending on the tide. On many rivers around the world, water hyacinth (*Eichhornia crassipes*) can be a problematic invasive weed that impacts flow and degrades quality. It can be detrimental because it consumes oxygen, thereby killing aquatic life, and the thick mass stops sunlight from reaching native water plants. The rapid-growing hyacinth also provides a breeding ground for mosquitoes and a snail that is host to parasites that can cause the

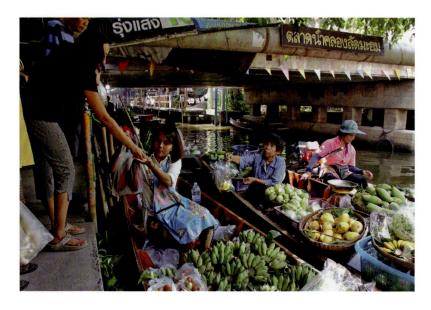

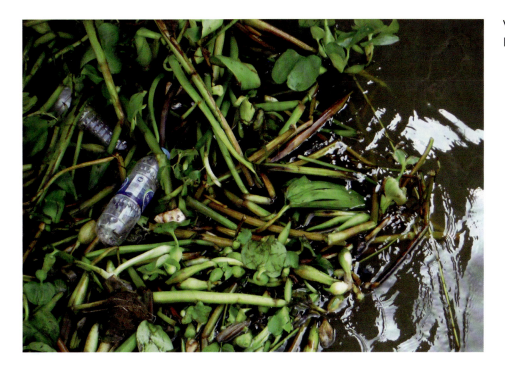

Water hyacinth with plastic debris. Photo by Derek Irland.

waterborne disease schistosomiasis (also known as bilharzia) in both animals and humans. This plant is extremely difficult to eradicate without a lot of planning.

However, on the beneficial side, scientists have discovered that this complicated plant can absorb and digest impurities in wastewater, and thus it has been used for purifying water much more cheaply than a traditional sewage treatment plant. Hyacinth can grow in sewage and act as a natural filter; therefore, proactive efforts are being made in some places around the world, including the American South, to use it as a natural form of wastewater treatment. Bacteria live on the root hairs and break down organic matter in sewage so that the nutrients can be absorbed. NASA has been involved in this research because of its application for space travel, where there is a need for more innovative methods of solid waste removal than conventional toilets. As an additional benefit, this versatile plant can absorb heavy metals and has also been used as a fertilizer and as animal feed. The water hyacinth is being recycled into baskets, furniture, and even flip-flops.

A quieter atmosphere settles over my body as nighttime arrives. There is less traffic, and slower boats ply tourists along under canopies of lanterns. Lights reflect on my surface from bridges and buildings as I move toward the Gulf of Thailand to join the sea.

BANGKOK, THAILAND 101

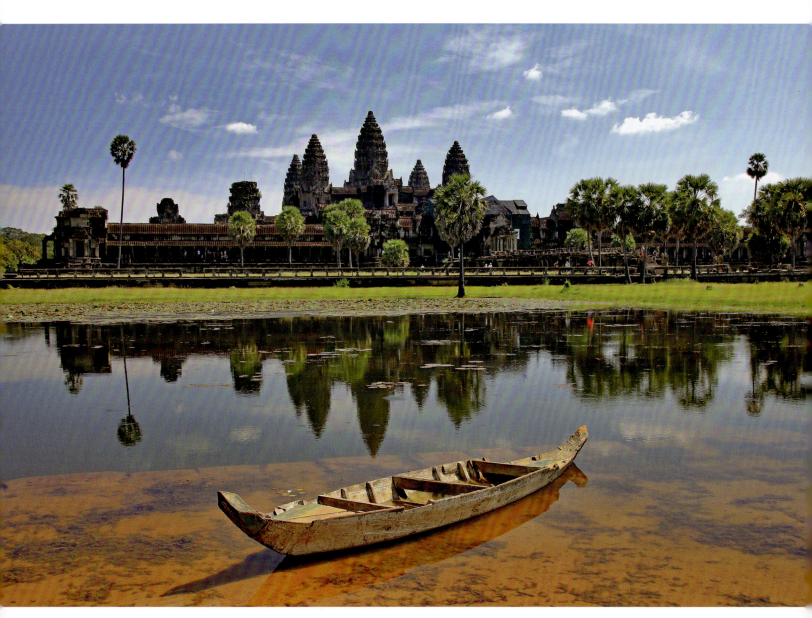

Angkor Wat World Heritage Site. Photo by Derek Irland.

Siem Reap River, CAMBODIA

As I flow through the town of Siem Reap, Cambodia, I am slow moving and bucolic most of the year, with green parks and benches for people to sit and watch me flow by, but sometimes, as with rivers around the world, during the rainy season I overflow and flood nearby buildings and roads. Along both of my banks, old collapsing wooden houses hang precariously over the water. These are being torn down to clean my body, while the local inhabitants are relocated to rice fields nearby. I have been sick for a long time, with plastic bottles and bags clogging my flow, but now there is an effort to dredge my underbelly by removing trash. I can breathe better as progress is made.

My source is a spring on the most holy mountain in northwest Cambodia, Mount Kulen (which translates as "lichee fruit"), and I have a long, dramatic history to tell. Almost one thousand years ago I helped build the grand architectural sacred complex of the UNESCO World Heritage Site Angkor Wat. Thousands of bamboo rafts were floated along my body for many miles, carrying millions of heavy stones from a sandstone quarry to be used in the construction of this ancient site, often referred to as the largest religious complex in the world. Originally built as a dedication to Vishnu, this Hindu temple gradually became a Buddhist monument and is therefore sometimes referred to as a combination Buddhist and Hindu temple. The architecture is covered on almost all surfaces, even the roof, with intricate bas-relief friezes, some of which depict epic scenes from the Ramayana and the Mahabharata. Today, there is a vast amount of reconstruction, partially a result of age and the roots of huge trees that have devoured crumbling chunks of stone. Bright orange–clad monks and religious students can still be seen walking between the buildings.

I did not begin as a natural river, because my body was originally a straight channel built to help with the construction of the enormous Angkor Wat buildings. My ancient streambed has garnered a few natural meanders and a unique ecosystem over the past thousand years, so even though I began as a human-made channel, I have now gained the title of river. Another interesting part of my history is that my water helps form a 650-foot-wide, 13-foot-deep moat around the three-mile rectilinear periphery of Angkor Wat. This artificially constructed waterway, originally symbolizing the ocean

Dwelling collapsing into Siem Reap River. Photo by Derek Irland.

The large moat under an entrance bridge to a historical Angkor building complex. Photo by Derek Irland.

Tree roots growing over one of the Angkor temples.

Young religious students.

in Hinduism, provides a perfect reflecting pool where the sight of the huge temple spires is doubled on the calm surface of this moat.

From my beginning I chug along downhill for fifty miles before I reach Tonlé Sap, Khmer for "Freshwater Lake," which fills and shrinks in cycles. I am the largest freshwater lake in Southeast Asia at the end of the wet season and help support several million people. As a combined lake and river system I provide much-needed water for Cambodia's rice fields. My shores are dotted with colorfully painted floating villages bobbing up and down while people onboard are busy going about their daily chores. But these boat dwellers, who have depended on my waters for their livelihood, are having a difficult time as fish and other species are disappearing because of overfishing, drought, threats from upstream dams, and climate disruption. My very name is now a misnomer, since I am rarely "fresh" anymore. At low levels, my water is often shallow, warm, and lacking in oxygen, so it is hard for me to even breathe. Numerous groups are trying to come to my rescue, and I hope it is not too late.

I may appear to be a quiet and innocent stream, but I have witnessed a brutal, sad history. The name Siem Reap translates as "Defeat of Siam" (today's Thailand), which refers to the old conflict between the Khmer and Siamese nations. In more recent times, I unfortunately saw many of the residents living along my shores killed and maimed in ruthless events. From 1965 until 1973 US troops flew over Cambodia with B-52 bombers loaded with napalm and cluster bombs with the intent to destroy Viet Cong supply lines and hideouts. These planes dropped more bombs here than were dropped on Japan during World War II, killing hundreds of thousands of Cambodians, with some estimates reaching to well over a million deaths.

But there was more horror on the horizon. From 1975 to 1979 a vicious regime called the Khmer Rouge, under the leadership of Pol Pot, evacuated towns and forced residents to work in labor camps in rural, agricultural communes. Families were separated, Buddhist monks were killed, temples destroyed. There was to be no music, no intimacy, no wearing of glasses (which meant, heaven forbid, that you were an intellectual), no laughing, no crying. All of these "crimes" were punishable by death. Estimates vary, but millions of people were killed during this time by murder, starvation, and disease.

One of the few places that was not entirely destroyed during this war, although it was heavily ransacked, was Angkor Wat. Entire extended families

A floating village of Tonlé Sap. Photo by Derek Irland.

hid out along with thousands of other refugees within the walls of the temple. It was not until April 1998 that Pol Pot died, and not until 2014 that two of the Khmer Rouge leaders were finally brought to trial and sentenced to life in prison. Even today, there are television programs that try to reunite families that were separated decades ago.

This legacy of so much war has left behind another major problem: millions of unexploded land mines. Most of the mines around my banks have been cleared away, but tons of dangerous mines remain scattered throughout the country. In 2022, antitank ordnance left over from the civil war detonated, killing three members of a demining team. These were experts trying to locate and detonate unexploded munitions, and yet they were killed. You can imagine how many villagers innocently walking in their fields come

across such deadly devices. Cambodia has thousands of amputees, among the highest of any country in the world.

On a more upbeat note, Cambodia hosted the Southeast Asian Games in 2023. I was witness to King Norodom Sihamoni lighting a torch at Angkor Wat temple for the beginning of festivities that included a marathon race. Thousands of athletes from eleven countries compete in these multisport games, which occur every two years. This event brought yet more visitors to the country, which fortunately has a thriving tourist industry.

A blue house is usually home to a Vietnamese family. Photo by Derek Irland.

The beginnings of the Alexandra Canal, an extension of the Singapore River. Plants were added to help soften the appearance of the concrete walls.

Singapore River (Malay: Sungei Singapura; Chinese: 新加坡河),
SINGAPORE

As I enter the bay, a swan floats gently on my surface, taking in the view of downtown Singapore. Swans usually mate for life, but I don't see this one's partner. The lone bird doesn't flutter or fly away, and in fact it seems to be anchored to a specific spot. Aha! This is no living creature, but rather a robot, called a NUSwan, or Swanbot, set up to monitor my water quality. It was jointly developed by the Public Utilities Board, the National University of Singapore's Environmental Research Institute, and the Tropical Marine Science Institute. A group of these realistic sculpted "swans" (an acronym for Smart Water Assessment Networks) transmit thousands of data points a day to a collection center where information about my pH level, dissolved oxygen, and chlorophyll content will be used to construct environmental models.

I am the Singapore River and am only 1.98 miles long from the Kim Seng Bridge to where I empty into the Marina Reservoir at the southern end of Singapore, an island country. It is strange to say that I begin at a bridge,

A view of the Marina Barrage.

109

(above left) Map of Singapore River entering Marina Bay and then the Marina Channel. The barrage, which stops seawater, is at the lower right.

(above right) The Cloud Forest biodome at Gardens by the Bay.

but if you study a map, my name appears just after the bridge. However, for those who wish to explore, my body extends another 2.4 miles upstream from Kim Seng Bridge to Queensway/Farrer Road with a mixture of open and covered drains, but for this segment my name changes to the Alexandra Canal, a constructed channel.

Once upon a time, I emptied into the Singapore Strait through a tidal estuary, but in 2005, a dam called the Marina Barrage was constructed to create a freshwater reservoir, alleviate flooding, and offer opportunities for recreation. The barrage, a 1,148-foot engineering marvel, spans the Marina Channel, allowing visitors to walk above both reservoir and sea. It also houses nine hydraulically operated steel crest gates and seven drainage pumps that help modulate reservoir levels.

I've been allowed to keep a few of my natural meanders, but I am essentially confined to a stone and concrete channel and am no longer subject to tidal influence, so that very little about me is recognizable as a free-flowing "river." The Marina Reservoir, too, is the result of human engineering and is surrounded by reclaimed land built mostly from imported sand, plus soil and clay. Much of this new ground is home to Gardens by the Bay, which contains two large glass air-conditioned biodomes filled with plants and towering walkways. Prominent fixtures of this park are the "Supertrees," massive metal

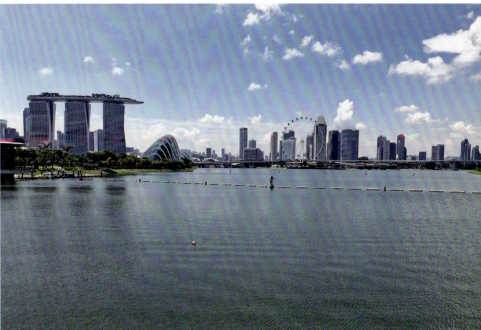

vertical armatures that light up at night and are covered with mostly nonnative vegetation, creating an artificial, constantly maintained display. Also built on this reclaimed land is the iconic architecture of the Marina Bay Sands. Opened in 2010, the three 55-story towers are topped with a boat-shaped structure that is prominent on the skyline of Singapore, which used to be known as the Garden City. That name has now coalesced into "City in a Garden," which means that many office and residential locations are dripping with greenery and a network of nature reserves. It is mandated that new developments have green spaces on the ground as well as higher levels of the building. Plants and trees line almost every roadway and grow overhead on pedestrian walkways.

Many of Singapore's wild regions have been lost to urban expansion. Natural forests of yesteryear have mostly been replaced by manicured gardens and ponds. There are, of course, arguments on both sides, since the designers of Gardens by the Bay admit that it was not an easy decision to relegate valuable downtown real estate to green spaces.

You may think the term "water scarce" refers only to arid desert, but equatorial Singapore is one of the most water-scarce countries in the world. It has no natural lakes or aquifers and is physically too small to amass much rainwater. Out of necessity, the island nation has diligently explored ways to ensure a reliable water supply, and the several techniques in use today are

(above left) Giant cranes hoist workers up to add more plants to one of the Supertrees.

(above right) Singapore as seen from the Marina Barrage, with Marina Bay Sands and the biodomes at Gardens by the Bay on the left and the giant Singapore Flyer Ferris wheel in the middle.

(below) NEWater treatment facility.

SINGAPORE 111

A cross section of one of the filtration systems.

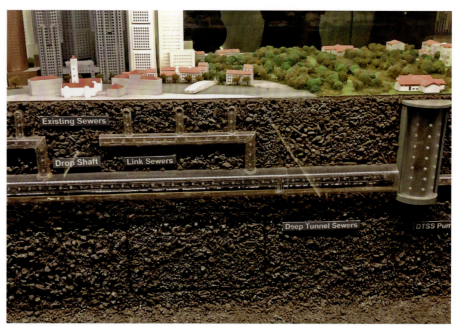

Miniature display of the Deep Tunnel Sewerage System.

NEWater ultraviolet light.

referred to as the National Taps. The first of these "taps" is local water catchments. Storm runoff is collected, routed through a network of canals, ponds, and waterways, and added to my body at the Marina Bay. There are additional reservoirs, most of which are impounded estuaries.

Introduced in 2003, NEWater is an additional national tap. It is wastewater that has been reclaimed under the supervision of Singapore's national water agency, the Public Utilities Board, or PUB. Sewage and used water is subjected to a rigorous treatment process that includes dual membrane technologies such as microfiltration/ultrafiltration and reverse osmosis. It also undergoes intensive ultraviolet disinfection, producing exceptionally clean water that is utilized primarily for wafer fabrication plants and air-conditioning in industrial complexes and commercial buildings. NEWater is added to the reservoirs during dry spells. It is also bottled and sold as drinking water to educate the public that it is safe to consume.

A massive underground construction project in Singapore is the Deep Tunnel Sewerage System, a submerged superhighway that conveys wastewater via gravity through a series of large tunnels to treatment processing plants. The treated water is then channeled for further reclamation into ultraclean, high-grade reclaimed water called NEWater, as mentioned above.

112 SINGAPORE RIVER

Before this modern removal system, most households had a "night soil bucket" for collecting human waste. The contents were then emptied into my unhappy current. Whew! The filth and stench were difficult to tolerate! The practice of this night soil collecting was phased out in the twentieth century, with the last households using this system holding out until the 1980s.

Currently, imported water from Malaysia meets a rather large portion of Singapore's human needs, but a contract for this imported water will expire in 2061 and will need to be renegotiated. Another water strategy is desalination, a process that removes salt from ocean water to make it potable. The first seawater reverse-osmosis plant in Singapore opened in 2005. There is certainly plenty of ocean available, but desalination infrastructure is costly to build and requires a lot of energy to operate. In addition, disposal of the waste discharge, known as brine, can negatively impact the environment, for it includes many harmful chemicals used in the desalination process.

Conservation and education efforts complete this nation's water acquisition program. PUB's mascot, Water Wally, is a big blue animated drop with arms and legs and a smiley face that appears everywhere around the country, from signage asking the public not to dump anything into my waters, to large bulbous sculptures at strategic locations such as the information

River signage depicts Water Wally warning citizens not to pollute.

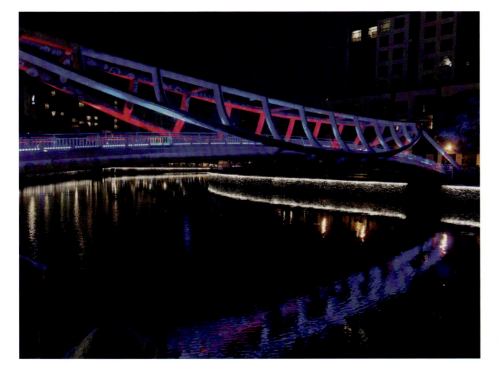

Alkaff Bridge at night. This bridge is shaped like a traditional river boat (*tongkang*) and is named after a prominent family of Yemeni Arabs who settled in Singapore.

SINGAPORE 113

(left) The Singapore River Festival.

(right) A street musician plays an *urhu* (*erhu*), a two-stringed Chinese instrument, beneath a bridge next to the river.

"Otters crossing" sign at Gardens by the Bay.

museum at the Marina Barrage. Water Wally also helps promote the message that NEWater is pure and safe to drink.

I am thankful that modern Singapore still values its namesake river, me! Originally, just a few transportation bridges spanned my spine, but today there are numerous pedestrian bridges in multitudinous shapes that are brightly lit at night, offering easy access to tree-lined walkways, shops, cafés, and restaurants on both my banks. There is even an annual river festival named after me, which aims to attract visitors to my shores for fun and celebration. In 2018, the festival's theme was "Your River, Your Vibe," and one event featured LED-illuminated kites shaped like manta rays flying above me. In 2022, the theme was "The Great River Cleanup," which aimed to get festival goers involved in keeping my body clean from all forms of debris.

Despite all this teeming human activity, birds, including hornbills with their enormous beaks, still flock to me for sustenance, and my water is home to an interesting variety of riverine creatures, including monitor lizards and smooth-coated otters. Often considered an "indicator species," otters need clean water to survive, so it is a true success story that families of Singapore River otters are thriving. An otter webcam allows fans to download photographs and videos, and signs all along my banks remind people to keep their dogs on a leash, not to feed or harass the otters, and to refrain from putting sharp objects into my water. This is gratifying to me, for the otter is among my favorite companions.

Short in length but long on history, I've been host to continuous human

(above left) A wild smooth-coated otter at the Singapore Botanic Gardens. Video still by Tan Beng Chiak.

(above right) A Malayan water monitor (*Varanus salvator*).

settlement since ancient times, when a thriving fishing village named Temasek was located at my mouth. By the late twelfth century, that town was renamed Singapura, meaning "Lion City" in Malay. Thomas Stamford Raffles, who understood the importance of a prosperous waterfront, founded modern Singapore in 1819 when he signed a treaty with the British East India Company, granting permission for a trading post here. Establishing Singapore as a "free port" brought thousands of immigrants to my shores. I was the island's "bloodstream"! My banks were lined with godowns, warehouses where trade goods from China and India were stored, and my surface teemed with watercraft. Until the barrage was built, you could still see bumboats (flat-bottomed barges also known as lighters or *tongkangs*) ferrying cargo to and from large ships moored out in deeper water. Today, some of these old tongkangs have been refurbished and turned into floating restaurants. Small, oar-driven sampans, or *kolek*, are still used for fishing and short-range transport of people and goods, but decades of waterfront rehabilitation have forced the majority of these traditional vessels into retirement.

We cannot get away from the lesson of pollution, for together with thriving trade came congestion and contamination. Duck and pig farmers used me as a disposal system. So did the local food vendors known as hawkers, and as industry developed, oil spills and toxins from boatbuilding factories sullied my water. Humans can be so ignorant and unthinking! They assume that I will carry away their wastes, but the truth is that it will always come back around, for there is no "away" on this water planet!

(upper left) The historical warehouses (godowns) are now dwarfed by modern condos and apartment buildings. Most have been turned into shops and cafés.

(upper right) With the head of a lion and the body of a fish, the Merlion has been used by the Singapore Tourism Board as an icon or logo for the city.

One of the trash removal boats that scour the river each day.

Some of the natural meanders in the river were left intact. This section of the river used to be soggy fields and mangrove swamps.

In 1977, Prime Minister Lee Kuan Yew proposed to give me and my cousins, the Kallang, Rochor, and Geylang Rivers, a thorough cleaning. It took ten years of coordination among numerous government and private agencies, and the expensive task involved relocating thousands of families from slums to public housing and relegating street hawkers and vegetable sellers to food centers, which are still a favorite inexpensive place for locals to eat instead of fancy restaurants. I had to endure the horrific dredging of foul-smelling mud and debris from my banks and the bottom of my streambed, but at least I was being cared for. Even after millions of dollars' worth of rehabilitation and a decade of healing work, the job of keeping me clean is ongoing. Special blue boats scour the length of my body daily to retrieve floating rubbish. Someday, I tell myself, people will learn not to litter, and there will be no need for trash boats.

Along my flanks, a collection of bronze sculptures reminds visitors of the daily activities of people throughout history—fishermen, financiers, merchants. One statue depicts a group of naked boys leaping gleefully into my midst. Those children used to plunge from tree branches and swim in a group for safety, avoiding the bumboats that churned me into waves. Times change. I'm not *that* river anymore, but I am still here, lending a hand as Singapore pioneers an innovative relationship with water that contributes globally to the future of water policy issues.

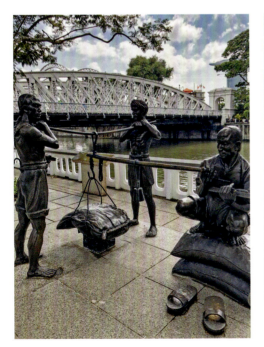
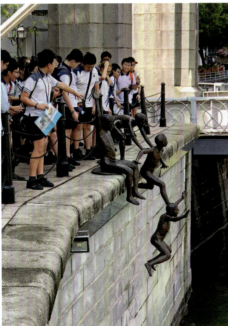

(left) A sculpture by Malcolm Koh, *A Great Emporium*, shows Indian and Chinese laborers weighing their trade goods.

(right) *First Generation*, sculpture by Chong Fah Cheong.

Chaobai River (Chinese: 潮白河, cháobái hé), BEIJING, CHINA

I am the Chaobai River, created at the confluence of the Bai He (White River) and the Chao He (Tidal River), which feeds into the Miyun Reservoir, one of Beijing's sources of potable water. It is a huge responsibility to provide millions of people with enough hydration to survive! When released from the dam, my water flows for fifty-nine miles into Beijing, the capital of China, initially through an open canal, then through iron and steel pipes, so that some of my liquid does not see daylight again until a person turns on the tap and I emerge into a residential sink, bathtub, or toilet. My total length is about 280 miles, and I eventually make my way out to the Bohai Sea.

Whereas I am used for potable water, a separate cousin reservoir of mine, the Ming Tombs Reservoir, named for the Ming Tombs nearby, and also known as the Shisanling Reservoir, is used as a power station. The water is pumped from a lower reservoir up to a higher one and then falls through four turbines. After the power is produced, the water discharges back to the lower reservoir and the cycle begins again. During the 2008 Beijing Summer Olympics, triathlon events were held near this reservoir, and across the street from the dam there is still a huge concrete bas-relief mural dedicated to the three sports of triathlon athletes.

The densely populated city of Beijing is among the most water scarce in the world, and discussions continue about how to obtain more water for the overpopulated metropolis. It has two rainy months, July and August, but the rest of the year it receives almost no precipitation. Historically, this capital received its water mainly from mountain springs, which flowed through canals into a system of lakes. However, in the past, deforestation to clear the land for development began to dry up the springs, so that many of them no longer flow, but there are plans to recharge these springs. Currently, groundwater from aquifers provides the majority of the city's water, but since subtraction is larger than replenishment, the groundwater table has declined, so constant decision-making about how to recharge the supply is needed. Since the turn of the century, water reclamation has been aggressively pursued.

Miyun Reservoir.

Ming Tombs Reservoir.

Bronze map of Beijing showing location of Miyun Reservoir in the upper right corner. This display is in the Beijing Urban Planning Exhibition Hall.

View from a boat on the Imperial Waterway.

Wastewater treatment plants throughout the city provide reclaimed water for nonpotable uses, such as hydrating parks and roadside plantings.

One massive project is the South-to-North Water Transfer Project, which will eventually add to the water supply by transporting water from the more water-plentiful southern regions up to the north. However, it was fifty years after the project was first proposed before construction commenced, and it might take another fifty years to complete, so this is not a short-term solution to water woes. This plan has naturally raised serious concerns such as the displacement of populations, destruction of land, loss of antiquities, and threat of pollution.

The construction of dams around the world usually displaces people who have lived on the land for many generations. This was also true of the Miyun, which displaced thousands of villagers residing in numerous small towns who had to be resettled. Some families moved their possessions in horse-drawn carts to new locations. In 1963, my belly at the reservoir began to fill. In the 1980s, tourism took hold all around the new reservoir, with hotels, restaurants, holiday resorts, and busloads of visitors flocking to be near me. But a few years later, pollution and security concerns led to the entire perimeter being fenced so that no one could come for a swim or a picnic, or even drive very near in a car. Fortunately, industries are prohibited from being located near my shores as a precaution against accidental pollution.

I feed a vast system of canals and moats, as do several of my Chinese river cousins. I provide water for the Beiyun River, which in turn provides flow for the Imperial Waterway in Beijing. In ancient times this was the preferred route of transport for royal families traveling to the Summer Palace, which is home to one of the best-preserved imperial gardens in China. In contemporary times, passengers on boats pass entrances to the zoo, aquarium, National Library of China, and Purple Bamboo Park. The water in Kunming Lake in the Summer Palace park flows all the way down from my reservoir up in the mountains.

My neighbor the Beiyun River is also fortunate to end up in a series of scenic lakes in this ancient city of Beijing. Qianhai Lake and Houhai Lake are part of an old water-supply route. Originally dug out during the fourteenth century, the lakes were later expanded during the Ming dynasty as harbors for barges traveling into and out of Beijing on the Grand Canal. Most visitors to these lakes do not comprehend the adventurous journey that my waters have taken to get here from far away in the mountains. Both lakes provide a cooling retreat during the hot and muggy summertime, and even though

(above) Old map showing Houhai and Qianhai Lakes.

(left) Bridge at the Summer Palace framing Kunming Lake, fed by Miyun Reservoir.

(above) Even on a chilly, rainy day, with "no-swimming" signs posted, swimmers enter the refreshing waters of Qianhai Lake.

(right) A resting dragon, who is said to calm the waters, guards Houhai Lake.

there are "no-swimming" signs posted, it does not stop intrepid athletes. In winter, my lake waters freeze, and visitors can ice-skate, play hockey, and walk across the ice.

Most major cities in the world have a river that helps define them. Paris has the Seine, London has the Thames, and Seoul has the Han. Beijing used to have as many as two hundred rivers. Today very little remains natural about any of my water, as I have been artificially channelized and managed through elaborate urban planning. The Beijing Municipality government invested large sums of yuan (Chinese currency) to replace several riverbeds with parkland. The 1.7-mile-long Huangchenggen Park is built on top of what used to be part of my body, so now what remains of me is buried underground. Without even knowing that I am here, visitors to the park enjoy a seven-month calendar of flowers including crape myrtle, Chinese rose, forsythia, magnolia, winter jasmine, and flowering crab apple.

In 2013, Chinese president Xi Jinping announced that cities should act "like sponges." This idea came with substantial funding to experiment with ways cities could mitigate floods by absorbing precipitation with rain gardens, green roofs, increased tree cover, constructed wetlands, and permeable pavements, which would help slow down, capture, and filter stormwater that could replenish aquifers or be stored. "Sponge cities" provide a new term for urban designers throughout the world. The traditional approach in a town is to cover the land with impermeable roads, sidewalks, and buildings that interfere with the hydrologic cycle, but sponge cities mimic the natural water cycle. Beijing has plans to develop numerous new green spaces to collect excess stormwater, which will help recharge the aquifer during the rainy season.

Cities will need to be retrofitted with green infrastructure, which is not easy or cheap, but it is beginning to look as though it is worth the effort. For example, some mountain springs have come back west of Beijing. These experiments in green city planning might help ease the stress put on my water in the Miyun Reservoir. And who knows, perhaps the natural ways of flowing water will be restored with reverence and understanding.

Kamo River (Japanese: 鴨川, Kamo-gawa), KYOTO, JAPAN

Every day, many friends walk the paths along my shores, ride bikes, have picnics, push baby strollers, and bask in the colors of cherry blossoms in spring and red maple leaves in fall. I flow next to the old district of Gion, where some women still wear traditional kimonos. I am certainly not considered a beautiful free-flowing river, but I function as a respite from the pace of urban life in Kyoto (which is nothing compared to busy downtown Tokyo). In Japanese I am called Kamo-gawa. Translated from the kanji, my name means "wild duck," and *gawa* is "river." Ducks as well as a large variety of other birds wade in my shallow waters in search of their next meal. Herons and egrets wait patiently as they stalk their food.

My source is in the mountains near Mount Sajikigatake in the northern ward of Kyoto. With a length of just nineteen miles, I flow into the Katsura River south of downtown Kyoto, and after joining other river systems we eventually make our way out into Osaka Bay. My depth is shallow, only three feet in most places, until the rainy season when some nearby pathways are drenched. In the fall, surrounded by the vibrant vermilion of the local trees, a person could walk across my width and get only their ankles wet.

Where the Takano River converges with my flow, a triangular area of land honors the river confluence at the Shimogamo Shrine near a forest. After

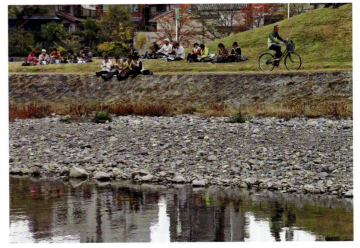

(below left) Diagram of bridge locations on channelized Kamo-gawa. Photo by Derek Irland.

(below right) Enjoying a picnic on the riverbank. Photo by Derek Irland.

Leaf photographed underwater.

125

Purifying rock with water at the Shimogamo Shrine. Photo by Derek Irland.

Grey heron (*Ardea cinerea*) with a snack. Photo by Derek Irland.

visitors donate to the shrine, monks give them a cloth-wrapped white rock, which is taken to a small stream where it is washed and purified. The stone is rewrapped in the cloth, carried to woven bamboo baskets, and placed among other blessed stones that will be used in the reconstruction of ritual sites. Purification is important to Shinto, so numerous ceremonies are held throughout the year at Shinto shrines in Kyoto. Also, Buddhist temples hold annually rotating festivities, so there is always activity in Kyoto in the immaculately groomed gardens of the shrines and temples.

Another example of the use of my waters for sacred purposes is located at one of the most celebrated temples in Japan. In the hills east of Kyoto, the Kiyomizu-dera, or "Pure Water Temple," was founded in 780. In 1994, it was named a UNESCO World Heritage Site. The main wooden hall was constructed without nails, and at the base of this hall, the waters of the Otowa Waterfall are divided into three falling streams. Visitors can fill long-handled cups with these special waters, one of which is purported to promote longevity; another, success at school; and if they drink from the third stream, they will have a good love life. But it is advised to choose only one so as not to be greedy.

Unlike some other rivers in Japan, I am not buried under cement, so it is

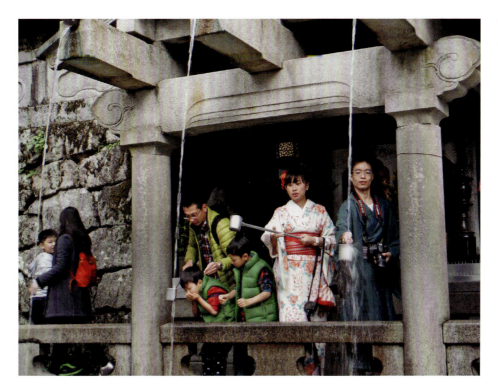

Visitors partake of the sacred waters at the Kiyomizu-dera Temple.

gratifying indeed to be able to see the locals who enjoy visiting me regularly. At night I am illuminated and set aglow with lights from bridges, buildings, and stone lanterns. I am sometimes referred to as one of the treasures of Kyoto. But I do miss natural meanders since my course is within a channel and my flow is an unnatural straight line. Roughly thirty bridges cross over my southern stretch carrying buses, cars, trains, and pedestrians.

Near the Imadegawa-dori Bridge, chunkily cast concrete stepping stones cross my back. The most prominent shape of the stones here is the form of turtles. Children wearing school uniforms and backpacks quickly hop from stone to stone while elders worry about how to step gingerly from one to another with water flowing by underneath. These stepping stones bring people of all ages to me, so I hear laughter and conversations up close as they zigzag across me, or sometimes they just choose a stone and sit quietly for a while.

Turtle-shaped stepping stones. Photo by Derek Irland.

KYOTO, JAPAN **127**

Hot air balloons over the río.

Río Grande (Río Grande del Norte, Río Bravo), USA AND MEXICO

I begin as a small trickle of spring water and snowmelt in the San Juan Mountains of southern Colorado at an altitude of 12,584 feet. It is beautiful up here in the pine and aspen trees, and part of me wishes I could just stay here, because once I'm on my way down to the Gulf of Mexico (a journey of 1,897 miles!), I will encounter dams, drought, unrealistic expectations of how much water I can reasonably provide, complicated water compacts, toxic discharges, contentious immigration issues fostered by my identity as a border, and so many problems that I have been declared an "endangered" river. But I also flow through beautiful deep canyons where my whitewater rapids are ridden by intrepid rafters and kayakers, and I look forward to the stretches that have been protected as a National Wild and Scenic River, with wilderness parks and bird sanctuaries. I am compelled by the laws of physics to flow, and so begins my journey through Colorado, New Mexico, and the vast expanse of the US-Mexico border.

Waterfall near the source.

My name, Río Grande, is Spanish for "Big River." In Mexico I am called Río Grande del Norte or Río Bravo, meaning "furious" or "agitated." With nineteen pueblos along my banks in New Mexico and other native peoples such as the Kickapoo Tribe farther south, I also have indigenous names in the languages of Keresan, Tewa, Tiwa, and Towa. For centuries it has been an honor to witness their ceremonies and beautiful dances, many in honor of my own life-giving waters.

After leaving the San Luis Valley in southern Colorado, I soon enter the 800-foot-deep Río Grande Gorge, which I have carved through layers of volcanic basalt. Here I speed along until the canyon ends near the town of Taos. Throughout northern New Mexico and even farther south, my water feeds a historical system of approximately eight hundred community ditches called acequias, which are recognized under New Mexico law as political subdivisions of the state. These small canals are not simply beneficial to the farmers allotted a specific amount of my flow for their fields; they also provide numerous benefits for the environment because water seepage helps replenish shallow groundwater and sustains rich riparian ecosystems beyond my own natural floodplain. With the growing climate crisis, however, sections of my body frequently dry up, and so do the acequias, drastically endangering this timeworn system.

(above left) Rafters paddling around an obstacle course of boulders.

(above) On maps, most rivers are depicted as blue, but the Río Grande is sometimes a muddy brown because of sediment from upstream.

(left) The Río Grande Gorge as seen from a steel bridge that rises six hundred feet above the river.

Shortly before reaching Albuquerque, I pass three handwoven structures on my right bank, which are wooden chairs with arches of riparian plants, providing a respite from hectic urban life. In one of these sculptures, constructed of desert willow, a man sits calmly, watching me and listening carefully as I float by.

Farther downstream, I pass through the shade and dappled sunlight of a long, narrow forest of Río Grande cottonwoods (Populus wislizeni), known locally as the "bosque." This unparalleled ecosystem is home to a huge variety of water-loving plants and countless creatures, from gopher snakes to great horned owls, from porcupines to crustaceans. This almost 100-mile-long riparian forest is the result of human interaction with my natural floodplain. Sadly, the combined effects of steady urbanization, the increased diversion of my water for agricultural and municipal use, the constricting nature of flood control and reservoir infrastructure, and the frequency of drought resulting from a warming climate have contributed to a decrease in water for the thirsty bosque.

Even so, white tufts of cottonwood seeds sail on my liquid surface every May and are carried far and wide by the wind. I have even seen cottonwood seeds embedded in huge books of ice, forming a riparian text. The artist who created these ephemeral sculptures hiked upon and researched glaciers that are diminishing worldwide because of climate disruption, which these hand-carved Ice Books help make visible. She knows the importance to my riparian zone of plants that sequester carbon, mitigate floods and drought, pollinate other plants, disperse seeds, foster soil regeneration and preservation, act as filters for pollutants and debris, supply leaf litter for food and habitat, slow erosion and hold my banks in place, promote aesthetic pleasure, and provide shelter and shade for riverside organisms, including humans. I have carried other hand-carved Ice Book sculptures by the same artist, embedded with seed paragraphs of mountain mahogany, desert willow, and Indian ricegrass, and I know hundreds of hands that helped to launch these time-based capsules upon my surface to call attention to important issues of river restoration.

At times some of my segments dry up entirely now, nothing left but a river of sand. Even in high-flow years, such as 2023 when above-average snowfall swelled my banks and caused flooding in some regions, I soon return to dry conditions. Historically, it was rare that my riverbed would go dry, but currently it happens almost annually in numerous sections along

Writer Dahr Jamail sits within *Contemplation Station II: Desert Willow*, a 2019 sculpture by the author.

USA AND MEXICO 131

Tome II at dusk on the banks of the Río Grande in Albuquerque, New Mexico, with riparian paragraphs of cottonwood seeds (*Populus wislizeni*). The hand-carved 250-pound Ice Book was made in 2009 by the author.

my course—and my voice goes silent. In addition to climate disruption, my water is overappropriated, meaning that there are more water users than there is water in my channel. Decades ago (in 1938) an intricate agreement was signed to facilitate sharing my annual flow among the states I pass through on my way to the sea. The Rio Grande Compact remains in effect today, with a series of gauging stations to monitor flow amounts, governing the division of my water and using a system of debits and credits to smooth my often-sizable fluctuations. A series of legal cases have addressed New Mexico's water obligations to Texas, including one settled in 2023. The United States and Mexico share my water with treaty agreements administered by the International Boundary and Water Commission. It is as if the

only legally sanctioned uses of water are consumption by various groups of human beings. Alas, such important pieces of paper tend to overlook the fact that I am a living being, with needs of my own that must be accommodated if I am to flow so far and serve so many.

One of my companion creatures, an endangered species named the Rio Grande silvery minnow (Hybognathus amarus), has enabled my streambed to retain a small amount of water thanks to flows allocated by agencies such as the Middle Rio Grande Conservancy District and the US Fish and Wildlife Service. Survival of the minnows depends on my having water, and thus our fates are intertwined. Once, the minnow was abundant along a thousand-mile stretch; now it is confined to a reach of only about seventy miles. A collaborative Silvery Minnow Recovery Program has been under way for over two decades at facilities like the Albuquerque BioPark where eggs are collected and raised in tanks. The small fry are then tagged for monitoring and released back into their native habitat—me!

(left) Dry riverbed near Socorro, New Mexico.

(above) *River Reciprocity*, a 1996 foldout book by the author with a poem about loss of habitat for the silvery minnow and a print of the tiny fish on the cover.

The author wearing *Río Grande Repository, Source to Sea*, a sculpture she made between 1995 and 2000, beside the *río*.

Federal, state, and local water "managers" determine my fate. My natural wild path is blocked by eight dams in New Mexico, plus others along the Texas-Mexico border, including Amistad and Falcon Dams, where my waters are often referred to as being "dead" because my water level is so low and I am so stagnant. I have been straightened to hasten floods off my banks, reducing my length by about thirty miles and leaving almost no meanders. I am confined to an engineered concrete channel at El Paso. All my water "belongs" to humans—to farmers, cities, tribes, and other water rights holders, but not to me! Like the minnow, I am endangered. In 2018, the World Wildlife Fund flagged 1,200 miles of my ancient course along the US-Mexico border because of risks to river access, wildlife habitat, and migratory corridors. Along the border wall, the Department of Homeland Security has often waived environmental laws designed to protect me. My lower reach supports a binational economy of oranges, tangerines, lemons, and grapefruit. Many tourists come to see my immense variety of wildlife, including hundreds of species of birds, butterflies, the Texas tortoise, peregrine falcon, javelina, and ocelot. I also flow through beautiful Big Bend National Park, Santa Ana National Wildlife Refuge, and Lower Rio Grande Valley National Wildlife Refuge plus several state parks and conservation areas on my Mexican side.

The same artist I have gotten to know so well over the last three decades once created a five-year project called A Gathering of Waters: The Río Grande, Source to Sea (1995–2000), which connected diverse communities along my entire length, allowing hundreds of participants to put a small amount of my water into the River Vessel Canteen, write in the Logbook, and pass both these items downstream to another person. This was not about theorizing in a classroom or boardroom, but rather about being physically present with me and interacting with someone else downstream, thereby forming a kind of human river that brought awareness to my ongoing plight. Lasting personal connections resulted from these interactions, and bonds were formed between people who might not have met otherwise. An archive of this project, Río Grande Repository, Source to Sea, in the collection of the New Mexico Museum of Art, is a sculptural backpack containing the Canteen, Logbook, scientific data, water analysis, hydrographs, art objects, a foldout book, photographs, and maps.

My artist friend has traveled my entire length (twice!), and she often shares stories with me about some of her favorite places south of Albuquerque, such as the Bosque del Apache National Wildlife Refuge in San Antonio,

New Mexico, that was established in 1939 as a critical stopover location for migrating waterfowl, especially cranes, geese, and ducks.

At El Paso/Ciudad Juárez, I am temporarily confined within a concrete channel. I'm not required to show a passport, and no one asks my immigration status, so I keep flowing through a vast desert expanse of agave, ocotillo, yucca, sweet-smelling yellow-flowered acacia, salt cedar, and desert willow. The small white butts of pronghorn bound through the brush alongside me, and red-winged blackbirds fill the hot air with song.

So much water is withdrawn from me upstream that I have lost my channel to salty silts and monotypic stands of tamarisk (Tamarix sp.), also known as salt cedar. At Presidio, my muddy hues are joined by the green waters of the Río Conchos, arriving from Mexico to provide a huge percentage of the water from here to the gulf. On a map you would not know that the location where this Mexican río arrives is behind a levee in fields of onion, alfalfa, and melon.

Closer to Big Bend National Park, the former ghost town of Terlingua is headquarters for the Far Flung Adventures rafting guides. When my water is too low for boating, I can hear rafters and musicians singing folk songs and narrative ballads called corridos, accompanied by guitar, accordion, and

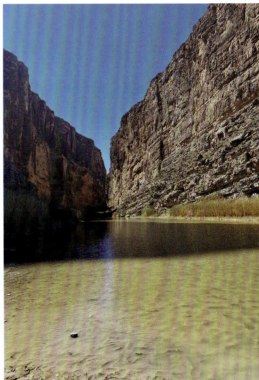

(below left) Migratory birds at Bosque del Apache National Wildlife Refuge. Photo by Derek Irland.

(below right) Santa Elena Canyon, Big Bend National Park. Photo by Jim Fisher.

USA AND MEXICO 135

Boca Chica. Some years river water flows into the Gulf of Mexico, and other years the mouth of the river goes dry when the water no longer makes it all the way to the gulf.

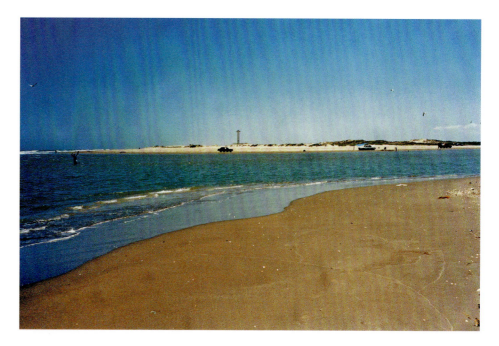

a one-string washtub bass. And there is always music at night from around the campfires of visitors to Big Bend. Their songs echo and reecho off the 1,200-foot-high stone bluffs of Santa Elena Canyon.

More miles downstream, I flow under a high bridge near my confluence with the Pecos River. An official-looking sign warns, "No diving from bridge." Indeed, when my water is low, anyone inclined to jump would end

up planted in the sticky mud. From Del Rio to Laredo, my flow is blocked by the massive Amistad Dam, and I am heavily patrolled, as I am everywhere along this border region. On a high escarpment nearby, the movie *Like Water for Chocolate* was filmed. Nearing Eagle Pass, I greet the traditional Kickapoo Tribe of Texas. This is one of three federally recognized tribes of Kickapoo people, who speak an Algonquian language and had an enrolled Texas member population of around 1,095 in 2023.

In Laredo, some of my loving constituents have built the Rio Grande International Study Center to learn and disseminate information about me. Their mission is "to preserve and protect the Río Grande-Río Bravo, its watershed and environment, through awareness, advocacy, research, education, stewardship and bi-national collaboration for the benefit of present and future generations." I am so grateful for their cross-border projects that help raise awareness of shared cultural and environmental issues through workshops and creative actions.

Soon, it's a delight to reach Los Ebanos, home of the only remaining hand-pulled ferry along my entire length. Automobiles line up on both sides of this fluid international border, and three vehicles at a time are driven up onto the ferry's deck. Once the metal gangplank is raised, six strong people rhythmically pull the boat along a worn yellow two-inch rope strung across the two hundred yards between my banks. Tex-Mex music blares from their old radio, and eventually the ferry reaches the shore at Gustavo Díaz Ordaz, Tamaulipas, where the current freight is offloaded and another three vehicles, plus any walk-on passengers, board for the return trip to the US side.

It's not much farther now. The towns of Brownsville and Matamoros slide by, and finally my goal is in sight, the Gulf of Mexico at Boca Chica. Sometimes, I contain sufficient flow to reach saltwater, but these days it is frequently a struggle just to come close. No more is this a wild and secluded beach. In recent years the arrival of SpaceX and its host of giant rockets has drastically altered the peace here. Impacts from the thunderous launches deposit pulverized concrete into my waters and disrupt delicate marine sanctuaries nearby.

But this is my destination, and once my tired water mingles with the salty gulf, I forget about the problems and changes I have encountered along the way. What is left of me evaporates to the ethereal clouds. Eventually, those clouds will grow heavy with moisture, and snow will fall on the Colorado high country. The snow will melt into rivulets. The rivulets will become creeks, where I will begin again this journey as the Río Grande. And my story continues.

ACKNOWLEDGMENTS

A partial list of scientists with whom I have collaborated and to whom I owe a huge debt of gratitude for their assistance and feedback in creating these essays includes the following: Jesse Barham, restoration biology (Nisqually Indian Tribe, Washington); Dr. Robert Brecha, physics and electro-optics (Potsdam Institute for Climate Impact Research) and head of sustainability (University of Dayton, Ohio); Dr. Michael Campana, hydrology and water resources engineering (department chair, Hydrology, Oregon State University); Dr. Dylan Fischer, ecosystem ecology (Evergreen State College, Washington); Dr. Carri Leroy, freshwater ecology and invertebrate community ecology (Evergreen State College, Washington); Wendy Pabich, environmental science and water research (Idaho); Dr. Nico Zegre, watershed hydrology (Division of Forestry and Natural Resources, University of West Virginia); Dr. Eric Sam Loker, schistosomiasis parasitology (former chair, Biology Department, University of New Mexico); Dr. Colden Baxter, ecology (Idaho State University); Prem Buddha and Dr. Ramesh Devokta, epidemiology and parasitology (Kathmandu, Nepal); Dr. Shawn Kaihekulani Yamauchi Lum (Asian School of the Environment, Nanyang Technological University, Singapore); Yap Wai Kit (Public Utilities Board, National Water Agency, Singapore); Dr. Kira Alexandra Rose (School of Humanities, Nanyang Technological University, Singapore); Tan Beng Chiak, science teacher and former president of the Jane Goodall Institute (Singapore); Dr. Fei Xue (University of Technology, Beijing, China); Dr. Changwoo Ahn (George Mason University, Fairfax, Virginia), principal investigator for the panel "EcoScience+Art: Interdisciplinary Collaboration between Ecosystem Science and Art to Enhance Ecological Communication and Resilience" at the International Association for Ecology, 2017 (Beijing, China), funded by the National Science Foundation; Dr. Graham Strickert and Dr. Tim Jardine, researchers (School of Environment and Sustainability, University of Saskatchewan, Saskatoon, Saskatchewan, Canada); Dr. Toddi Steelman (executive director, School of Environment and Sustainability, University of Saskatchewan, Saskatoon, Saskatchewan, Canada); Dr. Howard Wheater (Global Institute of Water Security, University of Saskatchewan, Saskatoon, Saskatchewan, Canada); Dr. Clifford Villa, professor (University of New Mexico School of Law) and senior adviser (EPA Office

of Land and Emergency Management); Dr. Mark Stone, civil engineering (University of New Mexico); Dr. Lee Brown (International Water Resources Association); Dr. Greg Cajete (Pueblo of Santa Clara, New Mexico); Michelle Minnis (Natural Resources and Environmental Law program, University of New Mexico School of Law).

A ton of thanks goes out to all the amazing, hardworking river advocates who have provided invaluable assistance: Mike Large, lead park ranger, Zion National Park, Division of Interpretation; Laurie Egan, Coastal Watershed Council, Santa Cruz, California; Phillip Johnson, interpreter, Indian Cultural Program, Yosemite National Park; Shelton Johnson, ranger, Yosemite National Park; Dakota Snider, environmental educator, Yosemite National Park; Holly Purpura, director, Friends of Deckers Creek, West Virginia; Andrew Holcombe and Elizabeth Douglas, French Broad River Academy, Asheville, North Carolina; Matt West, kayaker, Asheville, North Carolina; Andrea Parker, executive director, and Christine Petro, programs and education director, Gowanus Canal Conservancy, Brooklyn, New York; Leslie King, director, River Stewards, Great Miami River, Ohio; Hannah Sanger, manager, Science and Environment Division, city of Pocatello, Idaho; Laura Ahola-Young, Department of Art, Idaho State University; Gary and Karen Carriere, Swampy Cree tribal members, Saskatchewan River Delta advocates, Canada; Manuel Esquer Nieblas, Yaqui tribal member, Mexico; Dr. Janet Oliver and Dr. Stanly Steinberg, Mexico; Dr. Sara Ahmed, director, Living Water Museum, India; Erika Osborne, University of West Virginia; and Ann Friedman, Lucia Harrison, Justin Hall, Laura Lynn, Carmelle Olson, Karissa Carlson, John Montra, Lara Evans, and Marne McArdle, all of whom were helpful in my work along the Nisqually River, Washington State.

These essays would not exist if it had not been for the generous invitation from Sandra Postel, Global Water Policy Project director, to add my voice to National Geographic's *Water Currents* blog. Gracias to Sandra for her preface, and to Lucy Lippard for her foreword.

Appreciation to Meridel Rubenstein and Ben Shedd, Nanyang Technical University, Singapore; Diana Theodores, London; Jo Face, Taos; Steve Harris, executive director, Rio Grande Restoration; and Lisa Robert, former editor, New Mexico Water Dialogue newsletter. To my sister Lynne, for her support in every possible way. And most of all to my son, Derek Irland.

Special gratitude to editor Marguerite Avery, whose patience and foresight brought this book to light.

ABOUT THE AUTHOR

Fulbright Scholar Basia Irland is an artist, author, and activist who creates international large-scale community-based water projects, featured in her books *Water Library* (University of New Mexico Press, 2007) and *Reading the River: The Ecological Activist Art of Basia Irland* (Museum De Domijnen, the Netherlands, 2017). A monograph, *Basia Irland, Repositories: Portable Sculptures for Waterway Journeys*, authored by Patricia Watts, was published in 2023. Irland is professor emerita, Department of Art, University of New Mexico, where she founded the Art and Ecology Program.

Irland's website, basiairland.com, contains extensive documentation of her work, including collaborations with scientists, essays about global waterways written for a National Geographic blog, and images from her large museum retrospective in the Netherlands. She has created worldwide projects including *Waterborne Disease Scrolls*, based on research with epidemiologists in Nepal, Egypt, India, and Ethiopia; *A Gathering of Waters*, which fosters dialogue and connects communities along the entire length of rivers, accompanied by portable *Repositories*, archives of the projects; and *Ice Receding/Books Reseeding*, hand-carved ephemeral Ice Books embedded with native seed texts that are floated down streams to aid riparian restoration and raise awareness about climate disruption. Irland has constructed rainwater harvesting systems and produced documentaries about water.

In 2023 her work was shown in seven exhibitions, including *Going with the Flow: Art, Actions, and Western Waters* at SITE Santa Fe, curated by Lucy Lippard and Brandee Caoba, and she was honored as one of twenty global River Warriors by the Lewis Pugh Foundation. Irland has lectured internationally and was the keynote speaker, along with Amitav Ghosh, for an ecology conference in 2018 at Nanyang Technological University, Singapore. She was invited by the United Nations in France to write a chapter about American rivers for a book, *Water Culture*, published by UNESCO in 2023, and she is a Knowledge Network Expert for the United Nations. In 2021–22, she represented the United States in the Bienal Internacional de Cuenca, Ecuador, curated by Blanca de la Torre. Her projects have been featured in over seventy international publications.

SELECT RÉSUMÉ: BIBLIOGRAPHY, AND PUBLICATIONS

Bibliography

Book (monograph)

2023 *Basia Irland, Repositories: Portable Sculptures for Waterway Journeys.* By Patricia Watts. Santa Fe, New Mexico: ecoartspace Publications.

Books (containing references to Basia's work)

2022 新しいエコロジーとアート──「まごつき期」としての人新世 [Art and the new ecology: The Anthropocene as a "dithering time"]. Edited by Yuko Hasegawa. Tokyo: Ibunsha. Pp. 98–100. In Japanese.

2022 *Contemporary Art and Feminism.* By Jacqueline Millner and Catriona Moore. London: Routledge. Pp. 187–188.

2021 *Count.* By Valerie Martínez. Tucson: University of Arizona Press. Cover image, p. 40.

2020 *Albuquerque Museum Art Collection: Common Ground.* By Josie Lopez, Lacey Chrisco, and Andrew Conners. Santa Fe: Museum of New Mexico Press. Pp. 65, 178.

2019 *Arte con la naturaleza: Acciones artístico-científicas para el siglo XXI* [Art with nature: Artistic-scientific actions for the twenty-first century]. By Carmen Gracia. Valencia: Tirant Humanidades. Pp. 291–300. In Spanish.

2018 *Rivers and Society: Landscapes, Governance and Livelihoods.* Edited by Malcolm Cooper, Abhik Chakraborty, and Shamik Chakraborty. London: Routledge. Pp. 186–193.

2016 *L'eau de l'art contemporain: Une dynamique d'une esthétique écosophique* [Water in contemporary art: A dynamic of ecosophical aesthetics]. By Patrick Marty. Paris: L'Harmattan. Pp. 77–79. In French.

2015 *Art & Science* (2nd ed.). By Eliane Strosberg. New York: Abbeville Press. Pp. 238–239.

2015 *Visualizing Albuquerque: Art of Central New Mexico.* By Joseph Traugott. Albuquerque, New Mexico: Albuquerque Museum. Pp. 146, 150.

2014 *Art & Ecology Now.* By Andrew Brown. London: Thames & Hudson. Pp. 220–221.

2014 *Undermining: A Wild Ride through Land Use, Politics, and Art in the Changing West.* By Lucy R. Lippard. New York: New Press. P. 62.

2010 *Art and Politics Now: Cultural Activism in a Time of Crisis.* By Susan Noyes Platt. New York: Midmarch Arts Press. Pp. 288–290, 297.

2010 *Art + Science Now.* By Stephen Wilson. London: Thames & Hudson. Pp. 42, 66.

2010 *The Book of Symbols: Reflections on Archetypal Images.* Archive for Research in Archetypal Symbolism. Edited by Kathleen Martin. Cologne: Taschen. P. 357.

2010 *The Ethics of Earth Art.* By Amanda Boetzkes. Minneapolis: University of Minnesota Press. Pp. 23, 40–42, 185, 194–196, back cover photo.

2009 *Green Guide for Artists: Nontoxic Recipes, Green Art Ideas, and Resources for the Eco-Conscious Artist.* By Karen Michel. Beverly, Massachusetts: Quarry Books. Pp. 120–123.

2009 *Land/Art New Mexico.* Santa Fe, New Mexico: Radius Books. Pp. 126, 145.

2005 *Performing Nature: Explorations in Ecology and the Arts.* By Gabriella Giannachi and Nigel Stewart. Bern: Peter Lang. Pp. 208–211.

2004 *Ecological Aesthetics: Art in Environmental Design; Theory and Practice.* By Heike Strelow. Basel: Birkhäuser Architecture. P. 197. In German and English.

2003 *Women Artists of the American West.* Edited by Susan R. Ressler. Jefferson, North Carolina: McFarland. Pp. 190–192, 315, image "T" in color plates.

2002 *Ecovention: Current Art to Transform Ecologies.* By Sue Spaid and Amy Lipton. Cincinnati, Ohio: Contemporary Art Center, Ecoartspace, and Greenmuseum.org. Pp. 49–51, 140–141.

Articles and Other Media

2023 "Can Artists Channel the Force of Water?" By Nancy Zastudil. *Hyperallergic,* May 31. https://hyperallergic.com/824143/can-artists-channel-the-force-of-water-site-santa-fe/

2022 "Words on the Edge." Codex Foundation. Poster image.

2021 "Flow and Integration in the River Basin: Interview with Basia Irland." By Olivia Ann Carye Hallstein. *ecoartspace*, November 1. https://ecoartspace.org/Blog/12083152

2021 "New Mexicans Taking Action on Plastic Waste." By Greg Polk. Video documentary (17:17). https://vimeo.com/507294204

2021 "A River Reverie: Basia Irland." By Greg Polk. Video interview (9:33). https://vimeo.com/557778205

2020 "Basia Irland at Axle Contemporary." By Michael Abatemarco. *Pasatiempo*, August 7. https://www.santafenewmexican.com/pasatiempo/art/exhibitionism/basia-irland-at-axle-contemporary/article_842605b6-d0dc-11ea-80e7-a7cc1fd113fe.html

2020 "Lamentation." By WEAD (Women Eco Artists Dialog). *CSPA Quarterly* (Centre for Sustainable Practice in the Arts) 30 (December), cover image, pp. 38–43.

2020 "Pandemic Elegy: Basia Irland." By Pamela Allara, Mark Auslander, and Ellen Schattschneider. *Art beyond Quarantine*, August 8. https://artbeyondquarantine.blogspot.com/2020/08/pandemic-elegy-basia-irland.html

2020 "A Really Smart Project." By Adrian Gomez. *Albuquerque Journal*, August 2.

2020 "When Water Speaks for Itself." By Susan Hoffman Fishman. *Artists and Climate Change*, January 27. https://artistsandclimatechange.com/2020/01/27/when-water-speaks-for-itself/

2020 "The Written Image: Ice Receding/Books Reseeding." By Emma Komlos-Hrobsky. *Poets and Writers*, March/April. https://www.pw.org/content/the_written_image_ice_recedingbooks_reseeding

2019 "Artysta naturę ratuje" [The artist saves nature]. By Piotr Sarzyński. *Polityka*, March 26, pp. 76–79. In Polish; original title from print version of article is "Szerokie eko" [Wide eco]. https://www.polityka.pl/tygodnikpolityka/kultura/1786964,1,artysta-nature-ratuje.read

2018 "In the Midst of Worldwide Water Scarcity, an Artist Reminds Us, 'We Are Water.'" By Dahr Jamail. *Truthout*, March 19. https://truthout.org/articles/in-the-midst-of-worldwide-water-scarcity-an-artist-reminds-us-we-are-water/

2018 "Reading the River." By Richard Bright. *Interalia Magazine*, September. https://www.interaliamag.org/interviews/basia-irland/

2018 "Reading the River: Basia Irland; Artist, Ecologist, Activist." By Karen Thomas. *The Environment: The Magazine for the Chartered Institution of Water and Environmental Management*, October.

2017 "Basia Irland ve uluslararası su sorunları" [Basia Irland and international water issues]. By Ahunur Özkarahan. *Yeşil Gazete*, September 2. In Turkish. https://yesilgazete.org/basia-irland-ve-uluslararasi-su-sorunlari-ahunur-ozkarahan/

2016 "Climate Storytelling." By Karen Olsen. *Public Art Review* 27, no. 1, issue 54 (Spring/Summer), p. 49.

2015 "Basia Irland Reading the River: Het belang van water voor het leven op deze planeet" [The importance of water for life on this planet]. *UIT Magazine*, December. In Dutch.

2015 "IJsboeken voor de natuur" [Ice books on nature]. By Job Tiems. *Dagblad De Limburger*, September 5. In Dutch.

2015 "These Ice Books Transport Seeds and Reforest Lands." By María González de Léon. *Faena Aleph*, February 3. https://www.faena.com/aleph/these-ice-books-transport-seeds-and-reforest-lands/

2015 "Wondere wereld van water en boeken" [Wonderful world of water and books]. By Marjolein Welling. *Dagblad De Limburger*, December 7. In Dutch.

2014 "Art Can Show Us What's Wrong with Our Planet." By Becca Cudmore. *Nautilus*, December 8. https://nautil.us/art-can-show-us-whats-wrong-with-our-planet-235204/

2014 "¡COLORES! Basia Irland." *¡COLORES!* (TV show), New Mexico PBS, June 13.

2013 "Basia Irland's Gathering of Waters: An Invitation to Know Your River." By Mark B. Feldman. *Sculpture* 32, no. 7 (September), pp. 56–61.

2013 "Books of Ice: Sculptures by Basia Irland." By Kathleen Dean Moore. *Orion Magazine*, March/April, pp. 52–59. https://orionmagazine.org/article/books-of-ice/

2011 "A New Water Ethic." By Merrell-Ann Phare and Robert Sandford. *Alternatives Journal* 37.1, January/February.

2008 "The Autobiography of H2O, as Told to Basia Irland." By Miriam Sagan. *Santa Fe New Mexican*, January 18–24.

2008 "Basia Irland, Eco-Artist." By Amanda Sutton. *Albuquerque: The Magazine* 5, no. 3 (July), pp. 160–162.

2007 "A Gathering of Waters, Boulder Creek: Continental Divide to Confluence, by Basia Irland." *THE Magazine*, September, p. 43.

2005 "Water Library." By Valerie Roybal. *Quantum 2005: Research, Scholarship and Creative Works at the University of New Mexico*, pp. 26–30.

2004 "Basia Irland's Work Is Based on Water." *Indian Express*, December 22.

2004 "Gujarat Needs a Basia Irland." *People's Science Institute Magazine*, Ahmedabad, India (December). In Gujarati.

2004 "Speaking an Ecological Language." By Jhalak Bhavsar. *Times of India*, December 23.

2002 "A Water Conservation Masterpiece." By Delaney Hall. *Albuquerque Tribune*, July 24, pp. A1, A4.

2001 "A Confluence of Community: Gathering the Waters of the Rio Grande." By Craig Smith. *Orion Afield* 5 (Winter), pp. 28–30.

2001 "Navigating the Currents." Interview by David Williams. *Performance Research* 6, no. 3, pp. 113–122.

1997 "A Gathering of Waters: Approaching Water Issues through Artful Life." By Valerie Roybal. *Quantum: Research, Scholarship and Creative Works at the University of New Mexico*, Spring.

1996 "Gathering of Waters Draws Attention to the Río Grande." By Evelina Zuni Lucero. *Indian Country Today*, November, pp. 18–25.

1994 "Profile: Artist Basia Irland: A River Runs through Her." By Sharon Niederman. *Quantum: Research, Scholarship and Creative Works at the University of New Mexico*, Spring, pp. 8–10.

1988 "Basia Irland." By Harmony Hammond. *Artspace*, Summer, pp. 12–16.

1985 "Extensions of the Book." *Artweek* 16, no. 27 (August 10).

1983 "Basia Irland at the Centre for Book Arts, New York." By Ross Skoggard. *ArtMagazine*, no. 62 (Spring).

1983 "From Old Manuscripts." By Diana Freedman. *Artspeak* 4, no. 20 (May).

SELECT RÉSUMÉ: BIBLIOGRAPHY AND PUBLICATIONS 147

1981 "Basia Irland." By John Silverstein. *ArtsCanada* 38, no. 2 (July/ August), pp. 37–38.

Group Exhibition Catalogs

2023 *Going with the Flow: Art, Actions, and Western Waters.* By Lucy Lippard and Brandee Caoba. Santa Fe, New Mexico: SITE Santa Fe.

2023 *Think about Water: Rivers.* By Fredericka Foster. Garrison, New York: Garrison Institute.

2020 *Libro de recetas para un planeta otro* [Recipe book for another planet]. By Blanca de la Torre. Cuenca, Ecuador: Bienal de Cuenca. In Spanish.

2018 *HYBRIS: Una posible aproximación ecoestética* [HYBRIS: A possible approach to eco-aesthetics]. By Blanca de la Torre. León, Spain: MUSAC, Museo de Arte Contemporáneo de Castilla y León.

2017 *Becoming Water: Art and Science in Conversation.* By Susan Shantz and Graham Strickert. Saskatoon, Saskatchewan, Canada: University of Saskatchewan.

2017 *The Source: Rethinking Water through Contemporary Art.* Curated by Stuart Reid, edited by Stuart Ross. St. Catharines, Ontario: Rodman Hall Art Centre, Brock University. P. 22.

2016 *Breathing Art: Geumgang Nature Art Biennale 2016.* By the Committee of Geumgang Nature Art Biennale. Gongju, South Korea: 7th Geumgang Nature Art Biennale Committee.

2008 *E. P. A. (Environmental Performance Actions).* New York City: Exit Art.

2007 *Weather Report: Art and Climate Change.* By Lucy R. Lippard. Boulder, Colorado: Boulder Museum of Contemporary Art.

2006 *Contemporary Quarterly.* Vol. 4, *WaterWorks.* By Amy Lipton and Tricia Watts. Napa, California.

1992 *Completing the Circle: Artists' Books on the Environment.* By Betty Bright. Minneapolis: Minnesota Center for Book Arts.

1991 *Books as Art.* Boca Raton, Florida: Boca Raton Museum of Art.

1990 *A Natural Order: The Experience of Landscape in Contemporary Sculpture.* By Barbara J. Bloemink. Yonkers, New York: Hudson River Museum.

1987 *Books as Objects.* Syracuse, New York: Lowe Art Gallery, College of Visual and Performing Arts, Syracuse University.

1986 *Beyond Words: The Art of the Book.* By David J. Henry. Rochester, New York: Memorial Art Gallery of the University of Rochester.

1984 *Cover to Cover: Experimental Bookworks.* Santa Fe: Museum of Fine Arts, Museum of New Mexico.

1983 *One Cubic Foot.* By Norman Colp. New York City: Metropolitan Museum of Art, Thomas J. Watson Library, and Center for Book Arts.

1981 *Sky Art Conference '81.* By Otto Piene. Cambridge, Massachusetts: Massachusetts Institute of Technology, Center for Advanced Visual Studies.

Author Publications

Books

2017 *Reading the River: The Ecological Activist Art of Basia Irland.* Edited by Museum De Domijnen and Basia Irland. Sittard, the Netherlands: Museum De Domijnen.

2007 *Water Library.* Albuquerque: University of New Mexico Press.

Booklet

2001 *Water Library: Chapter One (Inscriptions: Stars, Tides and Ice).* Albuquerque: University of New Mexico Art Museum.

Small Press Books

1996 *River Reciprocity.* Albuquerque, New Mexico: Salient Seedling Press. Foldout book.

1996 *Water Cycle.* Riverdale, Maryland: Pyramid Atlantic Press, and Philadelphia, Pennsylvania: Borowsky Center for Publication Arts, University of the Arts. Funded by the National Endowment for the Arts.

Book Contributions

2023 "Contemplation Station II." In *Dark Mountain: Issue 24—Eight Fires* (Autumn), edited by Anthea Lawson and Steve Wheeler, p. 154. Southwold, United Kingdom: Dark Mountain Project.

2023 "Rivers: An Artist's Perspective." In *River Culture: Life as a Dance to the Rhythm of the Waters*, edited by Karl Matthias Wantzen, pp. 875–901. Paris: UNESCO.

2022 "Ice Receding/Books Reseeding." In *Ecoart in Action: Activities, Case Studies, and Provocations for Classrooms and Communities*, edited by Amara Geffen, Ann Rosenthal, Chris Fremantle, and Aviva Rahmani, pp. 203–208. New York: New Village Press.

2022 "River Repositories." In *Dark Mountain: Issue 22—Ark* (Autumn), edited by Neale Inglenook, Joanna Pocock, and Philip Webb Gregg, pp. 64–69. Southwold, United Kingdom: Dark Mountain Project.

2021 "Cottonwood." In *Embodied Forest*, edited by Patricia Watts, pp. 198–199, 202–203. Santa Fe, New Mexico: ecoartspace.

2021 "Ice Receding/Books Reseeding." In *Dark Mountain: Issue 20—Abyss* (Autumn), edited by Nick Hunt, Joanna Pocock, Tom Smith, and Steve Wheeler, p. 226. Southwold, United Kingdom: Dark Mountain Project.

2020 "Ice Receding/Books Reseeding: An Ephemeral Series of Hand-Carved Ice Books Reseeding Riparian Zones." In *Extraction: Art on the Edge of the Abyss*, edited by Samuel Pelts, pp. 476–481. Berkeley, California: CODEX Foundation.

2017 "Ice Receding/Books Reseeding." In *Downstream: Reimagining Water*, edited by Dorothy Christian and Rita Wong, pp. 181–191. Waterloo, Ontario, Canada: Wilfrid Laurier University Press.

2016 "Eco-Art." In *Keywords for Environmental Studies*, edited by Joni Adamson, William A. Gleason, and David N. Pellow, pp. 60–61. New York: New York University Press.

2016 "Ice Receding/Books Reseeding." In *Elemental: An Arts and Ecology Reader*, edited by James Brady, cover image, pp. 25–39. Manchester, England: Gaia Project Press.

2016 "Ice Receding/Books Reseeding." In *L'art de l'aigua: Aqua et ars in unum miscentur* [The art of water: Water and art mixed into one], edited by Domènec Corbella, pp. 48–53. Barcelona, Spain: Universitat de Barcelona.

2013 "An Ice Book Floats down the Karun River." In *Love and Pomegranates: Artists and Wayfarers on Iran*, edited by Meghan Nuttall Sayres, pp. 211–212. Santa Ana, California: Nortia Press.

2005 "A Concise Glimpse of Water in the History of Photography." In *Water Encyclopedia*, 5 vols., edited by Jay H. Lehr and Jack Keeley, vol. 4, pp. 766–769. Westport, Connecticut: Wiley Press.

River Essays

2015–present "What Rivers Know" essay series. Essays written from 2015 to 2017 were originally posted to National Geographic's blog *Water Currents: Insights into the Freshwater World.*

Articles

2022 "Ice Receding/Books Reseeding." *Public: Arts, Design, Humanities* vol. 7, no. 1. https://public.imaginingamerica.org/blog/article/ice-receding-books-reseeding/

2020 "Apothecary for Creeks and Other Living Beings." *SeedBroadcast agri-Culture Journal: Cultivating Diverse Varieties of Resilience*, no. 15 (Autumn), pp. 40–41, image p. 2.

2007 "River Reciprocity: A Gathering of Waters." *The New Quarterly: Canadian Writers and Writing* 101 (Winter), pp. 38–48.

2003 "Walkerton Life Vest." *The New Quarterly: New Directions in Canadian Writing* 87 (Summer), pp. 33–37, 58–67.

1997 "Running with the Water" and "Corriendo con el agua." *La Corriente*, newsletter of the Río Bravo/Río Grande Sustainable Development Initiative, 5 (July), pp. 3, 11.

1996 "A Gathering of Waters" and "Una coleccíon de las aguas." *La Corriente*, newsletter of the Río Bravo/Río Grande Sustainable Development Initiative, 4 (September), pp. 4, 10.

1996 "Po-weh'-geh, un juntamiento de aguas, a gathering of waters." *Dialogue*, New Mexico Water Dialogue newsletter, 5, no. 1 (March).

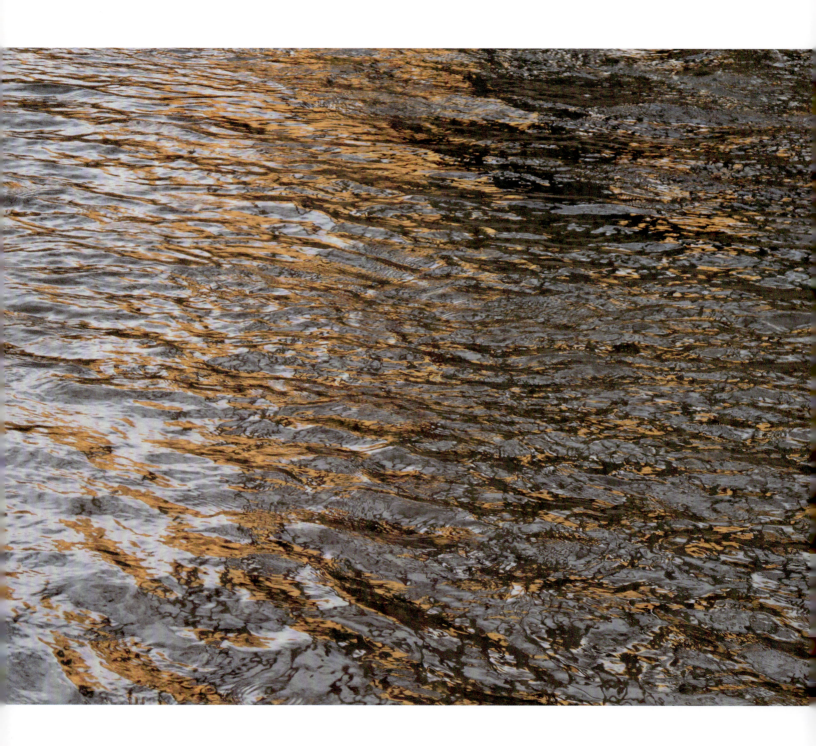

INDEX

The letter *f* following a page locator denotes a figure and the letter *p* denotes a photograph.

acequias, 129
activism, xxiii, 5–6, 34, 37, 50–51, 87
Adams, Eric, 67
Agiqua (French Broad River/Zillicoah/Tahkeeosteh) (Asheville, NC), 56*p*, 57–58, 58–59*p*
agricultural diversions, 33–34, 33*p*
agriculture: acequias used for, 129; Cambodia, 105; Ethiopia, 81–82, 82*p*; mine spill, effects on, 40–41, 43; Narmada River, 85; pollution caused, 5, 115
Ahwahneechee people, 15, 21
Alder Dam, 4, 4*p*
Alexandra Canal, 108*p*, 110
Alkaff Bridge, 113*p*
alluvial deltas. *See* Saskatchewan River Delta
Álvaro Obregón Dam, 33*p*
Amazon, xxii
Amistad Dam, 134, 137
amphibian species, 97*p*
Amstel Brewery, 75
Amstel River (Amsterdam), 74–77*p*, 75–77
Angkor Wat World Heritage Site, 102*p*, 103, 104*p*, 105–106
Animas River, 38*p*, 39–43, 42*p*
aquifers, 53–54, 119
art, ecological, xii–xiii
Art and Ecology program (UNM), xxi
avulsion, 47

Bagmati River (Kathmandu, Nepal), 91–93, 92–93*p*
Bahir Dar (Ethiopia), 79
Bakum, Mexico, 34, 35*p*
Ballengée, Brandon, xii
Banashivalingas, 85
Begaye, Russell, 41

Beijing, map of, 118*p*
Beiyun River, 120
Bhumibol Dam, 97
bicycle travel, 75–76
Big Bend National Park, 134–136
bilharzia (*schistosomiasis*), 79–80, 101
Billy Frank Jr. Nisqually National Wildlife Refuge, 7
bird species: Blue Nile Falls, 82–83; Bosque del Apache National Wildlife Refuge, 135*p*; endangered, 81; Kamo River, 125, 126*p*; Lake Tana, 81, 82*p*; Portneuf River, 28*p*; Río Grande, 131, 134, 134–135; Saskatchewan River Delta, 48, 48*p*; Seine, 77*p*; Singapore River, 114; Yosemite National Park, 20; Zion National Park, 24
Blue Nile Falls (Tis Ab☐y), 82, 82*p*
Blue Nile near Lake Tana and Bahir Dar (Ethiopia), 79–83
Boldt Decision, 5
Bosque del Apache National Wildlife Refuge, 134–135, 135*p*
bosque ecosystem, 131
Brahma, Lord, 85
Breen, Adam van, 75
breweries, 57, 75
Bridalveil Creek, 20*p*
Bridalveil Falls (Po-hó-no), 14*p*
Brossel, Colombe, 73
bumboats (*tongkangs*), 115

caddis fly larvae, 63, 63*p*
Carriere, Gary, 50, 50*p*
Carriere, Karen, 50–51, 50*p*
Castle Rock State Park, 9
celebrations, 94*p*, 95–96, 95*p*
Cement Creek, 39
cháobái hé (Chaobai River) (Beijing, China), 119–123
Chaobai River (cháobái hé) (Beijing, China), 119–123

Chao Phraya River (Maenam Chao Phraya) (Bangkok, Thailand), 97, 98*p*, 99–101, 99*p*, 117
Charlie, Perry, 41
Cherokee, 57
Chief, Karletta, 40–41
Chinook, 5, 7
cholera, 73
Chong Fah Cheong, 117*p*
Cloud Forest biodome, 110*p*
coal mining, 61–62
Coastal Watershed Council (CWC), 11
coho salmon, 5, 11
colonialism, European, 9, 35, 65
Colorado Plateau Mojave Desert ecosystem, 23
Conciergerie, 70–71, 71*p*
Contemplation Station II: Desert Willow (Irland), 131, 131*p*
cottonwoods (*Populus wislizeni*), 131, 132*p*
craft breweries, 57
crocodiles, 86
Cumberland House (Waskahikanihk), Saskatchewan, Canada, 47*p*, 50–51
Cumberland Lake, 47–48
cyanobacteria, 25

dams: alternatives to, 88–89; ecosystems, effect on, 48; hydroelectric, 4–5; to improve water quality, 93; Narmada River, 86–88, 87*p*, 88*p*; people displaced, 86–87, 120; Río Grande, 134, 137; rivers, effects on, 4
Deckers Creek (WV), 60*p*, 61–63, 61–63*p*
Deep Tunnel Sewerage System, 112–113, 112*p*
desalination, 111–113
Devil's Elbow, 16*p*
Dhap Dam project, 93
dikes, 75
Diné (Navajo Nation), 40–41, 43

153

diseases, waterborne, 24, 28, 58p, 79–80, 91, 101
displacement, 86–87, 117, 120
diversions: agricultural, 33–34, 33p; manufacturing, 35–36; Río Grande, 131; Seine, 70, 70f; Yaqui River, 33–34, 33p
drinking water: Chaobai River, 119; contaminated, 92; lack and costs of, 34, 35p, 36; mine spill, effects on, 41; reclaimed, 112, 112p, 114, 120
drinking water education, 10p

Eagle River (Colorado), xii, 44p, 45
earthquakes, 91
E. B. Campbell Dam, 48, 48p
eco-art, xii–xiii
eels, 97p
El Capitan (Tu-tok-a-nú-la), 15, 16p, 17
El Río de Nuestra Señora de la Merced (Merced River/Wa-ka-la)) (Yosemite National Park), 14p, 15–21, 18p, 20p
Elwha River (Washington State), xxii
endangered species, 11, 133, 133p
environmental disasters, 38p, 39–43
Escherichia coli (E. coli), 24, 28, 58p
Evergreen State College, 6–7

Falcon Dam, 134
farming. See agriculture
fecal coliform, 5, 62, 73, 91–92
ferry crossings, 137
First Generation (sculpture), 117p
fishery management, 5
fishing, revitalizing, 63
fishing rights, Indigenous peoples, 5–6
fish species: Chao Phraya River, 100p; endangered, 11–12, 23, 133; North Fork Virgin River, 23; Ping River, 97p; Río Grande, 133, 133p; Santa Cruz River, 11–12; Saskatchewan River Delta, 51
Five Rivers Fountain of Lights (Dayton, OH), 52p, 53–54, 54p, 55p
flooding: dikes for, 75; Merced River, 17, 19; North Fork Virgin River, 24; Portneuf River, 27; San Lorenzo River, 9, 11; Seine, 70–73, 71p; Siem Reap River, 103; sponging to limit, 123

forests, riparian, 131
Fort Lewis, 6
Frank, Willy Jr. (Kluck-et-sah), 5
Frank, Willy Sr. (Qu-lash-qud), 5–6
Frank's Landing, 5
French Broad River (Agiqua/Zillicoah/ Tahkeeosteh) (Asheville, NC), 56p, 57–58, 58–59p
French Broad River Academy, 58, 59p
Friends of Deckers Creek (FODC), 62–63
full moon ceremony, xii
funeral pyres, 90p, 91

Ganges River, 85, 91
Gardens by the Bay, 110–111, 110p, 111p
A Gathering of Waters: The Río Grande, Source to Sea project (Irland), 134
Gila River (New Mexico), xii
glacier melt, 2p
Goddess of Water (Phra Mae Khongkha), 95
Gold King Mine spill, 39–41, 43
gold mining, 17
Gowanus Canal (Brooklyn, NY), 64p, 65–67, 66–67p
A Great Emporium (sculpture), 117p
Great Miami River, 53–54
green infrastructure, 123
Gulf of Mexico, 137
Gustavo Díaz Ordaz, Tamaulipas, 137

Haaland, Debra, xxiii
Half Dome (Tis-sé-yak), 15, 16p
heavy metals, 45, 48–49, 101
Henry IV of France, 73
Houhai Lake, 120, 121f, 122p
Huangchenggen Park, 123
human remains, 66, 73, 91
hydroelectric power, 4–5, 119
hydrologic cycle, xix

Ice Books, 131, 132p
IJ, 75
Imadegawa-dori Bridge, 127
Imperial Waterway, 120, 120p
inchworm story, 15, 17
Independencia Aqueduct, 35–36

Indigenous peoples: activism, xxiii, 5–6, 34, 50–51; colonialism, effects on, 9, 35; culture, 15; fishing rights, 5–6; threatened, destroyed, pushed out, 17, 35–37
invasive species, 49, 65, 100–101, 101p
Irland, Basia: about the author, xi–xvi, xx–xxiii, 137; Contemplation Station II: Desert Willow, 131, 131p; A Gathering of Waters: The Río Grande, Source to Sea project, 134; Río Grande Repository, Source to Sea, 134, 134p; River Reciprocity, 133p; Tome II, 132p
Irland, Derek, xx

Jamail, Dahr, 131p
Jardine, Tim, 48
Jiak Batwe (Yaqui River/Rio Yaqui), xii, 32p, 33–37, 34p, 36p
Joan of Arc, 73
Johanson, Patricia, xii
Joint Base Lewis-McChord, 6

Kamo-gawa (Kamo River) (Kyoto, Japan), xii, 124–127p, 125–127
Kamo River (Kamo-gawa) (Kyoto, Japan), xii, 124–127p, 125–127
Kathmandu School of Music, 93
Khmer Rouge, 105–106
Khom Loi (paper lanterns), 96
Kickapoo Tribe, 137
Kisiskâciwani-sîpiy (Saskatchewan River), 46p, 47
Kiyomizu-dera Temple (Pure Water Temple), 126, 127p
Kluck-et-sah (Frank, Willy Jr.), 5
Koh, Malcolm, 116p
kolek (sampans), 115
krathong, 94p, 95–97, 95p, 96p
Kunming Lake, 121p

lagoons, 12
La Grande Dam, 4
Lake Tana, 78p, 79–82, 80–82p
land mines, 106–107
lanterns, paper (Khom Loi), 96
lingam stones, 85, 85p
Lippard, Lucy R., xiii

154 INDEX

lithium deposits, 37
litter hovels, 24–25, 25*p*
Los Ebanos, 137
Loy Krathong festival, 95–97

Maenam Chao Phraya (Chao Phraya River) (Bangkok, Thailand), 97, 98*p*, 99–101, 99*p*, 117
Maenam Ping (Chiang Mai, Thailand), xii
Maenam Ping (Ping River) (Chiang Mai, Thailand), 94–97*p*, 95–97
Magere Brug, 76, 76*p*
Malayan water monitor (*Varanus salvator*), 115*p*
mammal species: Blue Nile Falls, 82*p*, 83; Narmada River, 85–86; Portneuf River, 28*p*; Río Grande, 131, 134; Saskatchewan River Delta, 51; Singapore River, 114; Yosemite National Park, 20; Zion National Park, 24, 25*p*
manufacturing, water for, 35–36
Marie Antoinette, 71
Marina Barrage, 109*p*, 110, 111*p*
Marina Bay Sands, 111, 111*p*
Marina Reservoir, 110
markets on the river, 81–82, 82*p*, 100, 100*p*
McChord Air Force Base, 6
meerkoet, 77, 77*p*
Merced River (Wa-kal-la/El Río de Nuestra Señora de la Merced) (Yosemite National Park), 14*p*, 15–21, 18*p*, 20*p*
mercury pollution, 48–49
Merlion, 116*p*
Métis, 49–50
Ming Tombs Reservoir, 119, 119*p*
mining: coal, 61–62; drainage pollution, 61–62, 62*p*; gold, 17; heavy metals, 37, 45; silver, 34; Superfund sites, 45; toxic waste discharges, 39–40
Miyun Reservoir, 118*p*, 119, 119*p*, 123
Mondrian, Piet, 75
Monongahela River, 61
Monterey Bay, 9, 12, 12*p*
Mount Rainier (Tacobet), 3*p*, 5*p*
mouths, river, 11–12, 13*p*
Muir, John, 17

Mu-Koon'-Tu-Weap (Zion Canyon/Mukuntuweap), 23, 23*p*
Mukuntuweap (Zion Canyon/Mu-Koon'-Tu-Weap), 23, 23*p*
municipal planning, 73

Nagmati Dam, 93
Narmada Mai (Narmada River/Rewa) (India), 85–89, 86*p*, 88*p*
Narmada Parikrama, 85–86, 86*p*
Narmada River (Narmada Mai/Rewa) (India), 85–89, 86*p*, 88*p*
national parks, the first, 17
National Taps, 112
Navajo Nation (Diné), 40–41, 43
Nehru, Jawaharlal, 87
Nevada Fall, 17
NEWater, 112, 112*p*, 114
New Belgium Brewing Company, 57
Nieblas, Manuel Esquer, 33–34, 34*p*
Nile River, 79
Nisqually Glacier, 3*p*
Nisqually River (Washington State), xv, 3–7
Nisqually River Council, 5
Nisqually Tribe (Susqually'absh), 5–7
Nisqually Tribe Clear Creek Hatchery, 4
Norodom Sihamoni, King of Cambodia, 106–107
North Fork Virgin River (Zion National Park, UT), xx, 22*p*, 23–25, 24*p*
Northwest Indian Fisheries Commission, 5
Notre-Dame, 70, 70*p*
NUSwan, 109

Ohlones, 9, 9*p*
Ostrander, David, 40
Otowa Waterfall, 126
otters, 114, 114*p*, 115*p*

pain felt by a river: abuse, xi–xii; clogged with human remains, 91; confined to concrete channels, 11, 27, 110, 134, 135; dredging, 117; foul smells, 65, 117; impounded by dams, 4; lack of respect, xi, 27; night soil collections,

113; sediment buildup, 48; Space X launches, 137; stormwater runoff, 27; straightening, 9, 65–66, 127, 134; struggle to breathe, 66–67, 103, 105; toxic waste discharges, 39–40; trash dumped, 28; wastewater treatment discharge, 27–28; witness to war, 105–107. *See also* pollution
Paiute, xii, 15
Parc Rives de Seine (Park Banks of the Seine), 69
Paris Sewers Museum, 72, 72*p*
Park Banks of the Seine (Parc Rives de Seine), 69
Parker, Andrea, 67
Pashupatinath Temple, 91
pemmican (pimîhkân), 50
pesticide runoff, 34, 34*p*
Phra Mae Khongkha (Goddess of Water), 95
pilgrms, Narmada River, 85–86, 86*p*
Ping River (Maenam Ping) (Chiang Mai, Thailand), 94–97*p*, 95–97
plant species: Huangchenggen Park, 123; Río Grande, 135
Plastic Whale, 77
pleasures felt by a river: celebrations, 11, 95–96; ceremonies and dances witnessed, 7, 129; children, 7, 54, 55*p*, 96, 127; favorite words, 15; festivals, 95–97; laughter and conversations, 127; music of campers and rafters, 135–136; otters, 114; personal connections and bonds, 134; smells, xxiii, 20, 135
Po-hó-no (Bridalveil Falls), 14*p*
pollution: agricultural, 5, 115; coal tar, 64*p*, 65–67; Eagle Mine Superfund site, 45; fecal coliform bacteria, 5, 62, 73, 91–92; French Broad River, 58, 58*p*; Gold King Mine spill, 38*p*, 39–43; heavy metals, 40; human remains, 66, 73, 91; industrialization causing, 92; mine drainage, 61–62, 62*p*; plastic, 77; sewage, 58, 62, 65–67, 72–73, 91–93; Styrofoam, 96–97; toxic soaps, 62; trash, 75–77, 103; urbanization and, 92–93

INDEX 155

pollution education, 113–114, 113*p*
Pol Pot, 105–106
Portneuf River (Pocatello, ID), 26*p*, 27–31, 30*p*
Portneuf Valley, 27
Postel, Sandra, xiii, xvi, xxii
Puget Sound, 7
Pure Water Temple (Kiyomizu-dera Temple), 126, 127*p*
purification, water for, xii

Qianhai Lake, 120, 121*f*, 122*p*
Qu-lash-qud (Frank, Willy Sr.), 5–6

Raffles, Thomas Stamford, 115*p*
rainwater storage, 89
ranching, mine spill, effects on, 40–41
Ratchawararam Ratchawaramahawihan (Wat Arun), 100*p*
rats, 72
recreation: French Broad River, 57–58; Gowanus Canal, 67; Marina Barrage, 4, 110; Qianhai Lake, 122*p*, 123; swimming, 122*p*, 123; Yosemite National Park, 21
recycling: plastic, 77; tires, Ethiopia, 81, 82*p*; water hyacinth for, 101
Rembrandt van Rijn, 75
reptile species: Narmada River, 86; Ping River, 97; Rio Grande, 131; Singapore River, 114, 115*p*
resource, river as, xxii, 4
revitalization: Eagle Mine Superfund site, 45; Friends of Deckers Creek (FODC), 62–63; Gowanus Canal, 66–67; River-Link, 58; Seine, 77; Singapore River, 117
Rewa (Narmada River/Narmada Mai) (India), 85–89, 86*p*, 88*p*
Richard Mine, 61–63, 62*p*
Río Bravo (Rio Grande/Rio Grande del Norte), 128–130*p*, 129–137, 132–135*p*
Río Conchos, 135
Río Grande (Río Grande del Norte/Río Bravo), 128–130*p*, 129–137, 132–135*p*
Rio Grande Compact, 132*p*
Río Grande del Norte (Río Grande/Río Bravo), 128–130*p*, 129–137, 132–135*p*

Río Grande Gorge, 129, 130
Río Grande Repository, Source to Sea (Irland), 134, 134*p*
Río Yaqui (Yaqui River/Jíak Batwe), xii, 32*p*, 33–37, 34*p*, 36*p*
RiverLink, 58
River Reciprocity (Irland), 133*p*
rivers: being present with, xx–xxi, xxiii; dead, 134; desires of, 4–5; dry, 131–133, 133*p*, 136*p*; endangered, 129, 134; ferry crossings, 137; human bodies compared, xix–xx; navigable, 6; as resources, xxii, 4; rights of, xv–xvi, xx–xxi; as source of spiritual salvation, 91
rivers, characteristics of: avulsion, 47; carving the land, 15, 23, 129; common, xi; dendritic patterns, xxiii, 47; meanders, 9, 27, 30*p*, 103, 116*p*; sustance provided, 23, 24, 114. *See also* flooding
river spirits, 95
River Stewards, Great Miami River, 54, 54*p*
Romero, Mario Luna, 36–37

Salish Sea, 7
salmon, 5–7, 11
salvation, 91
sampans (*kolek*), 115
sanitation issues, 34, 34*p*, 91–92, 93*p*. *See also* pollution
San Juan River, 39–43, 42*p*
San Lorenzo River (Santa Cruz, CA), 8*p*, 9–12, 12*p*, 13*p*
Santa Cruz Riverwalk, 11
Santa Elena Canyon, 135*p*
Sardar Sarovar Dam, 86–87, 87*p*
Saskatchewan River (Kisiskâciwani-sîpiy), 46*p*, 47, 47*f*
Saskatchewan River Delta, 47–51, 47*p*
schistosomiasis (*bilharzia*), 79–80, 101
sediment buildup, 4, 9, 48, 99
Seine (la Seine) (Paris, France), 68–72*p*, 69–73
Sequoia National Park, 17
sewage: Bagmati River, 91–93; Deckers Creek, 62; French Broad River, 58; Gowanus Canal, 65–67; Seine, 72–73

sewage treatment, xix, 101, 112, 112*p*
Shimogamo Shrine, 125–126
Shinto ritual, cloth-wrapped white rocks, xii
Shisanling Reservoir, 119
Shiva, Lord, 85
Shoshone-Bannock Tribes, 27
Siem Reap River (Cambodia), 103–107, 103*p*
Sierra Nevada Brewing Company, 57
silver mining, 34
Silverton, Colorado, 41
Silvery Minnow Recovery Program, 133, 133*p*
Singapore River (Sungei Singapura), 108*p*, 109–117, 110*f*, 116*p*
Singapore River Festival, 114*p*
Singh, Rajendra, 88–89
sins absolved, 85
sky lanterns (Khom Loi), 96
Snake River, 27
Snow, John, 73
snowmaking, 45
Southern Sierra Miwok, 15
South-to-North Water Transfer Project, 120
Space X, 137
spirituality: ceremony, 92*p*; cloth-wrapped white rocks, xii, 126, 126*p*; Diné, 40; funeral pyres, Bagmati River, 90*p*, 91; Loy Krathong festival, 97; Otowa Waterfall waters, 126; pilgrms, Narmada River, 85–86, 86*p*
spiritual salvation, 91
Sponge cities, 123
starry flounder, 12
steelhead, 5–7, 11
stormwater runoff, 123
Strait of Georgia, 7
Strait of Juan de Fuca, 7
Strickert, Graham, 51
sturgeon, 51
Styrofoam, 96–97
Summer Palace, bridge at the, 121*p*
Sungei Singapura (Singapore River), 108*p*, 109–117, 110*f*, 116*p*

156 INDEX

Superfund sites: Eagle River, xii, 45; Gowanus Canal, 66–67
Supertrees, 110–111, 111p
Susqually'absh (Nisqually Tribe), 5–7
Swampy Cree, 49–50
Swanbot, 109
swim, requirement to learn to, 75

Tacobet (Mount Rainier), 5p
Tahkeeosteh (French Broad River/Zilicoah/Agiqua) (Asheville, NC), 56p, 57–58, 58–59p
Takano River, xii
Te Awa Tupua (Whanganui River) (New Zealand), xx
Te Awa Tupua Act, xx
Texas tortoise, 134
Thidet, Stéphane, 70
tidewater goby, 12
tire recycling, 81, 82p
Tis Ab☐y (Blue Nile Falls), 82, 82p
Tis-sé-yak (Half Dome), 15, 16p
Tome II (Irland), 132p
tongkangs (bumboats), 115
Tonlé Sap, 106p
top smelt, 12
Tórim, Mexico, 33p, 34
trade rivers, 115
transportation rivers, 99, 120
trash, dumping of, 75–77
trash removal, 116p, 117
tree species: Kamo River, 125; Río Grande, 131, 134, 135; Yosemite National Park, 20–21; Zion National Park, 23–24

Tu-tok-a-nú-la (El Capitan), 15, 16p, 17

Ukeles, Mierle Laderman, xii
United States v. *Washington*, 5
urban design, 123
urbanization, 111, 131

Valencia, Tomás Rojo, 37
Vernal Fall, 17
Villa, Clifford, 41, 43
Virgin River spinedace (*Lepidomeda mollispinis*), 23
Vishnu, 103

Wa He Lut Indian School, 6–7
Wa-kal-la (Merced River/El Río de Nuestra Señora de la Merced) (Yosemite National Park), 14p, 15–21, 18p, 20p
war: Cambodia, 105–107
Waskahikanihk (Cumberland House), Saskatchewan, Canada, 47p, 50–51
wastewater treatment, 73, 101, 112–113, 112p, 120
Wat Arun (Ratchawararam Ratchawaramahawihan), 100p
water: education programs, 93; Hindi words for, written in henna, 89p; imported, 111–113; for purification, xii
water agreements and obligations, 132–133
water filtration, 112–113, 112p
water hyacinth, 100–101, 101p
water purification, plants for, 101
water quality: attempts to improve, 93; North Fork Virgin River, 24–25

water quality monitoring, 109; Nisqually River, 7; San Lorenzo River, 11
Water Quality Working Group, 11
water scarce, 111, 119–120
water spirits, 95
Water Wally, 113–114, 113p
West, Matt, 58
Whanganui River (Te Awa Tupua) (New Zealand), xx
White Nile River, 79
Wild and Scenic River designation: eligibility, 21; Merced River, 19; North Fork Virgin River, 23; Río Grande, 129
Witsen, Willem, 75

Xi Jinping, 123

Yaqui, xii
Yaqui (Yoem Vatwe) people, 33–37
Yaqui River (Río Yaqui/Jíak Batwe), xii, 32p, 33–37, 34p, 36p
Yellowstone National Park, 17
Yew, Lee Kuan, 117p
Yi Peng celebration, 96
Yoem Vatwe (Yaqui) people, 33–37
yohhe'meti, 17
Yosemite Falls, 17, 19p
Yosemite National Park, 17
Yosemite Valley, 17

Zion Canyon (Mukuntuweap/Mu-Koon'-Tu-Weap), 23, 23p
Zion National Park, xii, 23
Zuiderkerk, 74p